abram kanof

jewish ceremonial art and religious observance

harry n. abrams, inc., publishers, new york

Standard Book Number: 8109-0178-1
Library of Congress Catalogue Card Number: 69-12798
All rights reserved. No part of the contents of this book may be reproduced
without the written permission of the publishers
HARRY N. ABRAMS, INCORPORATED, NEW YORK
Printed and bound in Japan

contents

ACKNOWLEDGMENTS My first and foremost teacher in this field was Dr. Stephen S. Kayser, to whom I express my respect and gratitude. Dr. Kayser organized, and for years directed, New York's Jewish Museum, the first in America, and has helped launch several since. These efforts, his writings, and his lectures make him a pioneer in awakening American Jews to their heritage of beauty. Professor Guido Schoenberger, Judaica Research Fellow Emeritus of the Jewish Museum and Adjunct Professor of Fine Arts, Institute of Fine Arts, New York University, was of great help. His careful annotation of the Museum collection is evident throughout this volume in the legends accompanying the photographs. The late Franz Landsberger earned the thanks of all who are interested in Judaica for his series of fascinating and scholarly articles in this field, most of which appeared in the *Hebrew Union College Annual,* to say nothing of his classic history of Jewish art. I want to acknowledge also the assistance of Siegfried Rosenberg, Registrar of the Jewish Museum. Frank J. Darmstaedter was most helpful. Thanks are due to my friend Harry N. Abrams for his encouragement and to Milton S. Fox and his staff for their insistence on high standards.

Most of all, thanks are due to my wife, Dr. Frances Pascher, to whom I lovingly dedicate this book. Numerous discussions with her over a period of years culminated in the idea; hours of conferences decided its approach and scope.

foreword

Judaism is a way of life that is dedicated to the transformation of every action into a means of communion with God. It is thus that Jewish law not only concerns itself with worship and ceremonial but extends to every conceivable facet of the relationship of man with man, and man with his environment. It is in the Sabbath, the festivals, and the occasions of special joy or sadness, however, that the communion with God is perhaps made most tangible. The enhancement of the symbolism of these occasions by artists and craftsmen through the ages has produced a truly significant heritage of Jewish ceremonial art and historical art objects.

Dr. Abram Kanof brings to this book about Jewish ceremony and ceremonial art a knowledgeability and devotion made even more remarkable by the fact that he combines his avocation in this area with the rigorous demands of a medical career. His interest and capability in the field of Jewish art have been matched by his generosity. The collection of modern ceremonial art in the Jewish Museum in New York has been greatly enhanced by the many gifts of Dr. and Mrs. Kanof. The design and execution of modern ceremonial objects in the Museum's Tobe Pascher Workshop, of which they are founders, owe much to their interest and support.

As one reads Dr. Kanof's extensive description of Jewish artistic expression in the meaningful areas of Jewish life, one is struck by the interrelationship of sanctuary and home which has marked Jewish history. The Passover seder, the kindling of lights during Hanukah, the kindling of the Sabbath lamps are all activities that bring to the home an aesthetic and holy dimension reserved in other traditions for the house of worship. The beautifully illustrated Haggadot, the menorot, the lamps of the Sabbath can make each Jewish home itself a sanctuary.

The religious atmosphere of both home and synagogue can always be made more beautiful. It is my hope that a thorough understanding of the history and role of Jewish ceremonial art—to which this book contributes greatly—will serve to encourage the artists of today to fashion objects inspired by tradition yet expressive of the best in contemporary design.

LOUIS FINKELSTEIN

Chancellor, The Jewish Theological Seminary of America, New York

INTRODUCTION:
CEREMONY AND ART
IN JEWISH LIFE

Religious experience is more commonly absorbed through the senses than through the intellect. Leaders of all creeds have recognized a visual aspect in religious experience, and accordingly have employed art as the handmaiden of religion both to instruct and to create an environment of reverence. It is no coincidence that, for most of human history, religion has given the impetus to much artistic endeavor.

The didactic function of art has rarely been important in Judaism; the level of literacy among Jews made it unnecessary. Still, beautiful architectural elements and ritual objects have been traditional since biblical times. True, it is the spirit of the service that gives significance to a ceremony, and a cup of any kind, if unflawed, can be used for the kiddush. Yet the rabbis of old called for *hidur mitzvah*, beautification as an integral aspect of pious duties. Sacred objects to enrich the simplest traditional act lend themselves to creativity which emphasizes the element of beauty in holiness; coincidentally there is recalled the intrinsic holiness of beauty itself. While the biblical sanctuary and its rituals have long since vanished, they live on in every home in which *klei kodesh* (sacramental objects) are meaningfully used. Abraham Heschel remarks: "We cannot make [God] visible to us, but we can make ourselves visible to Him."[1] We can do so by performing the *mitzvot* in a beautiful way.

Judaism is enriched by a great number of ceremonies, acts performed under specified conditions, formalized by tradition, and designed to inspire participants and observers. A ceremony sanctioned by religious tradition becomes a ritual or a rite. In Jewish belief, some ritual observances (for example, those of the Sabbath and Passover) have the force of Mosaic law; others (for example, the kiddush and the havdalah) are later developments made binding by rabbinic decree. All, however, have an element best expressed by the Hebrew word *mitzvah*. In this sense, Jewish ritual indicates God's special relationship to the Jews and emphasizes the religious significance of historic

events. Indeed, religious observances serve to emphasize special ethical principles associated with the events they commemorate. A ·pertinent example is Tishah B-Av (Ninth of Av), when in memorializing the fall of the Jewish state we also remember the warning of the Prophets that the seeds of destruction lie within ourselves: "Because of our sins were we exiled." Similarly, the joyous Passover celebration is the background for the constant reminder of our humble national origins and encourages humility and compassion: "For you were slaves in Egypt." The sukkah reminds us of our days of wandering, of the beneficence of shelter, and the thanksgiving due after a harvest. Ceremonies envelop ethical principles in warmth and create associations that do much to ensure adherence to these principles. Finally, the performance of ceremony gives the intangible nature of spirituality concrete form and endows it with a material dimension that reinforces the spoken ethical lessons. Perhaps that is what was meant when, in response to the announcement of the Commandments, the Israelites said first "we will do" and then "and obey" (Exodus 24: 3,7).

In Jewish life almost every act, even the most prosaic, has its element of piety and becomes an expression of the relationship of God to His people. Jewish living extends from one sanctification to another, bringing eternal values into worldly life: even the utensil used in the course of a ceremony becomes sacramental. The speech of Shmuel Yosef Agnon in accepting the Nobel Prize for literature in 1966 touched on the ubiquity of ritual in Jewish life:

Our Sages of blessed memory have said that we must not enjoy any pleasure in this world without reciting a blessing. If we eat . . . or drink . . . if we breathe the scent of goodly grass . . . of spices . . . we pronounce a blessing over the pleasure. The same applies to the pleasure of sight. When we see the sun in the Great Cycle of the Zodiac in the month of Nissan, or the trees first bursting into blossom in the spring, or any sturdy and beautiful trees, we pronounce a blessing.[2]

Rabbi Louis Finkelstein has summarized the theological significance of ritual observance:

The dominant principle of the Torah, whether love for man or obedience to God, obviously expresses itself in every commandment—ritual, moral, or legal. From the viewpoint of the School of Hillel, the legal and moral laws reflect the ideas of the Torah directly, and the ritual system only indirectly. . . . The positive commandments (such as eating unleavened bread on the first night of Passover . . . or reciting prayers . . .) have the great virtue of emphatic declaration of the truths inculcated in the whole Torah. Holy days, holy vessels, holy rituals, derive their sacredness from the fact that they make men especially mindful of the meaning of life and the Torah. The negative ritual commandments (such as refraining from forbidden fruit, forbidden marriages . . .) have the merit of continuity. Their symbolism is not vivid, but it is uninterrupted. They are the prose of the Torah; the positive commandments are its poetry.[3]

Ritual has great psychological importance for the modern Jew. In the performance of an ancient observance, he reaffirms his relationship with four millenniums of ancestry. As he re-enacts epochal moments, significant in the history of his people and of civilization, he establishes an identity that serves to counter the loneliness of urban living. For thousands of years this unique system of ritual, which affects every detail of daily living, has been the identifying characteristic of the Jewish people, and has made the Jew part of a large, great, and holy community. Ritual also is an appropriate, even necessary, format for the mobilization of emotion and thought. The great mass of men find it difficult to articulate their responses to the major events of their lives: marriage, the birth of a child, the death of a parent. Ceremony and benediction provide a satisfying formula for expressing such reactions. Is there a better way to reaffirm the joy of a happy marriage than by reciting *Eshet hail* ("A woman of valor") every Sabbath eve?

Ceremony relieves the monotony of utilitarian labels that denote daily and seasonal progression. The Shabbat removes Saturday from the mundane world, and makes its observance a mitzvah, bringing a taste of Paradise into the present and giving hope of a happy world to come. Spring, summer, fall, and winter designate the rhythm of the year; Pesah, Shavuot, Sukkot, and Hanukah brighten, enrich, and sanctify the seasons. In this century the idea of God seems increasingly difficult to grasp for great numbers of people. Daily rituals, with their associated objects, serve to personify the idea of God and create the comfort of a personal relationship with the One whose ethical precepts we obey.

As important as these ceremonies and ceremonial objects were to our parents, they are even more so to our children. The modern American family is a biological entity that tends to be disrupted socially by divergent interests, duties, and obligations. The traditional Jewish family is helped to overcome the distraction of peripheral obligations by the pattern of recurring domestic ceremonies. The most significant aspect of Jewish ceremonial is that it is predominantly observed in the home rather than in the synagogue. The difference between the two types of observance derives from tradition, the ceremonials for the home seeming to have their roots in the ritual of the ancient Temple, while those of the synagogue derive from historical events and social factors. The Talmud has a saying that after the destruction the table became the Temple. The partaking of kosher meat in the Shabbat or seder meal may be equated with the Temple offering and thus takes on a significance beyond that of a means of physical sustenance, while the washing of the hands before eating, accompanied by the reciting of a benediction, reminds us of the priestly purification rites.

In the course of home ceremonies all the senses are appealed to: we hear the benediction, we taste the wine, we touch the etrog and

lulav and feel the curve of the ceremonial cup, we smell the mixed herbs of the havdalah, and we see the gleaming surfaces of the candelabra, the rich fabrics of the tablecloth, the colorful east-wall marker, and the happy, expectant faces around the table.

Ceremony and ritual have a special meaning for the young. A child delights in repetitive activity: most children's games are based on reiterative doggerel, and baby stories and early reading are generally developed on slow action punctuated by repetition. Ceremonies experienced regularly in an atmosphere of sanctity build a bastion of security and foster a feeling of unity with others. Psychologists indicate that the father image has been blurred in the American home. We suggest that the father's rising to recite the kiddush, or conducting a proper seder, or conducting the havdalah ceremony can do much to enhance the paternal figure. These services not only define the father image but give each member of the family a clear place in the domestic hierarchy. The mother occupies the center of the stage on Friday night as she lights the candles; on that night and at the seder it is her cooking which excites attention and evokes from the father his recitation of *Eshet hail*. On Friday night the child receives the paternal blessing at the door; on Passover he recites the four questions as the whole family beams, and father responds. Mother, father, child—all individually significant in their own way—together create the total family.

Our sociologists remonstrate that American youth lacks a sense of reverence. The father who conducts these ceremonies with dignity, and with a sense of their importance, is cultivating in his children the sense of reverence. These acts become the basis for an established practice that keeps the child home on Friday nights, and brings him back for the Passover seder even if a continent must be crossed. A sense of security, an experience of reverence, the delineation of an authoritative father figure presiding over an established family configuration, and the strengthening of the domestic instinct—these are the rewards of a traditional home.

So deeply ingrained is the symbolic nature of recurrent ceremony, and so joyously does the Jew adhere to the principle of *hidur mitzvah*, that a large number of sacred objects has developed for the embellishment of these rituals. Religious observance thus has stimulated artistic creation, enabling the observant Jew to recite sincerely the Psalmist's hymn to the beauty of the Law: "Thy testimonies are my delight" (Psalms 119:24).

In the long history of man's cultural striving, the close relationship of art and religion is universal. Over a great part of this span, religion was the main spur to art, first in the human and animal representations of primeval man, then in the luxuriant architectural embellishment of the ancient Temple, and on through the epochs of lavish church and synagogue decoration. Art, in turn, has been an impressive popularizer of religion and its ethics and a great inspiration for religious feeling.

1. Judaism and Art

It is widely assumed that Judaism as a religion is antagonistic to art, and this is commonly attributed to the Second Commandment: "You shall not make for yourself a sculptured image, or any likeness of what is in the heavens above, or on the earth below, or in the waters under the earth" (Exodus 20:4). Less frequently noted is another injunction, intended to separate the Israelites from the cultural milieu of the Middle East: "You shall not follow the practices of the nation that I am driving out before you. For it is because they did all these things that I abhorred them" (Leviticus 20:23). Jewish antipathy to artistic expression has not been attributed to basic theological precepts alone; Scripture also contains passages in which the Prophets speak out against art as a symptom of debilitating luxury (Hosea 8:14; Amos 3:15, 6:4–7).

It seems that opposition to art on a religious basis was in fact a relatively late development among Jews, and that when it did develop it was not uniform but varied from time to time and place to place. Study of the record, both archaeological and literary, indicates that earlier biblical Judaism encouraged artistic development. The Second Commandment was directed against the sculptured image as idol, and it was thus interpreted by the priests and Prophets who coupled it with the verse that follows it: "You shall not bow down to them, and shall not serve them" (Exodus 20:5). The reading of the passage as two separate injunctions by stricter rabbis contributed to its interpretation as an absolute prohibition of sculpture in the round.

The name of the biblical craftsman Bezalel was derived from the Hebrew *bezal-El* ("in the shadow of God"), a phrase indicating that it was the Lord himself who "endowed him with a divine spirit of skill, ability, and knowledge in every kind of craft" (Exodus 35:31). The desert Tabernacle, designed and built by Bezalel and Oholiab, is described in the Bible as an elaborate structure (Exodus 25–26). Its central object, the Ark, the work of Bezalel, was a supreme achievement of the cabinetmaker's art; it was embellished with heavy and

diverse golden ornamentation and surmounted by cherubim.[1] The cherubim were a "sculptured image," although they certainly were not a "likeness of what is in the heavens above, or on the earth . . . or in the waters." The rabbis imagined the cherub as having a human face and the wings of a bird; modern scholars identify the cherub with the winged creature having the head of a woman and the body of a lion (called "sphinx" by the Greeks, perhaps of Egyptian derivation), which is known to us from Phoenician archaeological remains. Such remains clarify the biblical description of the Lord sitting upon the cherubim (I Samuel 4:4; II Samuel 6:2) and speaking from between the two cherubim (Exodus 25:22); the cherubim were supports for the throne of the invisible God of the Hebrews just as they were for the thrones of the visible gods of the neighboring nations. In the Tabernacle the cherub motif appeared not only in the figures of hammered gold at either end of the Ark cover but woven into the curtains (Exodus 26:1).

Doubts as to the historical accuracy of the biblical description of the Tabernacle are gradually being dispelled by an increasing body of evidence.[2] In any event, we meet the artist early in Jewish history— about 1300 B.C.E.—and find that "a theocratic concept of the world existed in biblical times in which the artist was accorded a strong and prominent position. . . . Seldom has a nation identified the work of an artist with its most sacred ideals, as did the Jews in the description of the tabernacle and of its builder and decorator."[3]

During the period of the Temples (1020 B.C.E.–70 C.E.), we can reasonably assume, sculpture and painting were permitted, provided idolatry was not involved. The legends of the Jews have been stressed by Ludwig Blau as indicating how the Jews have felt and thought about art in the past.[4] Particularly important is that body of legend preserved in the Aggadah, the nonlegal portion of the Talmud, since these stories reflect rabbinical opinion as well. The Aggadah records the traditional descriptions of Solomon's throne: the pairs of golden animals on the steps (six, in one account), the multitude of figures of birds and beasts, the golden candlestick with, most interesting of all, the names of the Patriarchs engraved on it (see fig. 218). The source of our knowledge of the Temple of Solomon is Scripture itself (I Kings 7:21–50). In the Temple's main courtyard stood the huge laver known as the Brazen Sea, resting on the backs of twelve carved oxen. Before the entrance the two columns Jachin and Boaz (calling to mind Herodotus's description of the two pillars of the temple of Heracles at Tyre) were surmounted by carved lilies. The interior of the structure was adorned by a profusion of decorative detail: palm trees, open flowers in gold, variously colored hangings, and figures of lions. In the Holy of Holies stood the two cherubim, side by side, their outspread wings touching each other as well as the opposite walls of the holy chamber. It may be seen that even in these early times there was by no means

universal observance of the specific admonition "not to act wickedly and make for yourselves a sculptured image in any likeness whatever, having the form of a man or a woman, the form of any beast on earth, the form of any winged bird . . . of any fish" (Deuteronomy 4:16).

The talmudic sages entertained no doctrinal objections to beauty. The word for wisdom, *hohmah* (meaning wisdom of the Torah), was also used to connote skill and artistic work. The Hebrew language does not lack words denoting beauty: in this category are *yafeh, nehmad, hemed, naveh, tov mar'eh* (a frequent biblical locution for referring favorably to the appearance of a person), *hadar, hen, na'eh, hod*. The rabbis amplified the declaration "This is my God and I will glorify Him" (Exodus 15:2) with specific admonitions: "Make a beautiful sukkah in His honor, a beautiful lulab, a beautiful shofar, beautiful fringes, and a beautiful Scroll of the Law, and wrap it about with beautiful silks." They were proud of Herod's Temple (20–19 B.C.E.) though it clearly showed the influence of Greek architecture. "He who has not seen the Temple of Herod," they said, "has not seen a beautiful building in all his life."

The Maccabees (second century B.C.E.), arch opponents of Hellenistic influence, had not been consistent in their iconoclasm: "Now Simon built a monument on the grave of his father and brothers and raised it high and embellished it with polished stone inside and at the rear. And he built seven pyramids one opposite the other, for his father, his mother, and his four brothers. And he decorated them artfully, and around them he set large pillars" (I Maccabees 13:27–29). The extravagance in mortuary art that characterized this tomb at Modin was not exceptional. In the great necropolis stretching for several miles on both sides of the road entering Jerusalem from the north is another tomb of the Maccabean period (as well as a number of tombs from the Herodian period) containing many varieties of intricate and decorative art.

In the field of coinage we find further evidence of the artistic expression permitted in Maccabean times. A considerable literature exists on Jewish coins struck in Palestine from the rule of Hyrcanus (135–104 B.C.E.) to the revolt of Bar Cochba (132–135 C.E.).[5] For the most part the decoration of coins of the Hasmonean period consisted of representations of Temple utensils, but some of the later Maccabees struck portrait coins in imitation of Roman practice. In the Herodian period there are coins with portraits of Agrippa I (r. 41–44) and Agrippa II (r. 49–70), Herod of Chalcis (r. 41–48), and Aristobulus (r. 70–92). On the reverse of a portrait coin of the last-named ruler is a likeness of his wife, Salome—the Salome of Christian tradition, who at the instigation of her mother demanded the head of John the Baptist.

The tannaim (rabbis of the first two centuries C.E.) interpreted the Law more strictly and particularly forbade representations of the moon and stars, frequently the objects of heathen worship. The new

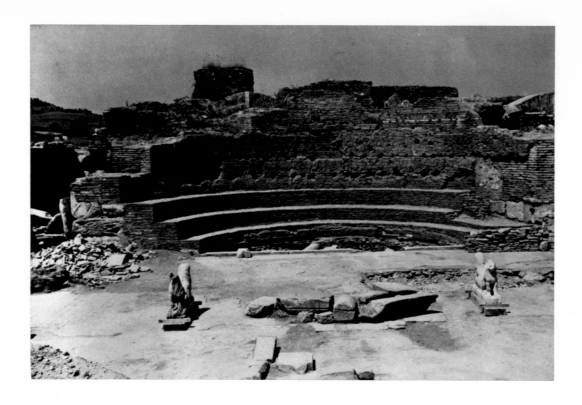

1. Two pairs of stone lions flanking the lectern of the synagogue in Sardis, Asia Minor. From Lydia, fifth or sixth century B.C.E.; probably acquired for the synagogue as symbols of the lion of Judah. Courtesy Professor George M. A. Hanfmann

rigidity was due chiefly to the concern of the tannaim about the increasing attraction of Hellenism for the Jews. They built strong and high the "fence about the Law." Roman coins bearing the face of the emperor were interdicted. Josephus tells us that Jewish youths risked torture and even death to remove the golden eagle that Herod had erected over the gate of his Temple. When Pontius Pilate set up his standards bearing the image of the emperor in the Temple area, huge crowds went to his headquarters at Caesarea and for five days and nights besought him to remove the human likeness from the holy area. Finally soldiers surrounded the crowd with drawn swords, but the Jews bared their necks, preferring death to acquiescence, and Pilate yielded.[6]

Even during this "fundamentalist" period the fence was breached. Consistency, as has been pointed out, notably by Solomon Schechter and, more recently, Saul Lieberman, was never a strong feature of rabbinic precept or example. While Menahem ben Simai (latter half of the second century) would not even look at the image on a small coin, Gamaliel II (late first–early second century) kept a diagram of stars and moon for calculating the seasons, despite the prohibition "And when you . . . behold the sun and the moon and the stars . . . you must not be lured into bowing down to them" (Deuteronomy 4:18). Gamaliel also patronized a Roman bath in which there was a statue of Aphrodite, replying in answer to critics that placement of the statue of the goddess in a bath obviously precluded its being worshiped: "What is treated as a deity is prohibited, what is not treated as a deity is permitted." In the reign of the Emperor Caligula (r. 37–41)

a royal edict requiring installation of and obeisance to his image in all places of worship in the Empire aroused waves of opposition, but in the third century a royal statue stood in the synagogue of Nehardea, in Babylonia, where such pious sages as Rav and Samuel worshiped. By this time—the period of the amoraim (rabbis of the period 220–500 C.E.—rabbinic authority either would not or could not suppress the human need for artistic expression. According to the tractate Abodah Zarah, in the days of Rabbi Johanon bar Nappocha (d. 279) "men began to paint pictures on the wall, and he did not hinder them." In recent excavations at Sardis, Professor George M. A. Hanfmann brought to light a synagogue dating from 200 C.E. in which there are beautifully carved lions and an eagle (figs. 1–3). In his monumental work on Jewish symbolism in Greco-Roman times, Goodenough[7] gives numerous examples of symbolic art among the Jews of this period which he thinks represent the integration of heathen artifacts into Jewish places of worship.

Relaxation on the part of later amoraim was due to various factors. Strict interdiction declined as the danger of idolatry waned during the consolidation of Judaism and the expansion of Christianity. Moreover, as Jews became better acquainted with the world about them they became increasingly impatient with the old restrictions. Inevitably, theological dicta became less potent as the authority of the rabbis

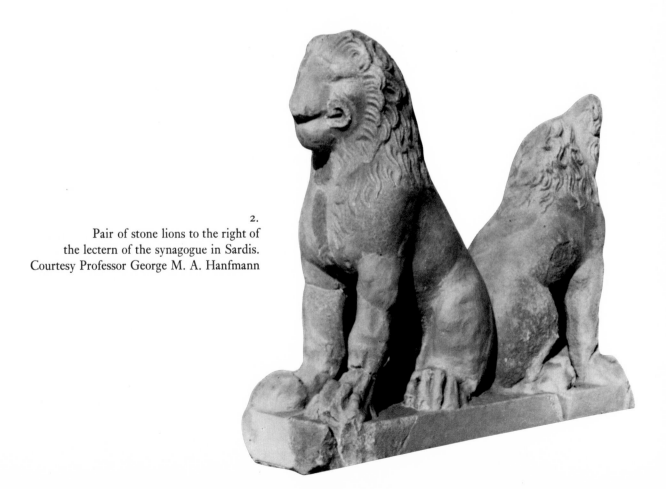

2.
Pair of stone lions to the right of
the lectern of the synagogue in Sardis.
Courtesy Professor George M. A. Hanfmann

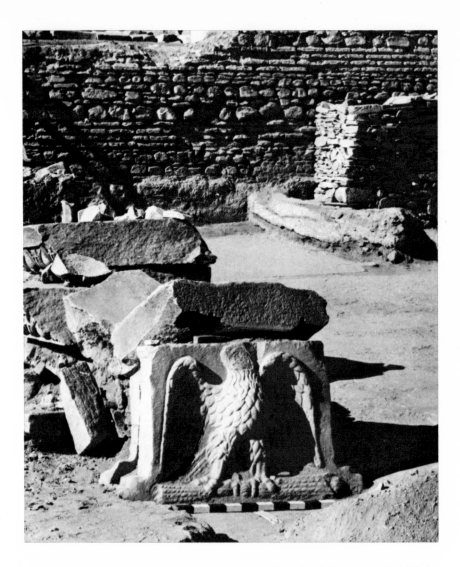

3.
Stone eagle on the base
of the lectern of the synagogue
in Sardis. Courtesy Professor
George M. A. Hanfmann

diminished with the wide dispersion of their followers. Rabbinic interdiction, it seems, was often no more effective than such early Christian rulings as the 36th canon of the Council of Elvira (beginning of the fourth century), which prohibited pictures on church walls.[8] It is evident that the early church fathers also had the problem of reconciling the Law of Moses and the natural law of the human spirit. They gave up the struggle early, but the more rigorous attitude was revived centuries later in some of the Protestant groups.

Socioeconomic factors in the liberalization during this period have been emphasized by Joseph Gutmann: the great prosperity among Jews and their friendly relations with the Roman rulers during the third century encouraged adoption of Roman attitudes. Moreover, as Professor E. E. Urbach has pointed out, the Jewish population of Palestine had by this time become largely urban and artisan, and in order to compete in the non-Jewish market Jewish craftsmen had to add the familiar pagan motifs to their works.[9]

Representational art by Jews and for Jews thus became widespread

after the third century; examples can be seen in the lintels, friezes, and floor mosaics of the excavated synagogues, in the monumental tombs and catacombs of Palestine, Syria, and North Africa, and in the richest storehouse of all, the catacombs of Italy. That a high point of permissiveness was reached during the third century is evidenced by the wall paintings of the synagogue of Dura Europos in western Syria. This exciting find undoubtedly represents a widespread acceptance of art in the synagogues of the time. To the question as to whether these paintings might have been a solitary instance occurring in an unorthodox section of local Jewry, Rachel Wischnitzer has answered: "The wall paintings of the synagogue of Dura cannot . . . be regarded as an isolated phenomenon. They appear as a manifestation of a growing sense of freedom of expression in the whole Jewish world. Their chief interest lies in the implication that they reflect general trends of thought and a group attitude rather than an episode and an individual effort."[10]

The Dura Europos paintings are arranged in three main zones, or registers; they illustrate leading events of the Scriptures, among them Jacob's dream, the finding of Moses, Moses giving the Law, the Exodus, Aaron and his sons consecrated, David's anointment, Ahasuerus and Esther. A large number of full figures are frontally posed in a manner calculated to impress and awe the viewer. All the biblical heroes are here, as well as Pharaoh's daughter, who is more likely to excite interest than awe, depicted full figure and nude as she rescues the infant Moses from the waters of the Nile. Equally striking, theologically, are representations of the hand of God in five of the wall paintings: the Exodus, Elijah raising the widow's child, Ezekiel's prophecy of the resurrection of the dry bones, Moses at the burning bush, and the sacrifice of Isaac.

By mid-fourth century, a statement of Rabbi Abun in the Abodah Zarah indicates, painted figures could be tolerated on pavements. However, Rabbi Abun stipulated, "a stone column carved with images and likenesses you may make upon the premises of your sanctuaries, but not to worship them."[11] For the fifth and sixth centuries, floors of mosaic are the best-preserved examples of synagogue art. This almost universal art form of the antique world was widely practiced in ancient Palestine. The earliest mosaics (e.g., those found in the Herodian palace in Masada) show simple geometric patterns in black and white.[12] By the fifth century, however, Jewish floors were being decorated with multicolored mosaics; these have been found in a variety of buildings and in a number of synagogues: Beth Shean, Beth Shearim, Nirim, Huldah, Hammam Lif, Naaran, and, above all, Beth Alpha. Moreover, in the synagogues mentioned the simple geometric forms had given way to figural representations despite the fact that prostration during prayer on a pavement bearing such designs might present the appearance of obeisance to an image.

The floor of the Beth Alpha synagogue is the most beautiful thus far uncovered. The Jewish artist Marianos and his son Hanina, signing their names in Greek but annotating their masterpieces in Hebrew, drew upon the cultures of two civilizations. The representations of the sun, moon, and stars, of the zodiac, and of the seasons and the hand of God dominating the action of the picture are all pagan-derived.[13]

The representations of the Holy Ark and the other appurtenances of Jewish worship are common motifs; the dominant picture, the sacrificial offering of Isaac, the Akedah (lit. "binding"; Genesis 22:1–19) is the most frequent pictorial theme in Jewish art. Figural representations appear in mosaics of other ancient synagogues: for example Noah's ark at Gerasa and Daniel in the lions' den at Naaran.[14] Beth Shearim, the seat of the patriarch Rabbi Judah (second century) and the Sanhedrin, and in the third and fourth centuries the site of the central burial place where pious scholars from far and wide were interred, abounded with elaborately decorated sarcophagi.[15]

The rise of Islam in the seventh century introduced a reaction to the trend. The Muslims were more iconoclastic than the Jews. It is stated in the Hadith that painters will be among those most severely punished on Judgment Day because of their presumption in trying to imitate the creativity of God. It is also said that the angels of mercy will not enter a house containing an image. But even these harsh strictures did not prevent the depiction in the frescoes in the Great Mosque of Cordova of the staff of Moses, the seven sleepers of Ephesus, and the raven of Noah.[16] The severe iconoclasm of Mohammed's followers discouraged artistic embellishment in the Jewish provinces under their rule, so that during a rich and highly cultured era in Jewish history there is a relative absence of representational art. By the same token, however, Muslim craftsmanship was discouraged; accordingly, in this milieu, the Jewish craftsman, finding himself free of non-Jewish competition, flourished.

By the end of the twelfth century, rabbinic restrictions were liberalized by the authority of Maimonides. He prohibited only the representation of the human figure in relief, whether in clay, stone, or wood. Figures of animals and figures of trees, plants, and the like were permitted even if the figure was raised. Figures on tablets or pictures woven into textile materials were permitted by this great sage. In the same century, Rabbi Ephraim ben Isaac of Regensburg (Ratisbon) went farther and permitted pictorial representations in the synagogue; even non-Jews, he said, no longer practiced idolatrous worship. The Sarajevo Haggadah (fourteenth century) depicts many biblical scenes, in one of which (the temptation of Eve in the Garden of Eden) wholly nude figures appear.

In the Middle Ages, while idolatry declined as a threat to both Judaism and Christianity, art presented a new problem to both rabbis and priests, namely, the rising interest in painting and sculpture,

4. Detail of a polychrome painting on a pendentive
of the synagogue of Wizuny, Poland. From M. and K. Piechotka,
Wooden Synagogues

which tended to divert the worshiper from pious contemplation. Maimonides, in a *responsum,* mentioned the distracting influence of synagogue decoration; we are told that he would shut his eyes so as not to be diverted from his prayers. The European rabbis—Rabbi Meir ben Baruch of Rothenberg (1215–1293), for example—reacted with renewed legal strictness to this intrusion of art into the services.[17] Ironically, when in 1282 the Archbishop of Canterbury gave permission for the maintenance of one synagogue in London, it was with the proviso that no pictures appear on its walls![18]

Rabbinic proscription could not, however, altogether discourage pictorial art. In the medieval period, and later during the Renaissance, it continued to manifest itself—in synagogue decoration, on gravestones, and above all in the many illuminated Hebrew manuscripts. The practice of illustrating the holiday prayer book (mahzor), the Scroll of Esther, and, particularly, the Haggadah was widespread; indeed only Torah scrolls remained strictly textual. Some manuscripts, prayer books included, displayed a freedom from restraint that would be remarkable even today. Full-length pictures of biblical characters abounded, including, on occasion, partially draped female figures. Marriage contracts were especially elaborate; among the decorations were flower forms, portrayals of historical personages, and scenes suggested by the bride's or the bridegroom's name, as well as, occasionally, voluptuous nude figures representing the first couple, in the Garden of Eden. In a fourteenth-century German mahzor, Jonah, seated under his tree, comes under the very gaze of the Deity. With the advent of printing, the Jews seem to have ceased to exercise restraint in regard to the representation of the human figure. An interesting compilation by Abraham Yaari shows sacred books adorned with, in addition to the usual symbols, well-favored angels, nude queens, full-faced Moseses and Aarons, and the hand of God.[19] Almost four hundred traditional Jewish art objects on which the human figure is painted, drawn, engraved, sculptured, woven, or embroidered have been enumerated by Moshe Davidowitz in a recent article: amulets, bookbindings, circumcision knives and plates, ritual cups, bsamim and etrog containers, sacramental lamps, megillah cases, Purim and Passover plates, and silver and fabric appurtenances for the Torah.[20] The inclusion of manuscripts and books would vastly increase the list. Representations of the Deity are not unknown. On a Sephardic gravestone of 1717 in Amsterdam and in the engraved frontispiece of a learned edition of the Bible published in Mantua in 1742 there are figures representing the Almighty, while the hand representing God is almost a commonplace.[21]

During the Renaissance the Roman Ghetto was alive with an exuberance of artistic expression. The walls of Jewish homes were often decorated with paintings. In the house of one Florentine Jew (1579) there were frescoes representing biblical scenes. It was also conven-

5.
Carved and painted
decoration
in the synagogue of Mogilev,
Byelorussia. From M. and K.
Piechotka, *Wooden Synagogues*

tional at this time for synagogue interiors to be decorated in the tradition of Dura Europos. In Rome the walls of the Scuola del Tempio (1555) were decorated with pictures of the sacred utensils of the Temple, and the sixteenth-century oratory of Casale Monferrato displays a view of the city of Jerusalem. When in the seventeenth century the synagogue in Carpi was enlarged, the Duke of Modena was asked to grant permission to have it decorated with frescoes, since "in all synagogues fine paintings are made without stint for adornment."[22] Other European synagogues permitted themselves similar leeway. In Poland the bimah at Luck (Lutsk) was decorated with a series of life-sized animals; the Holy Ark and the adjoining east wall in Urpzogrod displayed sculpture and painting, including a representation of Noah's ark with the procession of animals entering it. The synagogues in Gwozdziec, Jablonow, and Mohilev (Mogilev), and many others, had elaborate decorative murals on their walls (colorplate 1; fig. 4). The wooden synagogue in Mohilev had sculptured animals at the base of its bimah (fig. 5). A chandelier from the Altneuschul in

23

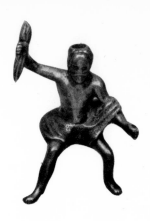

6. Figure of Jupiter
from a chandelier of the Altneuschul, Prague.
Seventeenth century. Copper. Jewish Museum,
New York. Gift of Albert and Vera List

Prague sported a Jupiter among its motifs (fig. 6). In the Rashi synagogue in Worms the base of a pillar was actually ornamented by a sculptured gargoyle, while the imposts of its pillars showed carved human and animal forms. Most striking of all in this ancient hall of worship was the candelabrum; it rested on a base composed of a figure of Jupiter, thunderbolt in hand, astride a full-figured eagle (fig. 7).[23] In a synagogue of Schnaittach, near Nuremberg (c. 1660), the chandelier had a figure of an angel in the round (described in an unpublished manuscript by Professor Guido Schoenberger). About a century later, an Orthodox congregation in America countenanced in their house of worship—the Touro Synagogue of Newport, Rhode Island (figs. 244, 245)—a chandelier decorated with four human heads (fig. 8).

The rise of capitalism broke down many economic barriers, enabling Jews of all ranks to enlarge the scope of their activities. The number of Jews with substantial means increased. They moved into urban centers of culture and became, more and more, patrons of the arts. The separation of church and state was a factor in freeing art in the mind of the Jew from the Christian associations which had for so many centuries been an inhibiting influence. Before the separation of church and state, the Jew had been accustomed to consider the church as society's chief sponsor of art, and indeed most art was based on religious themes.[24]

In America the Jew could create, commission, and enjoy works of art without apprehension as to civic or religious loyalties. This New World latitude is illustrated by an incident related by the famous Jewish world traveler Benjamin II (Israel ben Joseph Benjamin, 1818–1864). The Jewish community of New Orleans had decided to erect a statue of Judah Touro (1775–1854), veteran of the War of 1812 and the first of the great American philanthropists. When Benjamin, traveling through, heard of this, he made it an issue, but not a single Orthodox rabbi sustained his objections. This incident has an amusing European counterpart. At the fountain in the Jewish quarter of Siena there had stood for hundreds of years a statue of Moses. No one had ever taken exception to it until, at the end of the eighteenth century, a visiting Jew from Poland saw it and objected vehemently. As a result, the statue is now in Siena's municipal museum.

The emancipation and the many changes that followed in its train gradually brought about a new departure in the Jewish attitude toward

ceremonial objects. During the years when increasing secularization was tending to curtail the observance of the rituals themselves, Jews were becoming more interested in the historical and aesthetic aspect of the ritual objects. Collectors began to devote themselves to the study and acquisition of these objects. Thence it was but a short step to the organization of exhibitions and museums of Judaica. The earliest exhibition of Jewish sacred objects was held in London's Royal Albert Hall in 1887. The second, and one of the finest ever held, may be credited to the Board of Regents of the Smithsonian Institution, which sponsored a display of objects illustrating the practices of the various religions at the Chicago Columbian Exposition of 1893. To the small number of Jewish ceremonial objects owned by the Institution was added, through the efforts of Cyrus Adler, the famous Benguiat Collection of Jewish antiquities. The enlarged collection was displayed again in 1895 at the Cotton States and International Exposition in Atlanta and in 1897 at the Tennessee Centennial Exposition in Nashville. Similar exhibits of Judaica were held in several German cities at the beginning of the twentieth century. The first important exhibition of contemporary Jewish ceremonial objects was seen in the Palestine Pavilion of the World's Fair held in New York in 1939.

The end of the nineteenth century saw the beginning of a literature on Jewish art. Before then, published information on the appearance of ceremonial objects had appeared only incidentally in illustrations of books describing Jewish customs *(minhagim)*. The first work dealing with the ceremonial objects themselves was the magnificent catalogue of the Anglo-Jewish Exposition of 1887. In 1895, in Vienna, under the editorship of Dr. Moritz Gudemann, appeared the *Mitteilungen der Gesellschaft für Sammlung und Conservirung von Kunst und Historischen Denkmaler des Judenthums.* Two years later, in Hamburg, Max Grunwald founded the Gesellschaft für Jüdische Volkskunde; its publication, the *Mitteilungen der Gesellschaft für Jüdische Volkskunde,* appeared in 1898. The most important work of the period, however, was by the architect Heinrich Frauberger, Director of the Art Museum in Düsseldorf. A Christian, he became interested in Jewish ceremonials, and in 1899 he founded the Gesellschaft für Erforschung Jüdischer Kunstdenkmaler. The following year, he founded a Jewish museum in Frankfurt, and began to issue the *Mitteilungen* of his Gesellschaft. The first six numbers, written almost entirely by the editor, and profusely illustrated, constitute a rich mine of information about Jewish creative achievement. It was to this publication that

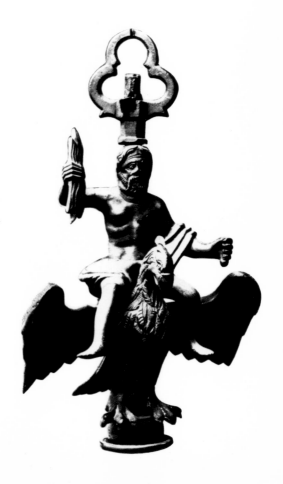

7.
Figure of Jupiter
from a chandelier of the synagogue in Worms.
Seventeenth century. Copper. Courtesy Professor
Guido Schoenberger

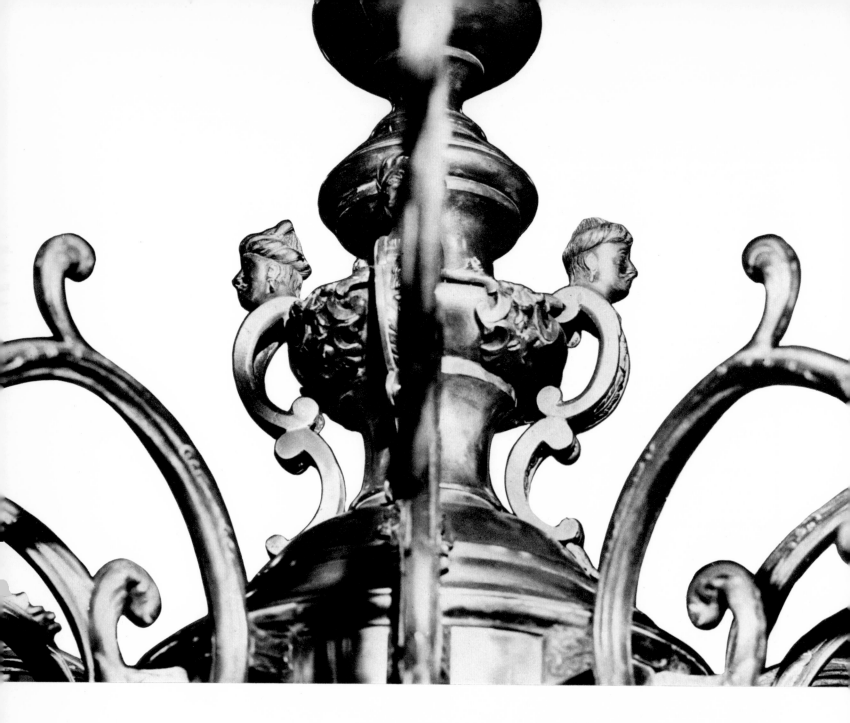

8.
Two of the four heads
decorating a chandelier of the Touro Synagogue,
Newport, Rhode Island. 1763. Brass.
Courtesy Rabbi Theodore Lewis

Albert Wolf of Dresden contributed his historical papers on Jewish art and artists, which were among the earliest systematic studies in the field and laid the basis for future works. Wolf, a jeweler, collected Jewish objects as a hobby; his collection later became the nucleus of the Berlin Jewish Museum. The first three books on Jewish ceremonial art also appeared in Germany: *Die Juden in der Kunst* by Karl Schwarz (1928), *Die jüdische Kunst* by Ernst Cohn-Wiener (1929), and *Einführung in die jüdische Kunst* by Franz Landsberger (1935).[25]

This interest in Jewish ceremonial art, first expressed in scattered exhibits and then explored with German scholarliness, inevitably led to the establishment of Jewish museums. The first was organized in

1900 by the Frauberger Gesellschaft in Frankfurt; subsequently similar institutions were founded: in Berlin (around the Wolf collection), Munich, Mayence, Breslau, and Strasbourg. The idea spread to other European cities, and museums were established in Danzig, Warsaw (around the collection of M. Berson), Vienna, Budapest, Prague, Amsterdam, Eisenstadt, Nikolsburg, and Petrograd.

The first Jewish museum in England was founded in London in 1932. It had, however, been preceded by beginnings of the Jewish Museum of New York. The Benguiat Collection, which, as noted, had been shown at the Smithsonian Institution, and for which Cyrus Adler and I. M. Casanowicz had written a scholarly catalogue (1901), was bought for the Jewish Theological Seminary in 1925; six years later, this and the collection of Maurice Herman were shown at the Seminary library; in 1947 these collections finally matured into the Jewish Museum of New York. The Museum of the Hebrew Union College in Cincinnati was formally inaugurated in 1948, its nucleus being the noted Kirschstein collection of Berlin, acquired in 1925.

The beginnings of the present National Museum in Israel go back to the Bezalel School and Museum established in 1906 by Boris Schatz, an ardent Zionist, as a society for the propagation of arts and crafts in Eretz Israel. A small exhibit was set up, and two years later it became the center of artistic activity in Jerusalem.[26] When the school and the museum separated, Mordecai Narkiss (1898–1957) became the head of the latter. A prolific writer, author of two important books on ancient Jewish coins and later an authoritative monograph on Hanukah lamps (hanukiot), and, above all, the authority in the field of Yemenite ceremonial art, Narkiss greatly influenced the Museum's development. Spectacular development of the Museum occurred after the foundation of the State of Israel, under the dynamic leadership of its American curator, Karl Katz. The culmination of this development took place on May 8, 1965, when the Israel National Museum was dedicated. It now includes the Bezalel National Art Museum, the Samuel Bronfman Biblical and Archaeological Museum, the Billy Rose Art Garden, and the Shrine of the Book. With this tremendous achievement by the State of Israel and its people, aided by Jewish art historians, architects, collectors, and artists everywhere, the relation between the Jews and art has come full circle: Judaism, in its earliest writings, extolled the sanctity of art, and the Jewish state, by the seventeenth year of its modern existence, had inaugurated one of the great international museums of art.

II. Jews and Art

The existence of a tradition of fine Jewish craftsmanship was largely unsuspected until relatively recent times. There was no difficulty in relating Jews to literature, or to the dance and music, but it was generally accepted that they had no bent for architecture, sculpture, and painting. As eminent a scholar as Immanuel Benzinger could actually state (1903) that Jews were handicapped by a lack of artistic inclination and a defective color sense, otherwise—the Second Commandment notwithstanding—they could not have resisted the impulse to creativity.[1] In an early work (1903) Martin Buber generalized: "The Jew of antiquity was more of an aural than a visual man . . . the most vivid descriptions in Jewish writings are acoustic in nature, the texts espouse sound and music, are temporal and dynamic, not concerned with color and form. The Jew seems not to see the things he looks at, but to think them."[2] In psychological terms, it has been suggested that Jew and Arab share a Semitic lack of talent for the figural arts.

The fact is that neither piety nor physiological limitation precluded Jewish artistic activity. Contemporary experience and modern scholarship reveal that despite the vagaries of the relation between Judaism and art, the line of Jewish craftsmen has continued unbroken from the earliest times to the present.[3] Had Benzinger lived a little longer, he would have witnessed and enjoyed the contemporary efflorescence of Jewish creativity and of Jewish activity in scholarly criticism and perceptive collecting.

The first mention of a craftsman in Jewish history comes early in the Bible with Tubal-cain, "who forged all implements of copper and iron" (Genesis 4:22). Biblical craftsmen whose accomplishment is described in greater detail are the Tabernacle makers, Bezalel and Oholiab, of the time of the Exodus. Three centuries later, when Solomon sent to Hiram of Tyre for a master metalworker to help in the building of his Temple, he promised that this artisan (who also bore the name of Hiram) would have the assistance of "the skillful men that are with me in Judah and in Jerusalem, whom David my

father did provide" (Chronicles 2:6). As Landsberger points out, evidently David, like other Oriental potentates of his time, had created a body of court artists, to which Hiram was now added.[4] Even before the initiation of the Temple project the boom in building of all kinds—private mansions, palaces, and government houses—had stimulated the development of craftsmen in Jerusalem. Temples for the various foreign divinities who had followers in the city were also being built. Judging from the repeated admonitions of the Prophets, idolatry must also have been giving scope to the creativity of ancient Hebrew craftsmen. Seal engravers seem to have been among the most important craftsmen of the time (Ecclesiastes 38:27).

During the Second Commonwealth (586 B.C.E.–70 C.E.) creativity, sacred and secular, continued to flourish. We know, from his writings, that by the time of Philo (20 B.C.E.–40 C.E.) there were in Alexandria Jewish guilds of goldsmiths, silversmiths, coppersmiths, and weavers. In Jerusalem at this time there were so many craftsmen that some of the guilds maintained separate synagogues for their members. The best-known achievement of the era is Herod's Temple, described in glowing terms by Josephus and in the Talmud. After the destruction of the Temple, in the year 70, craftsmanship found its chief outlet in the synagogues, which then became the prime institution of Jewish life. The synagogue in Alexandria (destroyed 117 C.E.) was described in the Talmud as one of the most beautiful buildings ever created. Whether its architect, or the architects of the large number of noble synagogues erected throughout the Middle East and in Palestine itself, were Jewish is uncertain, but it is known that some of the craftsmen were; the most famous names of the era are those of Jose ben Levi of Biram (third century) and Marianos and Hanina of Beth Alpha (sixth century).[5]

Jewish craftsmen were also active in the Diaspora. The Jews who had come to Rome, either as free men or as slaves, were often occupied as artist-craftsmen; some of their work can, in fact, be seen today in the Jewish catacombs of Rome. The ancient Hebrews had been partners with the Phoenicians in glass manufacturing, but it was in the production of gold glass—a technique in which designs in gold leaf were fused into glass—that the Jews of third-century Rome reached a level of artistic creativity which caused this product to be diffused throughout the then known world. Many of the gold-glass designs were based on Jewish themes; the greatest finds have been made in the catacombs. Roman Jews were also pre-eminent in weaving and dyeing: in the fourth century, the poet Claudian referred to a certain type of textile as *Judaica vela* (the "Jewish weave"). In the sixth century the monk Cosmas Indicopleustes of Alexandria, after describing the many crafts of his age, referred to some of them as occupations followed mostly by Jews. In the seventh century it is recorded that Greeks were imported into France to produce glass "in the Jewish manner." (This craft

remained "Jewish" well into the twelfth century.) The world traveler Benjamin of Tudela (d. 1173) observed that everywhere Jewish glassmakers, and also Jewish goldsmiths, coppersmiths, armorers, weavers, and dyers, were extremely active.

In medieval Spain Jewish craftsmen worked in every field. A synagogue in Cordova built by Isaac Moheb can still be seen.[6] The royal weavers of this period were the brothers Jacob and Joseph Ibn Gau. Lacemaking is said to have been a specialty of the Jews in Barcelona, Toledo, and Majorca: "During the twelfth and fifteenth centuries, sumptuary laws given out in Castilla, Aragón, León, and Navarra mention gold and silver *redecillas,* likewise called *telillas,* made by the Jews at Mallorca, whose brethren at Barcelona and Toledo were also skilled workers in this medium."[7] Jewish goldsmiths worked even for the churches. One account deals with a statue of St. Francis produced by a Jew in Guste in 1214. A certain Samuel of Murcia was given a safe-conduct in 1378 in order to provide a crucifix for the Infanta. We are told of a reliquary made by a Jewish goldsmith in 1399 for the Augustinian priory in Barcelona. In a bull of 1415 the anti-pope Benedict XIII forbade Jews to make Christian ceremonial objects, and in 1480 Queen Isabella of Castile appointed a representative to see that "no Jew or Moor paint the figure of our Lord and Redeemer Jesus Christ, or Holy Mary the Glorious."

In his book on the Jews of Spain—which lists and documents the variety of professions, trades, and crafts in which they engaged, including that of armorer, jeweler, silversmith, watchmaker, potter, weaver, dyer, gilder, parchment-maker, and bookbinder—Professor A. A. Neuman cites the extraordinary instance of King Pedro IV intervening in behalf of his jeweler, a Jew, to enable him to secure two seats in the synagogue of Calatayud.[8] In this city (Calatal-Yehud, or Castillo Dos Judios, "Fortress of the Jews"), one of the leading Jewish communities in Moorish Spain, a large synagogue was built by Aaron ben Yahya, and there was also a synagogue for the Jewish guild of weavers. The economic historian James Thompson has noted that "the most skilled workmen in Spain had not been Christians, but Moors and Jews," and that "in skilled industry, as in skilled agriculture, the expulsion of the Jews and the Moors was detrimental."[9] Both Neuman and Fritz Baer[10] adduce supporting evidence in their studies on Jewish history in medieval Spain.

Jewish craftsmen worked not only in Spain but throughout the medieval world and in many diverse fields. King John of England had a Jewish goldsmith in his employ. There is an account of a representation of the Madonna painted by a Jewish artist for Edward I of England. In 1345 a silversmith named Moses Jacobs was summoned from

Colorplate 2.
Page from the first known complete copy of a medieval manuscript of the code of Maimonides. From Central Europe, first half of the fourteenth century. Jewish Theological Seminary of America, New York. Gift of Louis M. Rabinowitz

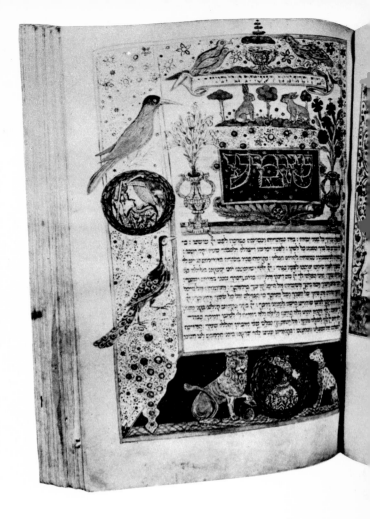

lished in the fourth century continued into the fifteenth and sixteenth and spread beyond the borders of Italy. The "Jewish weave" continued to be famous, and deservedly so, to judge from the beautiful collection owned by the Jewish community of Rome. Equally beautiful is the rich Bohemian fabric collection which can still be seen in the Prague Jewish Museum.[13] There are records of Jewish master craftsmen who executed superb Torah shrine curtains (parochot) for various Ashkenazic communities in the early eighteenth century. Some of these parochot, and also Torah wrappers and covers for the reading desk, were doubtless woven by pious mothers and grandmothers during long winter evenings. An example in the Jewish Museum of New York bears the signature of an ancestress of the Montefiore family, who apparently wove it as a child of six.

Some of the finest work done by Renaissance Jews was in the illumination of manuscripts. There were splendid Spanish illuminators, such as Joseph ibn Hayyim, who illustrated the Kennicott Bible (1476; Bodleian Library, Oxford); he was related to Abraham ibn Hayyim, author of a treatise on the making of colors for manuscript illumination.[14] Joel ben Simon was a skilled German illuminator who illustrated a number of beautiful Haggadot. Other exceptional manuscripts are the ritual code of Jacob ben Asher, of 1436, in the Vatican Library, and, in the Library of the Jewish Theological Seminary of America, the Rothschild codex of 1492 (fig. 9) and the fourteenth-century code of Maimonides in the style of the miniaturist Matteo di Ser Cambio di Bettolo of Perugia (colorplate 2). A large number of Jewish illustrators and illuminators of Jewish and non-Jewish manuscripts known to have been active in medieval and later times have been listed by Elkan Adler.[15] Landsberger adds that in the court of Avignon two of five bookbinders employed between 1336 and 1362 were Jews; in some instances they were actually commissioned to do the binding of a missal or codex of canon law. In Spain a Meir Salomo was employed from 1367 to 1389 to bind a registry of the Aragon royal treasury. In 1468 Meir Jaffe bound a Bible for the city council of Nuremberg. All this activity went on despite the bull that Benedict XIII had issued in 1415 against Jewish craft work for the Church, which also proscribed the binding by Jews of books in which the name of Jesus or the Virgin Mary appeared.

Jewish craftsmanship of the seventeenth, eighteenth, and nineteenth centuries is strikingly exemplified by the wooden synagogues of Poland. These were built by Jews (Simhah and Solomon Weiss, Hillel Benjamin) and were decorated by Jewish wood carvers and

painters (Ber Ben Israel, Eliezer Sussman of Brody, and Hayyim ben Isaac Segal of Sluch). In other parts of Eastern Europe, Judah Goldschmidt, David Friedlander, and Judah Leib were not only important synagogue architects but also excellent mural painters.[16] Activity continued in the eighteenth and nineteenth centuries with the work of a large group of engravers[17] and of such artists as Jacob Abraham (1723–1800) and his son Abraham Abramson (1754–1811), medal and seal engravers of the Berlin Mint, and also of miniature portraitists, among whom the most famous was Lippmann Fraenckel.[18]

In the eighteenth century American Jews became active in the field of craftsmanship. There were a number of Jewish silversmiths: Joseph Pinto, Isaac N. Moses, Daniel B. Coan, John Myers, Joseph Aaron, and, most prominent of all, Myer Myers. A New Yorker—veteran of the Revolutionary War, and president of the New York Silver Smiths' Society—Myers was one of the most successful craftsmen of his day. In addition to creating dozens of pieces for patrons throughout colonial America, he produced a not inconsiderable number of Jewish religious objects; the five sets of Torah finials (rimonim; fig. 10) and the circumcision shield and plate that have survived "place him in a position unique among colonial craftsmen."[19]

The late eighteenth and early nineteenth centuries saw a prodigious output of artistic energy on the part of Jews, as is recorded in standard reference works and specialized books.[20] Among the European pioneers were Solomon A. Hart and Solomon J. Solomon in England; Max Lieberman and Moritz Oppenheim in Germany; Josef Israels in the Netherlands; and the sculptors Mark Antokolski and Illia Ginsburg and the painters Askenazi, Maimon, Levitan, and Leonid Pasternak in Russia. In Russia, after the Revolution of 1917, a small group of Jewish painters (Nathan Altman, Issachar Ryback, Marc Chagall, and Eliezer Lissitzki) tried to form a Jewish art movement, but this effort fell apart under the pressure of Russian totalitarianism. Since World War I the Jewish artist of Europe and of America has entered the mainstream, and his personal history is not separable from the overall history of art.

The Jewish craftsman, working with Jewish ceremonial objects, continued to develop in the early years of this century. Toward the end of the eighteenth and the beginning of the nineteenth century there had appeared a group of Jewish silver- and goldsmiths in such East European cities as Nikolsburg and Prague. In Lemberg, Poland, there was a large group which had founded their own association. The German Jews, during this period, were excluded from the field by the powerful guilds; but by the early twentieth century the German Jew too had become active in the manufacture of sacred objects, and workshops for this purpose had sprung up in most of the larger Jewish communities. It was in the Frankfurt shop of Leo Horowitz that the fundamentals of silvercraft were learned by Ludwig Wolpert, who was

later to be designated "the first craftsman to use modern materials in the making of Jewish ceremonial objects."[21] In the same city there was a Society for the Advancement of Handicrafts among Jews (Gesellschaft zur Förderung des Handwerks unter der Juden), whose purpose was to encourage Jews to earn a living by manual work; in January 1916, this organization gave young Wolpert a scholarship to the Frankfurt School for Arts and Crafts (Kunstgewerbeschule).

The first school devoted to teaching the crafting of Jewish ceremonial objects was the Bezalel School, mentioned above in connection with the Israel National Museum. Its founder, Boris Schatz, saw in the return of Jews to the homeland the potential requisites for a renaissance of Jewish art. A graduate of a yeshiva and an art school, Schatz had been apprenticed in his early years to the sculptor Antokolski and to the painter Cormon; he had also been official artist to the Bulgarian Court. But Schatz seems to have been uninfluenced by modern trends, and the Bezalel School retained its partly Near Eastern,

10. Rimonim, by Myer Myers. New York, eighteenth century. Silver; heights 14″, 13¾″. Touro Synagogue, Newport, Rhode Island. Courtesy Rabbi Theodore Lewis

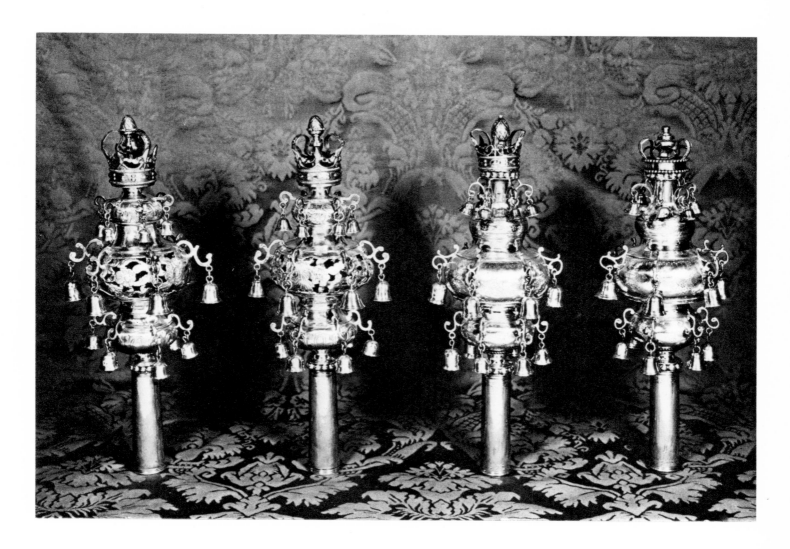

partly Art Nouveau style until the separation of the museum and school in 1932, when Joseph Budko took over the direction of the school. A graphic artist who had attained some prominence in Berlin, Budko transformed the Bezalel from an informal association of individual artists to a modern school. He not only gave courses in the technical aspects of the various crafts but also, aided by an influx of German emigrés, organized courses in the theory of color and form, in weaving, etching, painting, and sculpture, in commerical art, and, especially, in calligraphy. In this reorganization Budko was aided by Ludwig Wolpert, who succeeded Zeev Raban as head of the metalwork department. Wolpert was later joined by David H. Gumbel, but it was Menachem Berman who succeeded as master when Wolpert left for New York to found the world's second school for the crafting of Jewish ceremonial objects, the Tobe Pascher Workshop and School in the Jewish Museum.

The interest of Jewish artists in producing objects for Jewish use has greatly increased in recent years. Four factors have stimulated this trend. In the first place, there is the continuing realization, perhaps going back to the mid-nineteenth century, that applied art can be beautiful. The Renaissance saw the rise of the cult of the genius—the true artist was a figure producing works of art far removed from the requirements of daily living. In this milieu the applied arts became the stepchildren of art as such, hence the "true" artist did not involve himself in the making of ceremonial objects. Since applied art has been restored to its rightful place, talented Jews have been encouraged to enter the field. Secondly, the enormous activity in synagogue architecture since World War I has focused attention on the importance of ceremonial objects, and has spurred the replacement of the shallow copies of traditional examples with new and vital reinterpretations. Thirdly, non-representational art, the prevailing trend of our time, lends itself particularly well to the Jewish artistic sensibility. The fourth factor is the changing psychology of the artist. In the early decades of this century the Jewish artist, like other intellectuals, expressed his new-found freedom in an effort to be "universal" and therefore free *from* Judaism. More recently, many have advanced to a point where they regard being a Jew as itself an expression of freedom and creating an object with a Jewish theme as not necessarily a purely parochial achievement.

Some practical reasons for the change have been put forward by Percival Goodman, architect, art critic, and city planner:

If what I have said about the artist is true, then he can aid organized religion in its mission. On the whole, the artist is willing for several reasons: the subject matter is full of inspiration. We are tired of easel pictures and pedestal sculpture and seek a reintegration of the arts. We have come to that healthy condition of preferring to see our work used on the façade of the Louvre rather than embalmed with the mummies inside. Finally, the painters and sculptors

need patrons. Millionaires are fickle, princes vanishing, states immoral—can organized religion be the patron?[22]

Most, but not all, recent synagogue art is by Jewish artists and craftsmen. While one must give credit to the non-Jewish creator of Jewish ceremonial art of the past, it must be recognized that he was dependent on his Jewish patron for an understanding of ritual requirements. The Jewish craftsman, in contrast, generally brings to his work a personal involvement that motivates inquiry into the meaning and origins of the object he is to design. Side by side with the fresh look at tradition, the contemporary artist, lacking a specific Jewish tradition, has been more receptive to modern art, particularly abstract art, for incorporation into the synagogue. As a result, some of the new work has an authentic flavor based on its Jewish heritage; it is new in style yet surprisingly related to the past.

The combination of new techniques applied to study of the traditional use of the ceremonial object has attracted a fair number of craftsmen and artists to this field. Much of this trend is due to Percival Goodman. It was his vision and initiative that gave impetus to the new interest of Jewish communities in commissioning contemporary artists to execute works of ceremonial and synagogue art. His pursuit of the quest for a true synthesis of the architectural environment, art, and sacramental function deserves wide recognition for its continuing influence on artist and worshiper, congregation and community.

Many of the artists who have changed the look of the American synagogue were introduced to this field by Goodman. Among them is Seymour Lipton, a widely recognized master of direct-metal sculpture and an innovator who has applied new sculptural techniques and talents to ritual art (figs. 50, 58). Into this area he brings fresh imagery consonant with the requirements of religious doctrine. His menorah (fig. 50), conceived of as a living botanical form, recalls the ancient relation of the candelabrum to the tree of life. Efrem Weitzman is an artist-craftsman who works extensively in synagogue and temple. He has worked in glass, in fabrics, and in free-form sculpture. One of his most original creations is the group of windows in the chapel of Temple Beth-El in Rochester, New York. The nine windows represent nine concepts of joy and fellowship as enunciated in the Jewish marriage ritual. They are composed of glass in various bright colors, with interesting patterns superimposed by free-form copper artifacts.

Ismar David has designed ceremonial pieces both for the home and for the synagogue. Many of these reflect his chief interest, which is calligraphy. (He is the designer of "David Hebrew," a series of contemporary Hebrew alphabets forming a type family for machine composition.) Martin Craig began as a WPA sculptor; early in his career he won first prize in a Museum of Modern Art (New York) competition for industrial design. After a period in Paris, he returned to this country for a one-man show at the Museum of Modern Art, and he

37

has executed many commissions for synagogues, among them Temple Mishkan Tefila in Newton, Massachusetts (figs. 54, 57), the Fifth Avenue Synagogue in New York (fig. 53), Temple Beth Israel in New Rochelle, New York (fig. 55), and Temple Beth-El in Providence, Rhode Island. Samuel Wiener not only designed the stained-glass windows for Temple Beth-El in Rochester, New York, but also two sets of richly colored and eloquent tapestries. Before one enters the sanctuary, one sees two panels picturing Jacob's realization that his dream of a ladder reaching to heaven indicates communion with God: "This is none other than the abode of God, and that is the gateway to heaven" (Genesis 28:17); the second set of tapestries, within the sanctuary, illustrates the Tree of Knowledge and the Tree of Life. Maxwell M. Chayat has also worked extensively in sacramental objects, and he has studied intensively to acquire an authentic background for his talents. Luise Kaisch's talent creates visual expression of a deeply felt religious impulse. Her pure sculptures and her synagogue creations bespeak a deep spiritual and intellectual involvement with prophetic Judaism. Probably her greatest achievement is the ark for Temple B'rith Kodesh in Rochester, New York.

How the new spirit of artistic integration has affected American trends was shown by the extent to which Judaism was represented in the exhibition called "The Patron Church," held in 1957–58 at the Museum of Contemporary Crafts, New York. Some of the artists already mentioned exhibited there. Others include Earl Krentzin, Judith Brown, Adolph Gottlieb, Hortense Amram, Jack L. Larsen, Robert Pinart, Abraham Rattner, Herman Roth, Zelda Thomas Strecker, and Ludwig Wolpert.

Some artists who have formerly been represented in this field have backed away, chiefly because increasing popularity has priced them out of the reach of individual and synagogue budgets. Recently a Western congregation proposed to commission a famous sculptor, creator of several outstanding works notable for Jewish content, to execute a decorative panel for their temple; the price asked, three hundred thousand dollars, proved an insuperable obstacle to the plan. An equally famous painter who has worked in this field frankly admits that he can no longer accept the fees offered by religious organizations. However, it is heartening to note that a growing number of first-rate artists still accept assignments for the decoration of the new synagogues: among these are Arnold Bergier, Mitzi Solomon Cunliffe, Herbert Ferber, Edward Field, William Halsey, Merle James, Ibram Lassaw (figs. 51, 59), Robert Motherwell, Anton Refregier, Amalie Rothschild, Lewis Rubenstein, Esther Samolar, and Bertram Winters.[23] Their work, representing artistic integration of traditional and modern Jewish life, inspires a feeling of elation in the beholder: today the Jewish patron and the Jewish artist by creating objects of beauty can together worship the Creator.

38

III.

form and style in jewish ceremonial art

The first Jewish liturgical objects were those created, according to the biblical account, in accordance with divine instruction and placed in the Tabernacle. However, whereas the fruits of the Hebraic literary genius have, at least in part, survived the millennia, nothing remains of those sacred utensils, or of those created for the two Temples. The originals were destroyed, and in obedience to tradition, no copies had been made. The interdiction against duplication was probably grounded in the conviction that objects divinely inspired should remain unique, a belief that incidentally forestalled the rise of rival holy places in competition with the Temple in Jerusalem. In any event, we know of these objects only from later interpretations, such as the bas-reliefs on the Arch of Titus in Rome, which give us the Roman artists' version of things seen or heard about, and from reproductions on ancient coins, which give a reasonably accurate picture of the classic ceremonial cups and menorot.

Little of the surviving Jewish ceremonial art is more than three hundred years old. Given the historical circumstances, the desire of the Jews to surround their ceremonies with beauty could not always be fulfilled, and such embellishment was not, after all, essential to religious observance. Recurrent exile—often on short notice, or none—discouraged transportation, and bulky or heavy objects were usually left behind to the mercies of greedy impulses. It was generally the manuscripts and books describing the ceremonies, rarely the ceremonial objects themselves, that the Jews carried on their backs into exile. Thus some of the older pieces·are known only from a chance illustration or a rare written description, perhaps in a rabbinic letter or treatise.

The design of Jewish ceremonial objects reflects two forces. On the one hand there is the uniformity resulting from prescribed religious use and indigenous tradition. On the other hand there is the diversity generated by the varied national influences of the Diaspora. The development of the Hanukah lamp (hanukiah) affords a good ex-

ample of this interplay. These lamps are organic creations; the simple requirements—eight lights and a servant light (shamash)—dictate a specific functional shape. No matter how much the hanukiot reflect in their style the time and place of their making, and despite the fact that relatively few of the older examples were the work of Jewish craftsmen, the thread of ceremonial usage has never been broken. It was upon this Jewish base that environment imposed its influence. Both Polish and German hanukiot have the traditional row of eight lights and a decorative backpiece featuring a pair of lions, rampant. But while the typical German lamp is elegantly Rococo, with carefully modeled lions on the backpiece, usually supporting a sophisticated coat of arms, the typical Polish example is simple, with roughly sketched lions and a tree, perhaps symbolizing the biblical tree of life. So marked is the influence of the local style in many instances that even the less knowledgeable can easily identify a Hanukah lamp as coming from Poland, the Netherlands, Italy, or the Near East. The expert can often pinpoint even the city and the craftsman.

Another illustration of regional influences is offered by the container for the spices (bsamim) used in the havdalah, the ceremony that marks the conclusion of the Sabbath or festival. Many West European spice containers are in the form of Gothic towers; from Poland we have fanciful figures of man or beast; from the Middle East, fruit and flower shapes; from England, chaste, rectangular, compartmented boxes. There are even regional differences in the much-used filigree technique: Galician and German filigree tends to be coarse and composed of thick coils; Viennese work is very fine, with feathery filaments; Italian work resémbles the Viennese, but the patterns are more intricate and varied. It was the great triumph of the Jewish spirit, as Cecil Roth has said, to be able to express itself in a foreign idiom while keeping its inner integrity and ensuring ultimate return to its Hebrew origins.

Perhaps the earliest culture to influence the ancient Hebrews was that of their Egyptian overlords, as the resemblance of cherub to sphinx suggests. Centuries later the influence of Phoenicia is evidenced by the fact that King Solomon sent to Hiram of Tyre for help in the design and building of his Temple. When the synagogues became the focal points of worship, the influence of Greek and Roman temples, at least on their outer structure, could be seen; it was the interior arrangements, as required by the liturgy, that established their Jewish character. Not only architecture, but vases and coins as well, reflected the Greek influence.[1] As has been noted, even during the Hasmonean era (142–37 B.C.E.) Judean coins carried emblems borrowed from Hellenistic art, and there were similar borrowings in the ornamentation of buildings and tombs. The ancient synagogue at Chorazin shows centaurs and the club of Heracles; Capernaum has a frieze depicting six cupids; at Jaffa there is a typically Dionysian design of a tiger. In the mosaics of Beth Alpha, near the pictures of the sacrificial binding

of Isaac and of the Temple and its vessels, is the Greek god Helios in his chariot. The mosaic floor of the Nirim synagogue seems to be the same in design as the pavement of the church at Shellal (561 C.E.), except for the Hebrew symbols on its east border.

The third-century synagogue at Dura Europos exhibits Greek, Roman, and Greek Orthodox influences. In the wall paintings we see a cyclical arrangement frequently used to narrate Scripture. This style of cyclical art is regarded by Ernest Namenyi as being the first form to disengage representation from idolatry: hence it "constitutes the great contribution of the Jewish genius to the art of the western world."[2] However, the form also suggests many Roman and Greek historical reliefs, as well as Greek bowls and vases decorated with lively narrative Homeric scenes. At Dura Europos the individual figures show a variety of influences. David with his harp curiously resembles Orpheus playing before the angry beasts; it could be Aphrodite who rescues the infant Moses from the waters of the Nile; and the rod of Moses suggests the club of Heracles. Other figures are large, frontal, regally posed portrayals that, despite their being part of the narrative cycle, foreshadow the icons in Greek and Russian Orthodox churches. As we have seen, centuries later, both in Prague and in Worms, full figures of Jupiter with his thunderbolt, carved in the round, appeared in the base of synagogue chandeliers (figs. 6, 7).

The style typified by the Dura Europos paintings spread from western Asia into Europe, eventually developing into what we know as Byzantine art. Rostovtzeff, the discoverer of Dura Europos, was the first to suggest this early influence on European art.[3] Goodenough argued convincingly that the earliest conventions of Christian art were borrowed from Jewish and Hellenistic antecedents; early Church art, he believed, was largely a matter of turning to Christian purposes the allegories which lay behind Jewish painting. To Goodenough's list of examples, Jacob Neusner has added many more.[4]

With the passing centuries, Jews became farther removed from their origins, by geography as well as by time. Living in ghettos, their activities limited by the restrictive laws of medieval and even Renaissance Europe, the Jews generally did not enter into the mainstream of art and crafts. They were able, however, to engage in a number of activities, either of subprofessional status or else directed to the exclusive patronage of the Jewish community. A great deal of this work falls into the category of folk art. Indeed the circumstances of Jewish history and the character of folk art coincide. Unself-conscious and primitive in nature, for all its charm, folk art is essentially a village development, largely unaffected by any surrounding sophistication and with no pretensions to professionalism. Decoration tends to be flat, carried out in uncomplicated vertical and horizontal arrangements, with abstract forms and rhythmic, repetitious symmetry. As Malraux has pointed out, the folk artist directs his effort to simple persons, and

his work has the appeal of easy perception by artistically naive minds. A factor influencing all folk craftsmen is the paucity and crudeness of their tools, which accounts for the fact that wood carving is the most popular form. Stone carving, when seen at all, is shallow and runs to simple geometrical forms. However, decoration fashioned with such basic tools as needle, knife, and scraper is often intricate and elaborate.

Folk art emerges to a great extent from the functional necessities of life—house, furnishings, tools—and its chief events—birth, marriage, death. To a great extent it is motivated by the pious determination to provide these with the appurtenances of religious observance. There seems to be a special quality of piety associated with folk art. Cases in point have been cited by Arthur A. Cohen:

It may be recalled that in ancient Greece the Xoanon, an image of God made of wood, "rough and scarcely human" (G. Van der Leeuw, *Sacred and Profane Beauty: The Holy in Art*) was preferred in public religious processions to the sculptures of a Phidias or a Praxiteles. Similarly it may be observed in Mexico, or Spain, or Southern Italy, that some handsome, clean-cut, baroque religious sculpture of a saint is less evocative of popular devotion than would be a smoke-blackened, worn, wax-covered image. The one object has a history of veneration and responsiveness; the other is only beautiful.[5]

11.
Sukkah decoration,
by Jehoshuah Alter.
From the Ukraine, 1858. Colored crayon
on paper, 16½ × 13¾". The main
inscription, in the bottom section,
forms a stylized menorah. Collection
Heshil Golnitzki, Haifa

12. Haggadah.
Handwritten on paper. From Yemen, seventeenth
or eighteenth century. Collection
Heshil Golnitzki, Haifa

In folk art, mundane skills may lead to, or be allied with, artistic craftsmanship: witness the blacksmith who forges a candlestick, the tinsmith who cuts out a hanukiah, the potter who shapes a ceremonial plate, the needlewoman who embroiders an ark curtain (parochet), the carpenter who builds a timber synagogue, the mason who chisels a headstone. The need for cemetery headstones provided a constant outlet for the sculptural proclivities of local stonecutters, and in fact tombstone carving was one of the first forms of Jewish folk art to attract the attention of historians.[6]

The exigencies of Jewish history have left us but a minimal sampling of the great body of folk art of Jewish origin. The situation has been summarized as follows:

A small but significant collection of Jewish folk art in the Musée Alsacien, Strasbourg, includes such objects as crowns of paper flowers and leaves for the Pentateuch rolls; prayers for women in childbirth, with cut-paper and painted ornament; stencils for printing homely mottoes and Misrach pictures; pewter and pottery plates for the Passover supper, engraved or painted with Hebrew characters; pointers in the form of a hand carved of wood with a variety of ornamental detail, used for the reading of sacred texts at religious ceremonies; Hanukkah lights; wall mottoes of cut-paper silhouette or paper appliqué. Other collections may be found in Prague, in New York (Jewish Mus.), Haifa (Israel Ethnological Mus. and Folklore Archives), Tel Aviv (Municipal Mus. of Archaeology and Folklore), Jerusalem ("Bezalel" Nat. Mus.), etc.[7]

The stimulus of religious fervor added to natural talent ranks Jewish folk art with the best (figs. 11–18). A classic example is the sixth-century mosaic floor of the Beth Alpha synagogue. This creation by Jewish craftsmen exemplifies the traditional components of folk art: it tells a story, it is decorative, and it is certain to be understood. Besides, it is direct in its use of simple linear designs, in its

13. Cleavers. From
Germany, end of nineteenth
century. Wood and iron. Collection
Heshil Golnitzki, Haifa

43

14.
Yarmulke. From Warsaw,
nineteenth century. Linen, embroidered with
gold thread. Collection
Heshil Golnitzki, Haifa

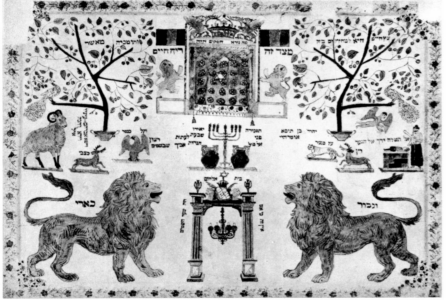

Colorplate 3. (FACING PAGE)
Parochet. From Italy, the work of "Simhah,
wife of Menahem Levi Meshulam"; 1681. Silk,
embroidered, with gold and silver
appliqué; 85×55". The Tablets of the Law
being handed down at Mount Sinai, the walled
city of Jerusalem with the Temple at its
center. Inscriptions: "The Lord spoke to you
face to face in the mount" (Deuteronomy 5:4);
"I come to you in a thick cloud"
(Exodus 19:9); "The mountain which God hath
desired for His abode" (Psalms 68:17).
Jewish Museum, New York.
Harry G. Friedman Collection

15.
Mizrach. From Poland,
nineteenth century. Water color on paper,
29½×21⅝". Tree of life, eagle, antelope,
lion, menorah, Tablets of the Law, Shield
of David, peacock, male angel, the sacrifice
of Isaac. Collection
Heshil Golnitzki, Haifa

avoidance of complex space concepts, and in its perceptible response
to, yet basic independence of, the stylistic currents of the period.

A special folk quality inheres in the decorative designs into which
scribes shaped the Masoretic notes on manuscripts; their minute calligraphy is seen arranged in the form of flowers, birds, fish, animals, and
human beings, as well as abstract ornament (fig. 147); this genre of
calligraphy even assumed patterns of narration (fig. 32). Of similar
interest is the technique of the decorative paper or parchment cut-out.
Especially popular among the Jews of Poland, such cut-outs, sometimes fantastically complicated, were usually pasted onto contrasting
backgrounds. They were used to decorate documents (colorplate 18)
and scrolls (fig. 183); the technique also lent itself especially well to
two types of ceremonial plaques, the shiviti (fig. 229) and the mizrach.

Europe. Largely the efforts of untutored but talented and pious hands, the carvings were delicately executed, with a rich assortment of lions and eagles, while the paintings often completely covered the walls with a phantasmagoria of plant and animal life, all set forth in gay and rich colors (colorplate 1; fig. 4).[9]

In the realm of metalwork the particular skills that European Jews, despite religious restrictions and outer pressures, developed to an almost professional level included silver filigree, niello work, and the decoration of pewter. The craft of filigree, which had been practiced in ancient times by Etruscans, Greeks, and Romans, was especially popular, from the medieval period onward, chiefly because it was neglected by professional, non-Jewish craftsmen. The filigree technique consists of twisting wire into various forms; the wires are held in place by being soldered to one another or to bars, or by being woven against and fastened to a solid background. The decorative effect was sometimes further enhanced by such other means as granulating the wires or placing a pearl or semiprecious stone at the center of the design. An exceptionally beautiful example of filigree work is the set of fifteenth-century rimonim in the cathedral of Palma (fig. 235). From the seventeenth century on, there is a great body of ceremonial objects of all kinds worked in filigree—Torah crowns, rimonim, mezuzot, bookbindings, bridal belts, rings, and, especially, spice containers. The tradition of filigree work was continued into this century by the craftsmen of the Bezalel School of Jerusalem.

In niello work, also widely favored by Jews, the artist engraves his design on the metal and then fills the grooves with a mixture of ground silver, copper, lead, and sulphur.[10] The plate is heated until the mixture fuses, liquefies, and finally fills the engraved lines. After polishing, the design shows up in black. This technique was practiced in ancient times by the Romans, from whom the Jews learned it. The great biblical commentator Rashi (1040–1105), in describing the technique, used the French word *nieller* (to blacken). The inventories of the Treasuries of the Palace of Fontainebleau of 1560 describe certain niello items, referring to them as *ouvrage de Juif*.

Pewter ware was used extensively for home ceremonials. Because of its malleability this material was a favorite of amateurs. These objects fall into two groups. In one are the ordinary household utensils adapted for ceremonial use—cups for the kiddush, plates for use at the Passover seder (figs. 129–133) or as Purim dishes, and lavers for ritual washing of the hands. Much of the work done on these is of professional caliber even though performed by novices. Decoration with Hebrew lettering and appropriate designs served to transform the mundane into the quasi sacred. The second group comprises pieces designed especially for ritual purposes: hanukiot, Sabbath lamps, and bsamim containers. Many of these were cast from molds; their wide dispersion indicates that these molds were circulated freely among pewterers.

47

The stylistic currents that held sway outside the ghetto naturally exerted a powerful influence. Thus in the Islamic countries, where synagogues and ceremonial objects reflected the modes of Muslim art, abstract ornamentation prevailed. In Europe an outstanding instance is the famous synagogue in the German city of Worms, a Romanesque structure, like the local cathedral, which was being built during the same period. The influence of the Gothic style is seen in the Altneuschul in Prague, with its angular roof, its ribbed, pointed-arch vaults, and its heavy exterior buttresses. The Gothic influence also affected ceremonial objects, as the pointed steeples of the bsamim containers and the similar shape of some of the oldest hanukiot give evidence. In the Sarajevo Haggadah, of the fourteenth century, Noah, building the ark, is depicted as a medieval entrepreneur, and the vaulted, pointed lines of the Hebrew letters appear to be superimposed on their cuneiform base.

In the seventeenth and eighteenth centuries, the Baroque style—bold, decorative, and flamboyant—was dominant in the world of art and architecture. The transition from Gothic to Baroque is seen in Prague in the Klaus synagogue, with its Renaissance vaults and stucco floral ornaments. In the synagogues of some Bohemian cities the Baroque effect was heightened by the installation of church high altars, converted into Arks, on the east wall. The synagogues of France, particularly those in Cavaillon and Carpentras, illustrate the style of this era.

It was during the seventeenth and eighteenth centuries that European Jews, particularly in France and Germany, became secure and affluent enough to commission and acquire large numbers of ceremonial objects; hence a great deal of the surviving Jewish ceremonial art reflects the richness and variety of the Baroque style. So great is the power of tradition and nostalgia that the Baroque is now widely considered an intrinsically Jewish style in ceremonial objects. Considering the biblical descriptions of the Temple utensils, it may well be. In any event, following the Baroque and the Rococo, the early nineteenth century saw the advent of the Neoclassic style, well exemplified by the Touro Synagogue in Newport, Rhode Island (figs. 244, 245).

The rise of modern functionalism presents a challenge to the tradition of extravagant decoration. The modern synagogue and home demand modern appurtenances and modern ceremonial objects. Each age has generated its own view of Judaism and has modified its modes of worship, and there is no reason why our age should not produce its own form of sacred accessories. Insofar as these objects are designed with faithfulness to the use for which they are intended, their form—whether modern or traditional—enhances their sacredness and does honor to the age.

Abstract art lends itself particularly well to Jewish liturgical needs,

since it precludes the raising of doctrinal objections to close imitation of nature. Of course, non-representational art in the service of religion is not a new development, as the mosques of Islam amply demonstrate. To cite but one more instance, there is also the precedent of medieval illumination, especially the large initial letters of Jewish books; the miniaturists, particularly of Italy, produced manuscripts and books richly enhanced by arabesques and by abstract geometrical designs. The difference in our century is that, coincidentally with the greatly increased interest in art, the non-objective has become the predominant style. Today a way has been rediscovered to create religious works of art that cannot be mistaken for idols.

With so many Jewish artists involved in functional and abstract art, it is not surprising that a good many should be attracted to liturgical expression, and to the application of modern ideas and materials in the creation of Jewish sacred objects. Here is a perfect sphere for the working out of the Bauhaus ideal—the integration of a building and its contents, the destruction of barriers between art and craft, artist and craftsman. Alongside the pure and functional approach of the new international style, with its utilization of new materials, there has developed a kind of "neo-Baroque" style. This is a somewhat more decorative but still fundamentally functional style. It is gaining favor because some of the artists working in this field are sculptors; their enrichment of functional objects further narrows the gap between applied and fine art.

The trend toward the involvement of Jewish artists has had an important effect on the design of Jewish ceremonial objects. In the Europe of old, much of the ceremonial art was produced by non-Jewish craftsmen. Since they tended to be affected by what they saw in the churches, many Jewish ritual objects show an alien influence. A Jewish craftsman is more likely to be inspired by the origins and requirements of the particular religious ceremony in question. For example, the Torah case that President Chaim Weizmann commissioned as a gift for President Harry S. Truman has lettering that, though contemporary, is reminiscent of the archaic style, and its shape, though modern, harks back to the old Sephardic metal cases for Torah scrolls (figs. 242, 243). Ludwig Wolpert, who made the Torah case for President Truman, has been a pioneer in applying modern ideas and materials in the creation of Jewish sacred objects. The freestanding Ark, reintroduced by Wolpert, is another example of a modern ceremonial object whose design is based on research into Jewish sources (figs. 220, 242). Instead of following the custom of the past two centuries, the Ark fixed in the east wall, Wolpert found inspiration and precedent for his modern freestanding Ark in the ancient usage of portable chests for the sacred scrolls.

A feature of the modern trend has been its experimentation with new materials. The older craftsmen usually worked exclusively in

49

metal, using silver for home ceremonials and, in some cases, gold for the synagogue. The once popular pewter has recently come back into favor. Brass, too, is increasingly popular, perhaps because it recalls, to some, the golden glow of ancient affluence. The use of glass, ceramic, wood, and the plastics has introduced a pleasant variety into ceremonial art, and has encouraged attempts at new shapes and forms, as is seen in the seder plate and the Elijah cup of Moshe Zabari (figs. 121, 136) and a set of glass-and-silver wine cups by Ludwig Wolpert (fig. 134). New media encourage an experimental attitude and new approaches to ornamentation. Replacing engraved and applied decoration, there is now modification of surfaces—selective polishing, roughing, oxidizing, and artificial weathering. Particularly stimulating have been the introduction of color in synthetics and the application of enamel to metal surfaces.

In the years since the first important exhibition of modern Jewish ceremonials was held, in 1939, in the Palestine Pavilion of the World's Fair in New York, Jewish ceremonial objects in the modern style have been entering with increasing frequency into American homes and museums. Present interest can be gauged by the large and important exhibits in the Israel National Museum, the Jewish Museum of New York, the Hebrew Union College Museum in Cincinnati, and the B'nai Brith Museum in Washington, D.C. In addition there are significant exhibits of contemporary and traditional ritual objects in the Smithsonian Institution and in the permanent exhibition rooms of a number of synagogues: Chizuk Amuno Congregation in Baltimore, Maryland; Temple Emeth in Brookline, Massachusetts; The Temple and Fairmount Temple, both in Cleveland, Ohio; Temple Beth El and Temple Israel in Great Neck, New York; Temple Emanu-El and Central Synagogue in New York; Temple B'rith Kodesh in Rochester, New York; and Beth Tzedec Congregation in Toronto. Modern Jewish ceremonial objects have also been featured in general exhibits of ecclesiastical craft, such as "The Patron Church," Museum of Contemporary Crafts, New York, 1957–58; "Today's Religious Art," Munson-Williams-Proctor Institute, Utica, New York, 1959; "At the Service of God," Seton Hall University Museum, South Orange, New Jersey, 1965; "Liturgical Art," The Interchurch Center, New York, 1965; and "Art in Worship," Museum of Contemporary Crafts, New York, 1967. The growing number of craftsmen who visit and study at the Tobe Pascher Workshop in the Jewish Museum in New York is even greater evidence of mounting interest.

17. Ark doors. From Poland,
eighteenth century. Carved wood; height 42″, width 28″.
Hebrew Union College Museum, Cincinnati

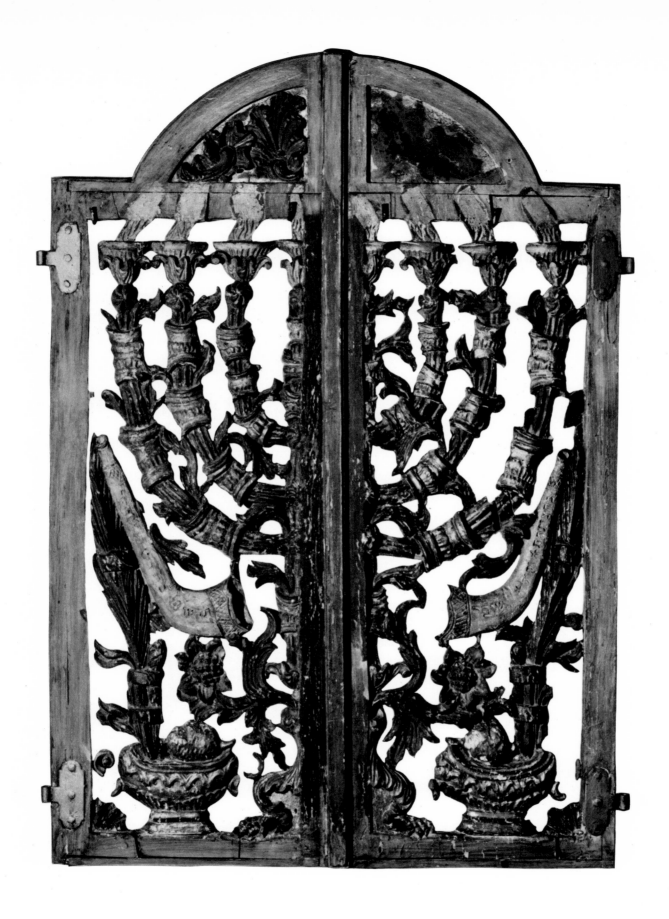

51

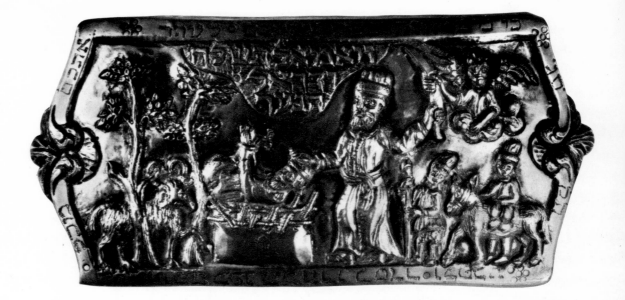

18.
Belt buckle for Yom Kippur.
From Lemberg (Lvov), Poland;
1803. Silver, $2\frac{1}{2} \times 4\frac{1}{2}''$.
Depicts the angel stopping
Abraham as he prepares
to sacrifice Isaac.
Jewish Museum, New York

IV.

MOTIFS AND SYMBOLS
IN JEWISH CEREMONIAL ART

Ritual objects such as the hanukiah and the bsamim container are recognizably Jewish because of their distinctively Jewish ceremonial functions. But how does one identify as Jewish an object that has an everyday use—a cup, a laver, or a dish? Since such pieces commonly conform in their general style to the mode of the particular period and locale in which they were created, it becomes the decorative features that establish their ritual status. These are usually Hebrew inscriptions and symbols indicative of Jewish aspirations, and generally evoking in Jews a worshipful and reverent attitude.

One of the remarkable features of Jewish ritual art is the survival throughout the disastrous centuries of its few fundamental forms and its many recognizable symbols and motifs. The two main groups of themes in Jewish decoration are those featuring biblical history and those expressing the Messianic hope. The story of the Akedah, or the sacrificial offering of Isaac, is the most widely used biblical motif. It is a daily theme of the morning service in the synagogue, and it also appears on a wall of at least one synagogue (fig. 19). As a symbol of Israel's unwavering faith in God, it is especially poignant during the High Holy Days (hence it appears frequently on belt buckles worn with the white robes traditionally associated with those days; fig. 18). The

Akedah, as we have seen, is represented on many mosaic pavements of early Middle Eastern synagogues, notably at Beth Alpha. Even more prominent is the placement of the theme among the paintings at Dura Europos, where it appears above the Torah niche (fig. 19). It appears frequently on plates (figs. 196, 197) used in the ceremonies of circumcision and the redemption of the first-born (pidyon haben) and occasionally on a mizrach (fig. 15). The ketubah (colorplate 18) and the Simhat Torah flag (fig. 149) should also be mentioned as among the ceremonial objects on which this motif is used. The story of Abraham and Isaac illustrates many illuminated manuscript siddurim[1]; during the sixteenth and seventeenth centuries it became a familiar feature of printed Hebrew books.[2] The Akedah decorates many of the old Sephardic tombstones in the Netherlands (fig. 20).[3] It happens also to be a favorite theme in Christian and Muslim religious art (fig. 21).[4]

Other biblical subjects popular as decorative motifs are Jacob's dream of angels on the heavenly ladder (colorplate 7; fig. 20) and his later struggle with the angel; the triumphant passage of the Israelites through the Red Sea; Moses striking water from the rock; the Tablets of the Law (colorplates 3, 10, 14, 25; figs. 5, 15, 130, 167, 229); Aaron in his priestly garb (figs. 91a, 145); Joshua's spies laden with grape clusters (figs. 23, 179); Samson and the jawbone (fig. 91b); David and Goliath; David and his harp (figs. 20, 91b); Solomon in various juristic poses (fig. 91a); Jonah in the belly of the great fish (fig. 32); and Ezekiel's vision of the dry bones brought back to life. Objects used in the observance of Purim, Passover, and Hanukah (referred to below in the chapters dealing with those holidays) are decorated with scenes from the appropriate biblical stories.

The theme of the Messianic return pervades every facet of Jewish art. The subject was an especially frequent one in the early centuries following the destruction of the Temple: for a thousand years after Titus the twenty-four-hour priestly watches remained ready to answer the call when services would be miraculously resumed. The Messianic hope finds its most widespread symbol in depictions of Jerusalem itself (colorplate 3; fig. 26), the Temple (fig. 75), the Temple appurtenances (figs. 24, 25), and the two columns, Jachin and Boaz, which stood at the Temple entrance (colorplate 3; figs. 19, 26, 37).

Sacred utensils, derived from the Temple, were used extensively to keep alive hope for the future. The table for the shewbread, the laver, and the hand shovel used for the sacrificial ashes were among such items. The shofar reminded the pious that on the day of redemption God would blow "on the great shofar." Sounded on the New Year, it revived the memory of solemn Temple services. Most ubiquitous as a symbol was the representation of the original Menorah, constructed for the desert Tabernacle and later placed in the Temple (Exodus 37: 17–24). When the Temple was destroyed, the original Menorah disappeared; tradition says it will be seen again on the Day of Judg-

19. Torah niche, Dura Europos synagogue. Right, the sacrifice of Isaac; center, the Temple façade; left, menorah, lulav, and etrog. Courtesy Yale University Press, New Haven

ment. The rabbis prohibited the making of a menorah resembling the original, but depiction as a symbol was permitted, and as such it is found in every country of the Diaspora. It is seen in mosaics (figs. 24, 47); on the various appurtenances of the synagogue (fig. 25) and on decorations of the synagogue itself (fig. 19); on hanukiot (figs. 163–166), seals, medals, wine cups, amulets, and coins (fig. 27); in sacred manuscripts and books (colorplate 2); on glassware (fig. 28) and on lamps (fig. 46). Used at the entrance to a house (fig. 29) or on a grave (fig. 30), the menorah was, and is, the identifying mark of the Jew, standing for personal as well as national redemption. Through the early centuries of the Common Era the menorah remained in use in many churches as an Easter candelabrum. In the twelfth century the Jews changed its status from a pictorial motif to one of actual use as a synagogue hanukiah, increasing its number of lights to nine. By the sixteenth century the seven-branched version was again current in Jewish life. In our time, the menorah has regained popularity as a symbol, particularly as the emblem of the State of Israel (figs. 31,40), while still enjoying practical use in home and synagogue.

20. Gravestone
of Mordechai Mendes (d. 1687) and Sarah
Franco Mendes (d. 1696). Carvings depict
the offering of Isaac, David with his harp,
Jacob's dream, and sacrificial offerings.
From D.H. De Castro, *Keur Van Grafsteenen. . .*

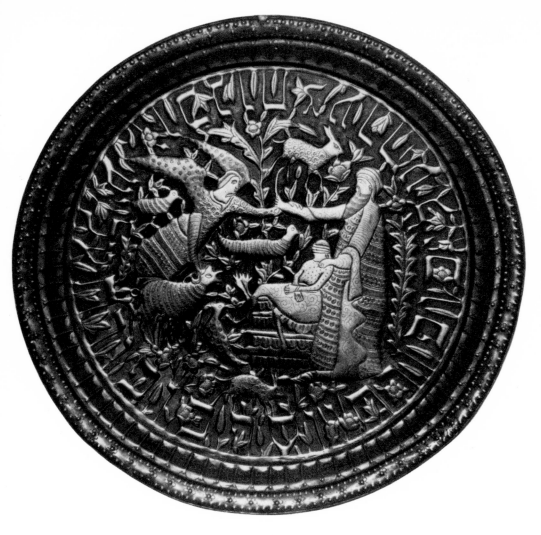

21. Plate.
From Asia Minor, nineteenth century.
Hammered brass, diameter 22⅝″.
Against a floral background (tree
of life), with animals and birds,
the sacrifice of Isaac.
Jewish Museum, New York.
Harry G. Friedman Collection

The form of the seven-branched menorah is thought to have a profound affinity to the Middle Eastern concept of the tree of life (fig. 33), which is so often found in Jewish art, and which is also a motif embodying the Messianic hope. The development of the menorah form from the tree is believed by Goodenough to be almost unquestionable; he also cites a suggestion that there is an analogy between the menorah as a light-bearing tree and the burning bush, from which God spoke to Moses (Exodus 3:2).[5] The metaphor of the sacred tree persisted in Jewish tradition, and it is reflected in art and in Scripture: The Torah "is a tree of life to them that lay hold upon her" (Proverbs 3:16–18); "The fruit of the righteous is a tree of life" (Proverbs 11:30); "Hope deferred maketh the heart sick; but desire fulfilled is a tree of life" (Proverbs 13:12). At Shechem God appeared to Abraham at the terebinth of Moreh (Genesis 12:6), and under this same tree Jacob buried the alien gods of his followers (Genesis 35:4). In the biblical story man is driven from Paradise in a sense because he violated the tree. To Paradise he will return; and there he will find the

22.
Synagogue emblem,
by Ludwig Wolpert, in Shaare Torah
Community Center, Brooklyn. Welded bronze;
height 21″, width 6″. The Tablets of the
Law handed down in flames from Mount Sinai.
Gift of William Blanksteen

tree of life standing at its center. As a great symbol of hope it appears extensively wherever the return from exile is a dominant theme (figs. 15, 34, 129); it is especially popular on the backpiece of the hanukiah, whose shape accommodates its spreading branches particularly well (figs. 157, 160, 161, 168).

One of our richest sources of knowledge concerning Messianic symbols and motifs is the relatively large number of surviving ancient Jewish coins,[6] which has been greatly increased by the recent Masada excavations. While much of the Palestinian coinage was minted by the Hellenistic and Roman conquerors, there were two periods of Jewish ascendancy during which coins carried authentic Hebrew symbols. In the Hasmonean period (167–37 B.C.E.) the motifs include—in addition to flowers—the wreath, the star, the anchor, the palm branch, the helmet, the shewbread table, and the menorah. Jewish coinage during the Jewish-Roman Wars (66–70; 132–135) was distinguished by symbols representing either Temple accessories or appurtenances of the Jewish festivals: the goblet, cluster of three pomegranates, amphora, vine leaf, palm tree between two baskets of fruit, lulav and etrog, three palm branches tied together, a wreath of palm branches.

Since they refer to the implements or services of the Temple, most of these symbols carry the message of hope. The clustered pomegranates have been interpreted, variously, as Aaron's budding rod, as a hyacinth, and as a lily, but most commonly they are regarded as reminders of the fruits brought to the Temple as a first offering. Pomegranates, we are reminded, decorated the columns Jachin and Boaz that stood before the Temple, and, according to Josephus, they appeared as motifs on the Menorah and on the garments of the high priest. The goblet was undoubtedly a Temple vessel, for it appears on the shewbread table carved on the Arch of Titus. It must have recalled such scriptural references as the cup of divination (Genesis 44:5), "cup of consolation" (Jeremiah 16:7), and "cup of salvation" (Psalms 116:13). The amphora also was a Temple utensil: such vessels were used for libations of wine or water and for storing the pure olive oil burned in the lamps of the Menorah. The grape, like the pomegranate (fig. 199), was one of the seven products of Palestinian agriculture (Deuteronomy 8:8) and one of the ritually offered fruits. Golden vines decorated the wall and doors at the Temple entrance; grape-bearing vines appear in the decorations of all the early Palestinian synagogues and on sarcophagi in the Jewish catacombs in Rome, as well as in the painting above the Torah shrine at Dura Europos. The vine and its grapes were also a popular motif throughout the pagan world; in pagan rites, drinking wine afforded humanity an opportunity to share in the divine nature. Wine as a promise of immortality became part of both Jewish and Christian symbolism.

56

23. Oil lamp. Mediterranean type,
third to fifth century C.E. Terra cotta, length 4⅝″
Joshua's spies and the large grape cluster attest to use
as a Jewish ceremonial object. Jewish Museum, New York.
Harry G. Friedman Collection

24. Panel of mosaic floor
of the Beth Alpha synagogue
(sixth century C.E.). The Ark
of the Law, a pair of menorot,
various Temple appurtenances,
and other motifs including birds
and beasts. From E. L. Sukenik,
The Ancient Synagogue of Bet Alpha

The palm tree is the symbol of Judah, but it also signifies abundance and national redemption. The palm branch was a favorite motif of the ancient Jewish craftsman; it is found on widely dispersed tombs, in synagogues, and on gold glass, as well as on Jewish coins. When carried in religious and festive processions, palm branches signified victory, joy, and honor. Indeed the palm branch was, and still is, a symbol that decorates many a home in the Mediterranean area. When Jesus entered Jerusalem, "much people . . . took branches of palm trees, and went forth to meet him, and cried Hosannah" (John 12:12–13). The etrog (citron) and lulav (palm branch) recall the feast of Sukkot. They were carried in triumphant processions around the Temple grounds during the Sukkot holiday, the lulav being shaken symbolically to gather the rainclouds from all corners of the earth (figs. 19, 24,28,137–140). The ram's horn was an especially poignant symbol; it reminded the pious that on the day of redemption—the day of the Messiah's coming—God would blow "on the great shofar." It revived the memory of those most solemn moments of the Temple services when it was sounded to usher in the New Year. After the destruction of the Temple, representation of its Torah shrine and the Torah scrolls it contained came into prominence as a motif (figs. 24, 28, 36).

The Hebrews even during the time of the first Temple engaged in star worship,[7] but the star first appears as a motif on a coin minted during the reign of Alexander Jannaeus (126–76 B.C.E.). The same motif appeared in subsequent coinages, especially during the First Revolt against Rome (66–70).[8] The star reached its zenith as a symbol during the Second Revolt (132–135), which was led by Bar Cochba, "son of the star."

The six-pointed star, or double triangle—the Magen David ("Shield of David")—while probably the most ubiquitous Jewish symbol in the past two centuries, is by no means the oldest; nor has it firm roots

25.
Torah mantle. From Italy, 1710. Red velvet and embroidered
brocade; height 38½″, width 12½″. Decorated with priestly and
kingly crowns, the name of the donor, several verses from Psalms,
as well as the Temple Menorah and table for the shewbread.
Jewish Museum, New York. Benguiat Collection

26.
State of Israel medal, 1966.
Obverse: stylized impression of Jerusalem.
Reverse: façade of the Temple, with the Ark
of the Law in the center. Courtesy Israel
Coins and Medals, Inc., New York

27.
Coin struck by Antigonus
Mattathias, last of the Hasmonean
rulers. Base metal. This mintage
marks the first appearance of
the menorah as a motif on coins.
From A. Reifenberg,
Ancient Hebrew Arts

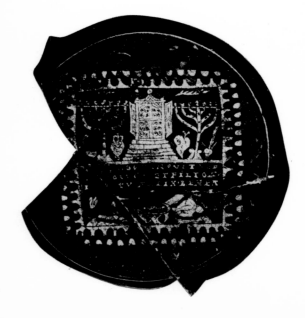

in Jewish tradition. It was a common decorative motif in the ancient world and as such appeared also in Jewish surroundings—on an ancient Hebrew seal, and on the wall of the synagogue at Capernaum (third century C.E.). Except for an occasional coincidence, such as its appearance on a (sixth-century) tombstone in Taranto, the symbol had very little relationship to Judaism until the seventeenth century. During all these intervening years it was not found in synagogues or on Jewish ceremonial objects. Instead, many instances can be cited of Christian use of the six-pointed star. Adorning the front of an antique ecclestiastical vestment in the Benaki Museum in Athens is such a star, with Jesus in the center; the star, without the figure, appears also on each half of a clasp and on a gold pectoral in the same museum. The emblem appears in other unusual Christian contexts: on the cardinal's hat in a painting of *The Presentation of Christ in the Temple* by Orazio dal Paradiso (c. 1550–1600); on the main altar of the cathedral in Toledo; on an ancient wooden screen in a window of the Alhambra (fig. 38); on the façade of the Chapelle San Martial as depicted in a fresco in the pope's private chapel in the Papal Palace in Avignon. It can be seen decorating churches as far apart as Tennessee, the Gaspé Peninsula, and France. Two other interesting uses of the star—non-religious—may be cited at random: it appears on the caps of the traffic police in Lisbon and on a stained-glass window in the Nautical Museum of Belem, in Portugal.

The double triangle was called interchangeably "Shield of David" and "Seal of Solomon" apparently because both monarchs were, in legend, reputed to have possessed magical talismans—King David a shield and King Solomon a seal ring. Indeed in medieval times while the Magen David did not appear as a motif, it was the subject of much literary interest,[9] especially in the writings of the cabalists, the Karaites, and later in the speculations of the followers of Sabbatai Zevi, the false messiah of the sixteen hundreds. During this period the symbol came to be regarded as a safeguard against misfortune and

28. Gold glass. From Rome. Shows an elevated Ark
with scrolls in separate compartments, two menorot, a shofar,
jars for oil and wine, lulav and etrog, palm branches, fish
on a round table. Inscribed in Latin to "Vitalis" (Hayim)
and his wife and son. State Museums, East Berlin

in that way found its way onto many mezuzot. In 1354, Emperor Charles IV permitted the Jews of Prague to "bear a flag"; in 1527, when Ferdinand I entered the city the Jews greeted him bearing a flag on which there was a large Shield of David. (A duplicate of this flag, made in 1716, is still in the Altneuschul.) From Prague the idea spread; several communities in Eastern Europe and South Germany made themselves similar flags. From then on, the six-pointed star gained increasing currency, serving as a signal of Jewishness in all sorts of uses—on synagogues, ceremonial objects, amulets, gravestones.

In 1897 the first Zionist Congress, in Basel, chose the six-pointed star as its symbol, thus elevating it to a uniquely universal status as a Jewish symbol. Nazism gave it its sacred connotation when it was forced as a symbol of shame on a people who transformed it through suffering into a signal of honor. By virtue of its long association with Jews and Judaism, and despite its non-Jewish roots, it properly became the symbol on the flag of the new Jewish state.

The idea of national restoration, which of course dominates the Passover seder, is exemplified most eloquently by the figure of Elijah. The motif of this Prophet, usually blowing a shofar as he guides the Messiah, mounted on a white donkey, toward the gates of Jerusalem, decorates many an old Haggadah. In Elijah's honor a special wine cup— the delight of craftsmen for centuries (figs. 135, 135a)—is part of the setting of the seder table. Other traditional symbols of the restoration that will come with the Messiah are the leviathan, the fish on whom the elect will feast on the day of days, and the *ziz*, a fabulous bird which will also regale the pious on Judgment Day.[10]

Other motifs, aside from those based on the idea of national restoration, have their origin in national legends, ethical precepts, and common folklore. The zodiac, for instance, was a favorite theme in synagogue art during the fifth and sixth centuries, the most famous example being the floor of the Beth Alpha synagogue. The zodiac also appears in the mosaic floors of the synagogues at Naaran, Isfiya, and Tiberias and in a floor at Beth Shearim. In medieval times the zodiac appeared with considerable frequency in Hebrew manuscripts. In the seventeenth and eighteenth centuries it appeared also in ketubot, in at least one Haggadah, and in numerous Hebrew books.[11] The twelve signs of the zodiac have been linked to the twelve tribes of Israel, the twelve loaves of shewbread (Exodus 25:30), and the twelve precious stones in the breastplate of the high priest Aaron (Exodus 28:17–20). Emblems of the twelve tribes are also found as symbols (figs. 40, 213). A brilliant example of their use is Marc Chagall's magnificent windows

29. Lintel of a house in ancient Nave (mod. Naua, Syria). Wreath, plant ornaments, two menorot. From A. Reifenberg, *Ancient Hebrew Arts*

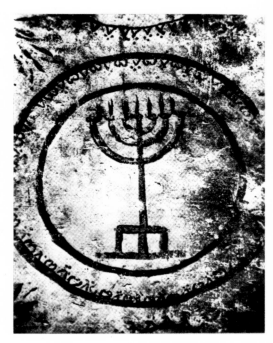

30. Menorah motif in wall painting in the Catacomb at the Villa Torlonia, Rome. From A. Reifenberg, *Ancient Hebrew Arts*

31. State of Israel coin, Tenth Independence Day Commemorative, 1958. Silver. Courtesy Israel Coins and Medals, Inc., New York

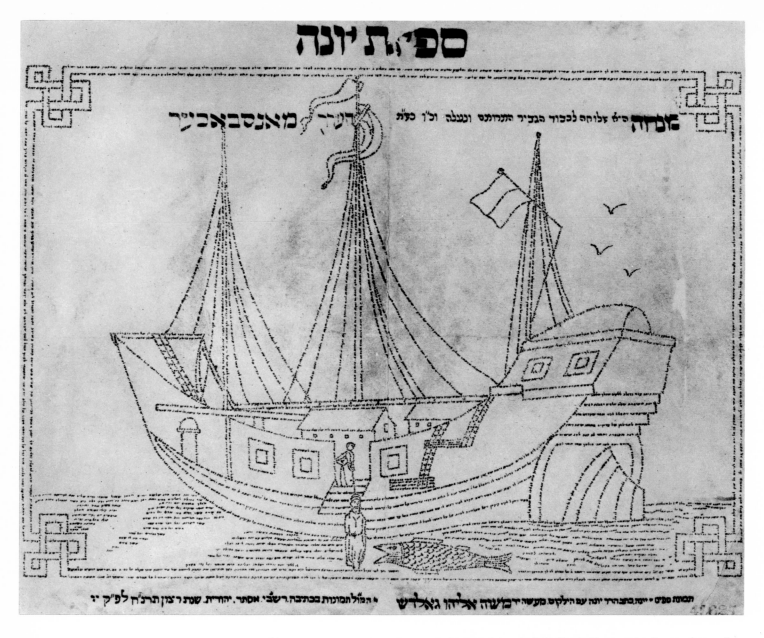

32.
The Book of Jonah with the
text in miniature script depicting the story.
Executed by Moshe Eliyahu Goldsch... 1881.
Library of the Jewish Theological Seminary of
America, New York

in the synagogue of the Hadassah Medical Center in Jerusalem. According to an old tradition there are twelve gates to heaven and the prayers of every Jew reach the Almighty through the gate representing his tribe.

The crown of the Torah *(keter Torah),* symbolizing learning, is frequently used as a motif (colorplate 25; figs. 150, 167, 228); sometimes it is triple, sometimes quadruple. The fourfold version represents the crowns of the world as assessed in the Pirke Avot (Ethics of the Fathers): the crown of Law, the crown of royalty, the crown of priesthood, and the crown of a good name. In manuscripts and books the columns Jachin and Boaz and the figures of Moses and Aaron are especially popular for framing title pages, and these motifs appear often on Torah breastplates. The spiral form of these columns is traced

back to the twisted column which stands in the Cappella della Pietà in St. Peter's in Rome and which was reputed to have been brought from Solomon's Temple. The Jews of Rome probably thronged to this reputed relic of their ancient glory, just as, according to Vasari, they flocked to San Pietro in Vincoli, to gaze worshipfully at the statue of Moses carved by Michelangelo for the tomb of Pope Julius II.

An interesting feature of Jewish decorative art is the use of animals and birds (colorplate 8; figs. 15, 151, 162, 163, 168, 172). The lion of Judah is the favorite animal motif ("Judah is a lion's whelp"; Genesis 49:9), but the deer is also favored; together they exemplify the injunction of Rabbi Judah ben Tema in the Pirke Avot to "be fleet as a hart and strong as a lion, to do the will of thy Father who is in heaven." While the lion as a decorative motif had a wide range of use during the Hellenistic period (fig. 2), for European Judaism it is associated exclusively with the Ark of the Law and the Torah scroll and its appurtenances. Other animal motifs often seen are the bear, the sheep, the hare, the squirrel, and the ox.

Birds have a special place in the metaphor of the Bible and in later writings such as the Aggadah and the Zohar (a cabalistic interpretation of the Five Books of Moses, probably written in Spain in the thirteenth century). God is pictured in the Bible as riding in a chariot powered by cherubim or fiery birds (Psalms 18:11; Deuteronomy 33:26; II Samuel 22:11; Isaiah 19:1). The eagle, reminiscent of the winged cherubim, is often represented as hovering protectively over the crown of the Torah, the Tablets of the Law, and the lion of Judah. The eagle has its own Messianic meaning. It was especially popular in the decoration of ancient Palestinian synagogues (fig. 3); presumably it reminded worshipers of the promise of redemption: "You have seen . . . how I bore you on eagles' wings and brought you to Me" (Exodus 19:4). In later literature God's chariot is described as being carried through the firmament by a team comprising an eagle, a lion, an ox, and a man.

In Jewish and Muslim tradition, as in pagan legendry, the soul is often depicted as a bird, and the souls of the righteous, in the form of birds, sit at the throne of the Almighty, singing His praises. Birds are also often seen in ceremonial objects associated with the traditional Temple entrance and with the tree of life. Other feathered creatures that appear in ceremonial art, though less commonly than the eagle, are the dove (symbol of fertility), the peacock, the pelican, the duck, and the goose.

In addition to animals and birds, fish, the universal symbol of fertility, often appear. Fantastic creatures such as a serpent with a human head, the griffin (figs. 162, 229), the legendary unicorn, and the dragon (fig. 158) also are known. Various fruit, flower, rosette, and stylized leaf motifs are practically omnipresent in the repertory of Jewish themes:

33. Tree of life on stone bowl from Susa, Elam. c. 2300 B.C.E. The Louvre, Paris. From E. R. Goodenough, *Jewish Symbols in the Greco-Roman Period*

34. State of Israel Liberation Medal, 1958, celebrating a decade of independence. Gold. Courtesy Israel Coins and Medals, Inc., New York

35. State of Israel coin (twenty-five prutot), 1949. Nickel. Courtesy Israel Coins and Medals, Inc., New York

36.
State of Israel coin, Thirteenth
Independence Day Commemorative, 1961. Silver.
Obverse: olive branch with ten leaves and three
olives. Reverse: ancient Ark with Torah scrolls.
Courtesy Israel Coins and Medals, Inc., New York

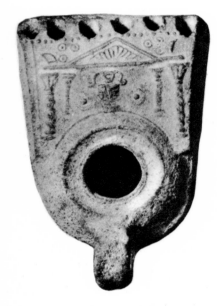

37. Oil lamp. From Palestine,
c. third century C.E. Terra cotta; length 5½″,
width 3½″. Temple columns Jachin and Boaz; the
leviathan. Jewish Museum, New York.
Harry G. Friedman Collection

38.
Shield of David in the latticework
of a window in the Alhambra. Courtesy
Victor Laredo, New York

even these simple forms may have a Messianic content, suggesting the "branch of David" or the "shoot of Jesse."[12]

A relatively infrequent symbol in ancient times is the hand representing the Deity ("with a strong hand I have delivered you out of Egypt"). A rare motif, though famous because it occurs on a huge stone in the synagogue at Capernaum, is the temple-like structure on wheels representing the sacred Ark of the Covenant, probably copied from a coin of the Bar Cochba period. Seen with increasing frequency in modern times is the burning bush, mentioned above in connection with the menorah. Originally the motif on the façade of the Jewish Theological Seminary of America in New York, it is now a favorite among Conservative congregations (fig. 41).

How much the Jews borrowed from their pagan neighbors is a debated question. Goodenough postulated that the Jews, with the decline of rabbinic influence, adopted for their own use a large number of pagan symbols.[13] He pointed out that Jewish graves and synagogues during the Greco-Roman period, besides exhibiting the characteristic Jewish symbols, also showed a variety of pagan deities. Thus, as stated earlier, in the wall paintings of Dura Europos the discoverers of the infant Moses in the Nile appear to be Aphrodite and her nymphs; Orpheus with his lyre becomes David with his harp; Moses with his sacred rod is rendered like Hercules with his club. Goodenough made clear, however, that no matter how much the Jews made use of these figures, they never, or rarely, depicted them as actors in the pagan cult or in the myths associated with them. Goodenough's thesis has been

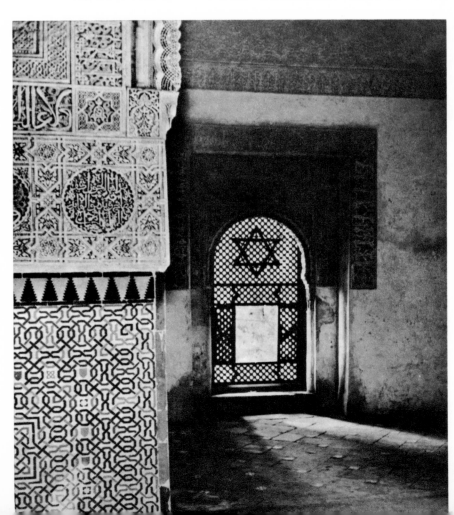

vigorously disputed by Professor Ephraim E. Urbach of the Hebrew University,[14] but Jacob Neusner has supported it, adding that after the destruction of the Temple, in the year 70, Jews were particularly avid in adopting pagan symbols related to personal salvation and union with God.[15]

Illustrations in medieval manuscripts and incunabula, Hebrew and Christian, have many similarities. Thus a picture of Moses and his family entering Egypt may resemble a Joseph and Mary entering Jerusalem. Moses and Aaron sometimes look like Christian bishops, and the four sons of the Haggadah often look like evangelists or knights. The simplest explanation for this trans-cult borrowing is that Jewish engravers and printers, when they had no access to artists, used Christian prototypes. Indeed an illustrated Christian Bible of 1593 seems to be the basis for several generations of Haggadah illustrations.

The winged angel so prominent in Christian art is seen in Jewish works (psalters, mahzorim, Haggadot) but is generally considered to be basically a non-Jewish motif, usually appearing in Jewish works only when copied from Christian models. According to Landsberger, however, angels with wings were common decorative symbols in early Jewish art and were abandoned only when (about the third century) Christian art began to abound in such representations. The motif re-appeared in a Jewish manuscript of the thirteenth century and in several manuscripts two centuries later. The best-known appearance of the winged angel under Jewish auspices is in the Sarajevo Haggadah. This motif did not last long; it was eventually eliminated in order to sharpen the difference between Christian and Jewish decorations.[16]

A number of symbols of personal identification are used on Jewish ceremonial objects. A pair of hands in the gesture of the priestly blessing (fig. 133) indicates that the donor of an object is, or was, a Kohen; a ewer with basin identifies a Levite. On gravestones the name or the calling of the deceased is symbolically suggested; an example is the

39. Three ring seals.
From Germany, fourteenth century.
From *Monumenta Judaica: Katalog*

40.
State of Israel Bar Mitzvah Medal, 1961.
The menorah as a seal of the state; emblems of the tribes of Israel. Courtesy Israel Coins and Medals, Inc., New York

41. Burning bush motif, by Ludwig Wolpert, over the Ark in Bellrose Jewish Center, Floral Park, New York. Welded bronze strips. Courtesy the artist

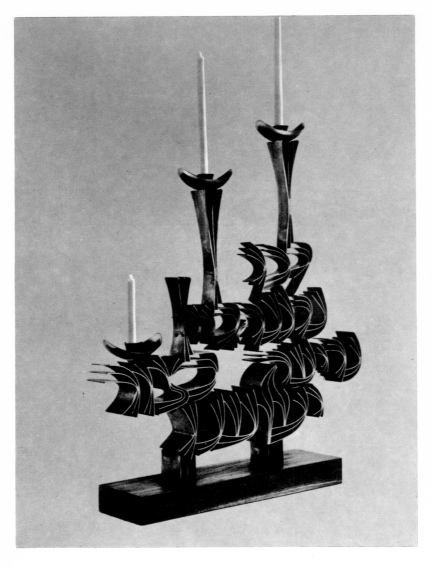

42. Sabbath candelabrum for
synagogue and home, by Ludwig Wolpert. Welded
bronze strips; height 16″, width 12″. The form
spells out: "Come, let us exult before the
Lord, shout for the joy of our salvation"
(from the Sabbath eve liturgy). Collection
Dr. S. Siegmund Stahl, New York

lion on the tombstone of the celebrated Rabbi Loew (d. 1609) in the Old Jewish Cemetery of Prague. Besides these symbols, it is not uncommon for a donor to have vital data included in the designs of the synagogue object he has donated.

Of all the ornamental elements that grace Jewish ceremonial art, the Hebrew alphabet has the oldest and richest history. One talmudic legend has it that when Moses came to heaven he found God engaged in plaiting crowns for the letters of the *aleph bet*. The thirteenth-century cabalist Abraham ben Samuel Abulafia meditated long and earnestly on the pure beauty and perfect immateriality of the Hebrew letter; from the cabala he learned, and in his heart he believed, that the Hebrew letter is a prime force with mystic powers. According to another talmudic legend, God drew the Hebrew letters, hewed them, combined them, weighed them, interchanged them, and through them produced the whole Creation.

Like most Middle Eastern alphabets, the Hebrew derives from the ancient Canaanite, but unlike many others it still retains the archaic appearance of its origin. From this beginning Torah scribes, during the time of Ezra, developed a square letter which remains clean, legible, decorative, and capable of transmitting a feeling of profound piety. As we have seen, some of the early Masoretic scribes arranged their scripts into fanciful figures, scrolls, and even human and animal forms (figs. 32, 147). Lettering on manuscripts, prayer books, Haggadot, tombstone inscriptions, community records, and ritual objects enjoyed a continuous development, frequently with beautiful results. Landsberger notes the combined use of pictorial and verbal decoration in Jewish ceremonial objects: "The Jew . . . liked to read and to visualize at the same time. . . ."[17]

The invention of printing tended to stifle creative calligraphy, and the Hebrew page became a dull affair of massive blocks of black lettering. In the past quarter century, however, the Hebrew letter has been released from its archaic form and is now employed extensively in Israel for secular use, in easily read and pleasant-appearing texts, book jackets, inscriptions on buildings, tablets, memorials, coins, medals (figs. 31, 36, 40, 43, 44), and advertising signs, as well as on ceremonial objects.[18] Some of these designs have been poorly done; many are good and a few are excellent. Reuben Leaf has revived several alphabet styles, for graphic use, which he has included in a reference book of alphabetic samples ranging from the earliest times to the present. Ismar David has not only studied the Hebrew alphabet in a scholarly way, but has designed, in addition to "David Hebrew," mentioned earlier, several fine new alphabets, mainly for display, which he has employed in book design. In Israel, Henri Friedlander, Franziska Baruch, E. Korngold, Theodore Hausmann, and M. Spitzer have been experimenting with new type faces. Ben Shahn, recalling a talmudic legend in which each letter seeks from God the privilege of being the first in the holy story of Creation,[19] fashioned a fine alphabet that he used in a new Haggadah, a modern ketubah (fig. 206), and in the production of a series of lithographs and paintings expressing the message of prophetic Judaism. Ludwig Wolpert and David H. Gumbel, in their search for Jewish decoration, have done beautiful modern work in metal with the Hebrew alphabet (figs. 42, 134, 143, 239).

43. State of Israel coin, 1966, marking eighteen years of independence. Silver. Courtesy Israel Coins and Medals, Inc., New York

44. State of Israel Medal of Valor, 1959. Bronze. Courtesy Israel Coins and Medals, Inc., New York

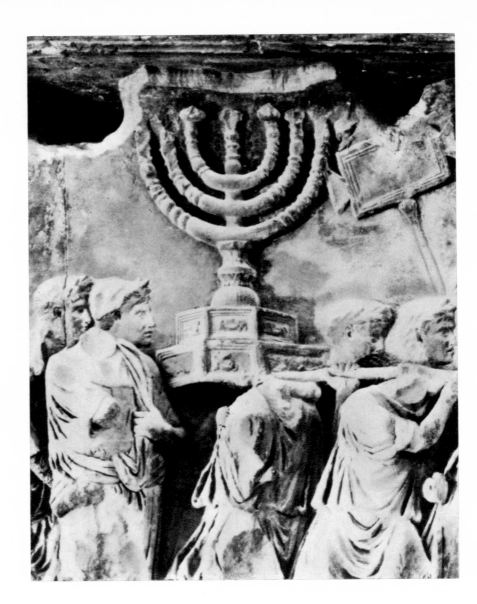

45.
Menorah and shovel
used in the sacrificial service in the
Temple. Detail from the Arch of Titus, Rome.
A. Reifenberg, *Ancient Hebrew Arts*

v. Light in Jewish Ceremonial

From his earliest days man has been fascinated by light. Primitive man could not but look with awe upon the sun, moon, and stars and occasional lightning. On the mountaintops he observed smoking volcanos that often erupted with fiery glory, and in his dwelling fire gave light, warmth, and comfort, cooked his food, and helped to relieve the eerie mystery of night. It is not surprising that all over the globe primitive men, and later even sophisticated peoples, worshiped fire and light. Evidence of sun worship is found not only among the

Zoroastrians in Iran, but also in Egypt, Babylon, Greece, and among ancient Hindu, Australian, and African tribes. The sun was worshiped by the American Iroquois, the Plains Indians, the Aztecs, and the Incas. The Creek Indians of North America kindled their sacred fire as the climax of the harvest festival, and subsequent domestic fires all year long were kindled from this sacred source.

This captivation with light is recorded in the earliest literature of the Jews, and indeed of all peoples, from the noble cadences of the Creation story to the Greek tale of Prometheus. Legend became philosophy when Aristotle included fire among the basic elements of the universe, along with air, earth, and water. The Talmud says, "Three creations preceded that of the universe: water, air, and fire. The world is still governed by these principles." The modern Hebrew poet Chaim Nachman Bialik summed up the universal urge in a simple sentence, "Creation longs for light."

For the ancient Hebrews, fire and light had a special significance. Abraham had been rescued from a fiery furnace by God himself; this was a rabbinical elaboration of the scriptural statement (Genesis 12:1) that God had called Abraham to His service from the city Ur of the Chaldeans (Heb. Ur Kasdim)—an elaboration based on the fact that the common noun *ur* means fire. To Moses God had revealed Himself from the burning bush (Exodus 3:1–10); to Ezekiel and to Daniel God appeared as fire itself (Ezekiel 1:4, 27,28; Daniel 7:10; 10:6). Indeed it is stated, "For the Lord your God is a consuming fire, an impassioned God" (Deuteronomy 4:24). The Torah was given to Israel amid fire and lightning, from a mountain peak enveloped in smoke (Exodus 19:18). Departing from Egypt, the Israelites were led through the wilderness by fire: "For over the tabernacle a cloud of the Lord rested by day, and fire would appear in it by night, in the view of all the house of Israel throughout their journeys" (Exodus 40:38). In the Temple there was a continual fire on the altar used for the burnt offering (Leviticus 6:5). The perpetual flame had a miraculous beginning; when Jerusalem was overwhelmed by Nebuchadnezzar (586 B.C.E.) it was extinguished, but it was rekindled when Nehemiah and the faithful returned from Babylon.

The kindling of lights is part of most of the rituals performed in the Jewish home. It initiates and marks the end of the Sabbath. It signals the beginning of the festivals—Passover, Shavuot, Sukkot, Shemini Atzeret, and the High Holy Days, Rosh Hashanah and Yom Kippur. Candles are lighted every evening of the eight successive days of Hanukah. In memory of the departed, a single somber candle burns throughout the first seven days of mourning (shiva period), again through the twenty-four hours of the anniversary (yahrzeit) of a death, and still again on Yom Kippur. Thus times of sorrowful remembrance as well as moments of peace, joy, and festivity are all marked by their particular illumination.

The Hebrew language has three words to express fire and light: *esh, or, ner. Ha-esh* is the elemental substance, fire; *ha-or* denotes firelight, the most useful aspect of fire, but still recalls its elemental source. *Ha-ner* is simply the word for the beneficence of light, unconnected in any way with its source. In the story of Creation we read, "God said, 'Let there be light'; and there was light" (Genesis 1:3). The Hebrew word here is *or,* not *esh,* as if to emphasize the beneficent ("God saw how good the light was"; Genesis 1:4) rather than the catastrophic force inherent in fire. Most of the benedictions over light use the word *ner* (e.g., *ner shel Shabbat, ner shel Hanukah*), completely avoiding the destructive implication of fire. There is one exception, namely, the blessing pronounced during the havdalah ceremony: "Blessed art Thou, O Lord our God, King of the Universe, who creates the lights of fire *(boreh m'oreh ha-esh)*." Thus when the Sabbath departs and the workday week begins, the word signifying beneficent light and the word indicating its somber source are combined in an impressive remembrance.

The noblest expression of Jewish reverence for the element of light—and an indication of the traditional regard for the form of Jewish sacred utensils—is the story of the Biblical Menorah, and the legends surrounding both its origin and its destiny. Its origin was divine; its destiny was to become the symbol of Jewish life throughout the ages. In the Midrashic legends we read that the craftsman Bezalel and his assistant Oholiab were chosen by God Himself to construct the Me-

46.
Oil lamp. From Palestine,
third century C.E. Terra cotta; height 3¼″,
width 2¾″. Menorah design. Jewish Museum,
New York

norah for the desert Tabernacle. Like most patrons of art throughout the ages, the Lord was not content to leave the design entirely to the craftsmen but actually showed Moses a picture of what He expected. Moses, however, possessed neither the exaltation of the patron nor the genius of the artist. Twice he was shown the picture; twice he forgot. God then decided to illustrate with a model. He took white, red, green, and black fire, and out of these He pictured a Menorah with its oil cups, knops, and flowers. Still Moses failed to understand. Then God bade him throw a talent of gold into the fire. Moses obeyed, and an image of the Menorah shaped itself out of the flames.

Even then Moses found himself unable to describe its form to the craftsmen. But Bezalel managed to grasp the idea instantly and executed the commission. Moses exclaimed in amazement: God showed me repeatedly how to make the candlestick, yet I could not properly grasp the idea. And thou, without having it shown thee, could fashion it out of thy own knowledge. Truly dost thou deserve the name *Bezal-El,* in the shadow (protection) of God, for thou dost act as if thou hadst been in the sight of God while He was showing me the candlestick. The legend emphasizes the high esteem in which the artisan is held in Jewish tradition. Indeed we are told that when the great Temple was on the verge of being destroyed, the Almighty Himself sought to save what was most precious to Him in His house: the Ark, the cherubim, the holy spirit of prophecy, the fire of the altar, and the Menorah.

The Menorah is one of the few objects that can be considered exclusively Jewish. The original, crafted by Bezalel for the Tabernacle, was later placed in Solomon's Temple, where it stood among ten similar candlesticks made by the Phoenician metalworker Hiram (I Kings 7:49); its successors, the Menorah of the Maccabeans and of Herod's Temple, were probably reconstructed from the biblical description. The Menorah made by Bezalel had a central stem with three branches extending symmetrically to each side; stem and branches were adorned by buds and flowers. The branches fanned out and up; their seven tips were cupped to hold oil. We do not know whether the branches were curved or straight, nor do we know the form of the base. This treelike effect, seen with especial frequency as a theme in hanukiah design, probably harks back, as has been noted, to the ancient Mesopotamian and Hebrew legends of the tree of life. In the earliest known representation of the Menorah, on a bronze coin (fig. 27) struck by the last Hasmonean king, Antigonus Mattathias (r. 40–37 B.C.E.), the arms are curved, as are those of the Menorah depicted on the Arch of Titus (fig. 45). Whether the lamp or its base, with its sea lions, eagles, griffins, and sea monsters, truly represents the original cannot be said.

By virtue of its intrinsic simplicity the Menorah was predestined to become a popular motif. After the destruction of the Temple, it

became—whether rendered realistically or abstractly—the most frequent decorative and identifying device of the Jews. It is the one symbol which, when found anywhere in the ancient and medieval world, always bespeaks a Jewish origin (figs. 45–47). So deep and pervasive is its significance as to impel a Christian student of Jewish ceremonial art to speak of it in these terms: "Were I a Jew who from infancy had watched his mother, on Sabbath after Sabbath, light the lights, touch her eyes, and bless God, and then had watched my wife doing this before my own children, and finally had seen my daughters do it also, I could think of no symbol of hope more appropriate to put upon my grave than a Menorah."[1] Throughout the Diaspora the Menorah came, as we have seen, to serve as a coat of arms for Judaism, finally becoming the official emblem of the State of Israel (figs. 31, 40, 44).

The Menorah's history has proved a fulfillment of a prophetic legend in the Talmud. The children of Israel, on learning that they had been commanded to kindle lights, asked, "O Lord of the World: Thou biddest us kindle a light for Thee that art the light of the world!" God replied: "Not because I need your light do I bid you burn lamps before me, but only that I may thereby distinguish you in the eyes of the nations that will say: Behold the people of Israel that hold up a light before Him who bestoweth light upon all the world."

It is interesting to speculate as to the fate of the ancient Menorah of the Tabernacle, which had been placed in Solomon's Temple. We are told that it was hidden by the priests when Jerusalem was captured by Nebuchadnezzar; certainly it has not been seen since. The candelabrum of the second Temple, rebuilt 538–515 B.C.E., in part by Zerubbabel, was possibly one of Hiram's duplicates. This Menorah perished in 168 B.C.E. at the hands of Antiochus and was replaced by Judas Maccabeus three years later. It is assumed that the Menorah carved on the Arch of Titus (fig. 45) depicts the Maccabean model, removed from the Temple when it was destroyed by Titus in the year 70, which, in turn, probably resembled the original. After the collapse of the Maccabean (Hasmonean) dynasty the candelabrum was probably placed in the Temple of Jupiter Capitolinus and was later melted down. A tradition related by Procopius (sixth century) has it that the Vandals captured the candelabrum during the sack of Rome (410) and bore it off to Carthage, whence it was taken by Justinian to Constantinople, and that from there some other conqueror, with a historical turn of mind, brought it back to Jerusalem.

According to an account in the Talmud, Rabbi Eliezer bar Jose Ha-Galili visited Rome in the second century to search for traces of the Temple treasure; he found nothing. Despite this early testimony, there were many assertions, up to the sixteenth century, that the Temple spoils were among the relics in the Church of St. John Lateran, and guidebooks of the period mention a *candelabrum aureum* in its treasury.

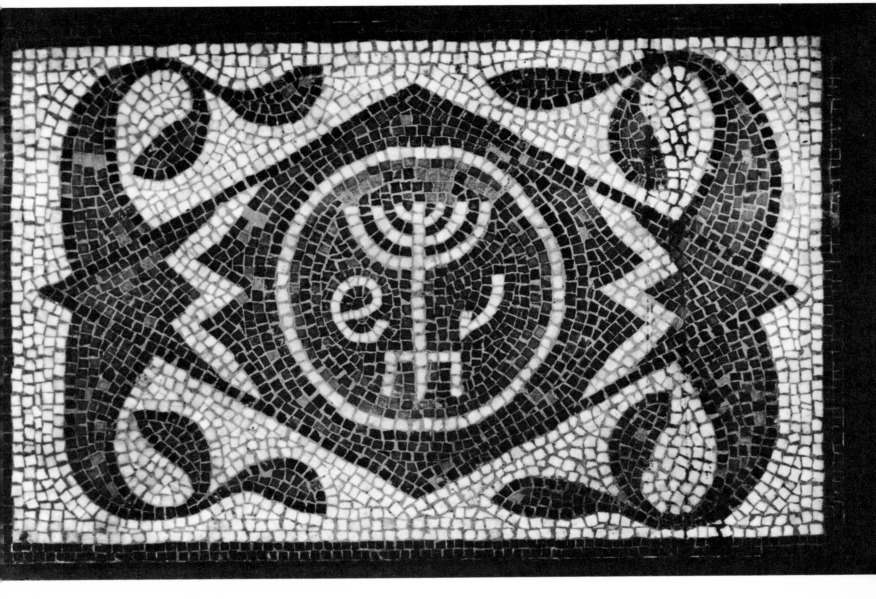

47. Portion of mosaic floor from the synagogue
of Hammam Lif, Tunisia; fifth century C.E. Length 25″, width 40″
Menorah with abstract renderings, perhaps representing lulav and
etrog, on either side. Brooklyn Museum, New York

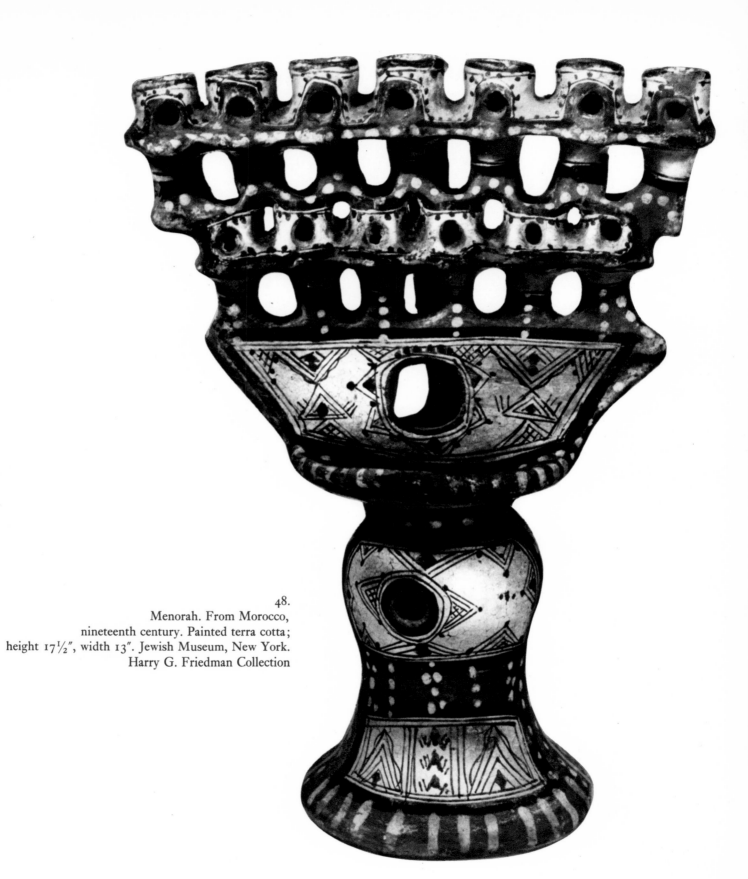

48.
Menorah. From Morocco,
nineteenth century. Painted terra cotta;
height 17½", width 13". Jewish Museum, New York.
Harry G. Friedman Collection

In any event, the Christian tradition that the true Menorah still existed and was safely under the protection of the Church caused the inclusion of many fanciful counterparts in various important European churches. On either side of the high altar in the Cathedral of Saint-Sauveur, in Aix-en-Provence, stand two seven-branched menorahs held by angels, and similar candelabra may be seen in cathedrals in Essen, Klosterneuburg, Braunschweig, Reims, Paderborn, and Mölln.[2] It was thus that Christians, by actually constructing candelabra for their Easter ceremonies, kept the traditional form in sacred use during the Middle Ages, while among Jews, because of the rabbinic interdiction against making copies for ritual purposes, it existed only as a representation and a symbol. Not until the twelfth century did the Jews begin to create candelabra for actual use, first as synagogue hanukiot and later, in smaller versions, as combination menorot-hanukiot for use in the home. In the sixteenth century the seven-branched candelabrum again returned to function in the synagogue, perhaps with the central lamp extinguished to dramatize the difference between it and the ancient and sacred original (fig. 48). In the present century the menorah form enjoys its status as both motif and source of light. In its classic form and in abstract variations it appears on synagogue walls, both inside and out, and often figures in the design of stained-glass windows. Its modern abstract forms can no longer be thought today to violate the rabbinic injunction against exact reproduction of the Temple appurtenances (figs. 49–55).

From earliest times the number seven seems to have had a special relationship to the lamp. A few examples of round terra-cotta seven-branched lamps have been found in early Palestinian excavations. These lamps, some on rather high stands, have seven nozzles; they are dated to Iron II (930–586 B.C.E.). It may be that the seven-branched Menorah of the Temple was based on an even older formalized tradition such as these pottery specimens exemplify. The seven lights, according to rabbinical literature, represent the seven days of Creation, with the Sabbath symbolized by the central lamp. Ilya Schor used this idea as a theme for wood engravings[3] and later in the decoration of a superb kiddush cup (figs. 78,101). Scripture (Zechariah 4:1 ff.) supports the tradition that the seven lights of the candelabrum may be taken to refer to the seven planets, which in turn may be interpreted as the seven eyes of the Almighty. The seven lights of the Menorah are also interpreted as representing the seven continents (did the rabbis know about Antarctica?) and the traditional seven heavens.

The creation of the Tabernacle Menorah was in response to the divine command to the Israelites to bring "clear oil of beaten olives for lighting, to maintain lights regularly" (Leviticus 24: 2–4). Thus the Menorah is the prototype of the eternal light (ner tamid), the tradition being that the central lamp was never permitted to go out, whereas the other six burned only during the night. Though the original eternal

49. Menorah, by Calvin Albert, in garden of Temple Israel, Tulsa, Oklahoma. Lead alloy, height 8'. Courtesy Percival Goodman

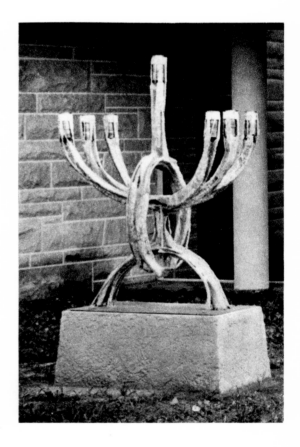

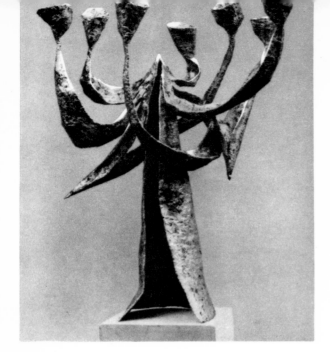

50. Menorah, by Seymour Lipton,
in chapel of Temple Beth-El, Gary, Illinois. Nickel,
silver, and steel; height 30". Courtesy
Percival Goodman

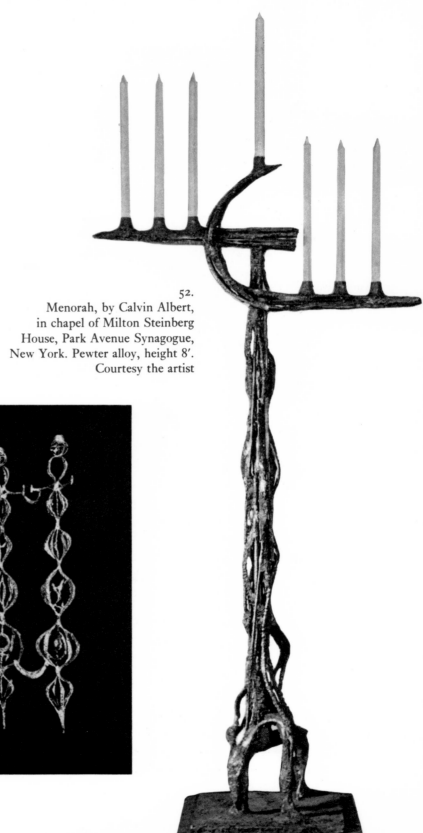

52.
Menorah, by Calvin Albert,
in chapel of Milton Steinberg
House, Park Avenue Synagogue,
New York. Pewter alloy, height 8'.
Courtesy the artist

51. Menorah, by Ibram Lassaw,
in chapel of Temple Beth-El, Springfield, Massachusetts. Bronze,
height 30". Courtesy Percival Goodman

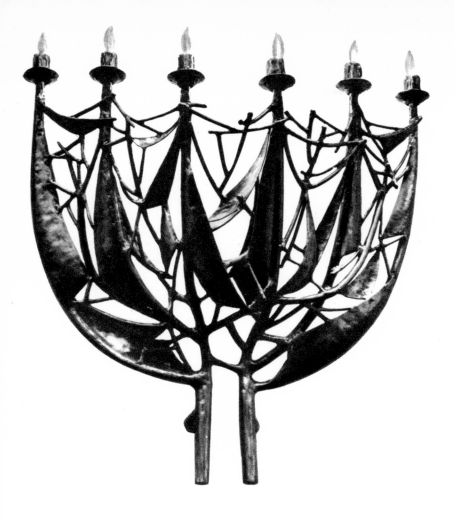

53. Menorah, by Martin Craig,
one of a pair in the Fifth Avenue Synagogue,
New York. Welded bronze, height c. 26″.
Courtesy the artist

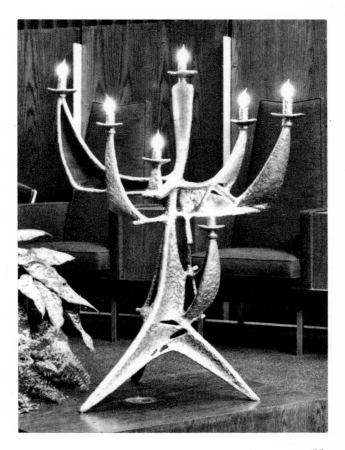

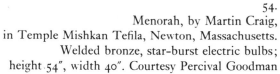
54.
Menorah, by Martin Craig,
in Temple Mishkan Tefila, Newton, Massachusetts.
Welded bronze, star-burst electric bulbs;
height 54″, width 40″. Courtesy Percival Goodman

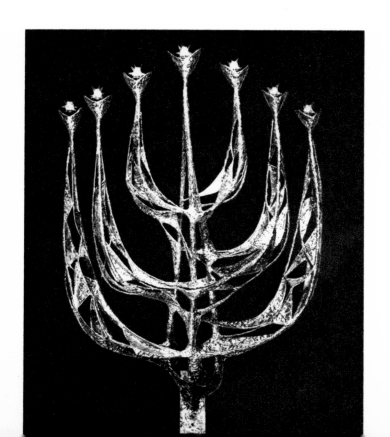

55.
Menorah, by Martin Craig,
in Temple Beth Israel, New Rochelle, New York.
Welded bronze, height 40″. Courtesy
Percival Goodman

75

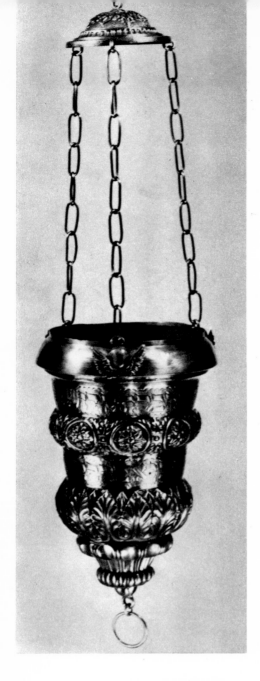

56. Eternal light.
From Italy, nineteenth century.
Silver, pressed, hammered, and engraved;
height 22″. Jewish Museum, New York.
Harry G. Friedman Collection

light was apparently a standing lamp, when the early Christian churches, and later the Muslim mosques, adopted the idea of an eternal light, a pendant form was preferred, and this gradually came to be the accepted form in the synagogue as well. Hence these synagogue lamps are identical with early Christian and Muslim examples and are "Jewish" only by virtue of their inscriptions (fig. 56). Modern craftsmen have produced a large variety of new forms (figs. 57–59, 226). According to the rabbis, the ner tamid represents the light that Israel shows the people of the earth. Practically, it presupposes a watchful reverence for the sacred contents of the Ark. Since frequent renewal indicates frequent inspection, Percival Goodman has advocated abandoning the automation of the electric light bulb and returning to the earlier oil lamp, which would require regular rekindling by members of the congregation. Such a service, with its connotations of reverent observance, might be an appropriate duty for the recent bar mitzvah to perform.

The association of light with resurrection antedates both Jews and Christians. All ancient peoples expressed hope for the continued existence of the departed by putting a light, or lights, into the tomb. Practically all the pagan tombs of the ancient world have been found to contain lamps. This is also true of Jewish and Christian tombs, not only in Palestine but also in Alexandria, Cartagena, Ephesus, Cyprus, Syracuse, Rome, Syria, and Malta. Among the Jews of ancient times, fires were lit at the graveside, and many of the deceased's possessions were burned therein. In some parts of the world it is customary today for Jews to light candles at the bedside of the dying in honor of the Divine Presence, which comes to meet the ascending soul. In talmudic times an oil lamp, or torch, was lit at the head of the bier (see fig. 60), and even in broad daylight the funeral cortege was accompanied by torchbearers.

It was a simple transition from including a lamp or torch in the interment ceremonies to lighting a lamp at specified intervals in honor of the departed. The custom of burning a candle for the first seven days of mourning has been followed by observant Jews at least since the thirteenth century. It did not become common practice until the eighteen hundreds. The Jewish custom of lighting a memorial candle

58.
(FACING PAGE)
Eternal light, by Martin Craig, in
Temple Mishkan Tefila, Newton, Massachusetts. Welded bronze; height 4½′, width 7′4″. The outstretched wings of the cherubim face each other above the parochet; from between them the voice of the Lord issues to speak to His congregation. The inner section of the design, a flame motif, is lighted by a pair of star lamps, to preclude any interruption of the light.
Courtesy Percival Goodman

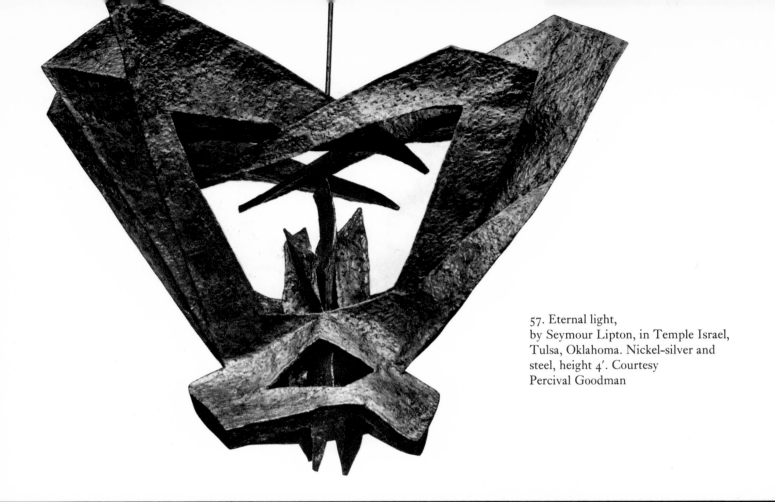

57. Eternal light,
by Seymour Lipton, in Temple Israel,
Tulsa, Oklahoma. Nickel-silver and
steel, height 4'. Courtesy
Percival Goodman

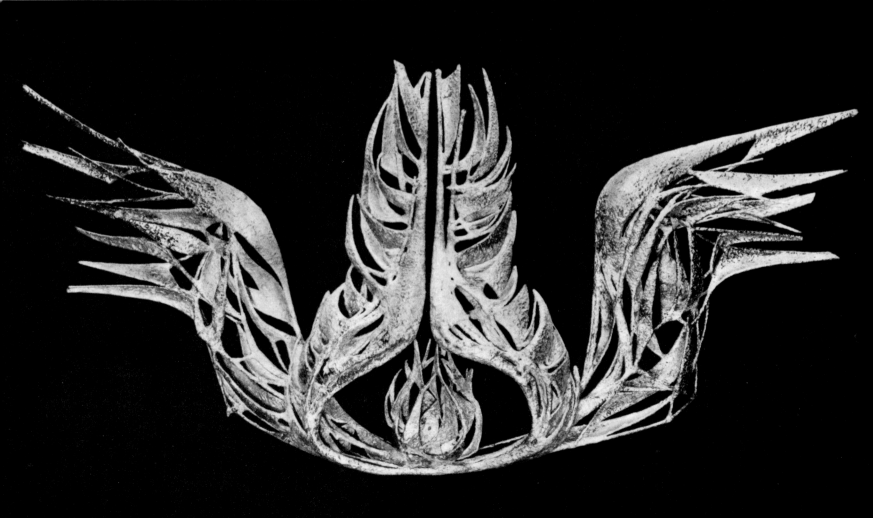

59. Eternal light, by Ibram Lassaw, in Temple Beth-El,
Springfield, Massachusetts. Calcite crystal; height 2', width 3'.
Courtesy Percival Goodman

for each departed member of the family on Yom Kippur eve first attained formal status in the codifications of the talmudic scholar Abraham Danzig of Vilna (1748–1820). A number of types of memorial lamps have been used in the past, and the Jewish Museum of New York has several examples, the most interesting being a typical piece of folk creation (fig. 61). In modern times we are most familiar with the mass-produced wick-in-paraffin type in a glass tumbler. However, there have been designed recently a number of holders to enclose the ordinary tumbler variety. The Natzlers of California have created a holder for a long-burning memorial candle that because of its ceramic composition possesses an air of reverence despite its contemporary design (fig. 62). For the commercial memorial lamps in glass tumblers Ludwig Wolpert has created a brass holder (fig. 63) on a ringstand, its concave sides pierced to form the Hebrew words *ner Adonai nishmat adam* ("God's light is the soul of man"). A more elaborate silver holder for the memorial candle, by Ilya Schor, has six panels, each dedicated to the memory of a member of a family. The rim is engraved with the names of the Hebrew months and each month has a niche for a tiny diamond which, when inserted, will designate a yahrzeit (fig. 64). The design of memorial lights for the departed members of a congregation is receiving fresh consideration in newer synagogues. Percival Goodman has designed an alcove in which individual bronze plaques, each inscribed with a name, may be hung. On the Friday preceding

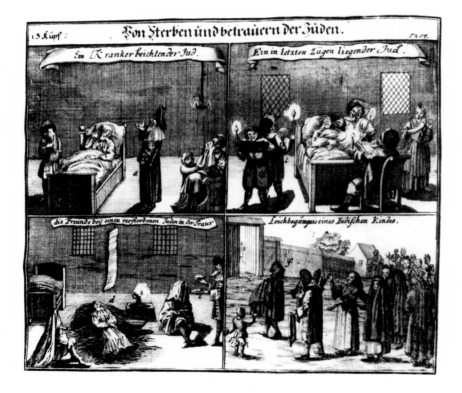

60. Ceremonies for the dead and dying. From Paul Christian Kirchner, *Jüdisches Ceremoniel*

79

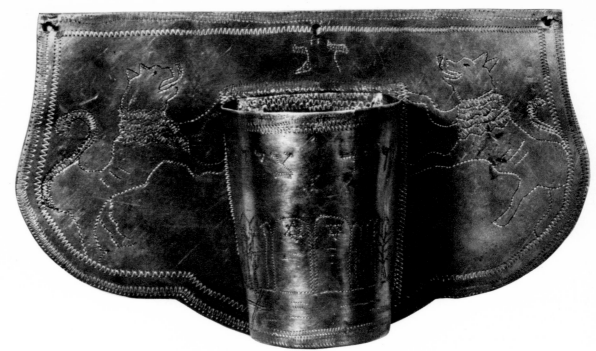

61. Yahrzeit lamp.
From Russian Poland, eighteenth century.
Silver, engraved; height 3½″.
Jewish Museum, New York.
Harry G. Friedman Collection

62.
Holder for Yahrzeit light, by Gertrude
and Otto Natzler. Earthenware with dull green
glaze, height 4½″. Inscribed: "The spirit of
man is the lamp of the Lord" (Proverbs 20:27).
Jewish Museum, New York

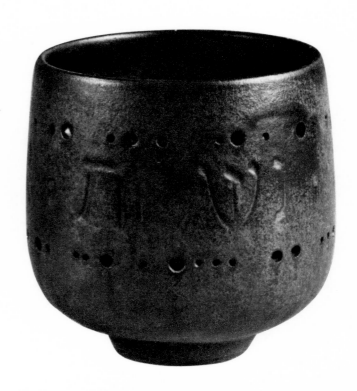

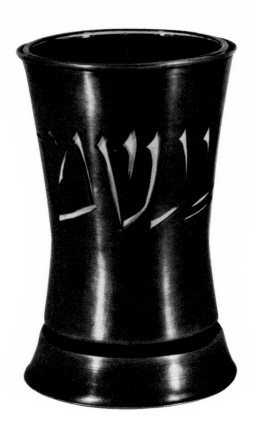

63. Holder for yahrzeit light,
by Ludwig Wolpert. Bronze, with cut-out lettering;
height 5½″, diameter 3½″. Collection
Dr. and Mrs. Morton Pizer,
Raleigh, North Carolina

64.
Holder for yahrzeit light, by Ilya Schor.
Silver, with diamond markers; height 4½″, diameter
2¾″. Collection Dr. and Mrs. Abram Kanof,
New York

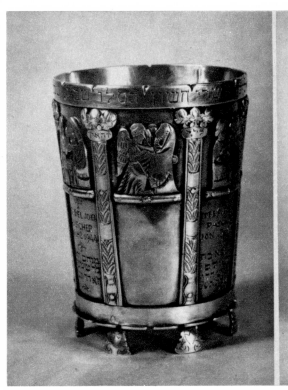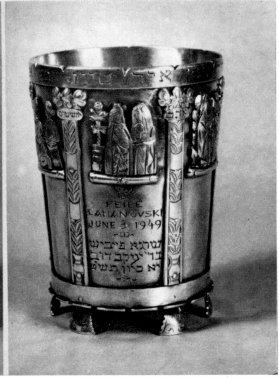

65.
Yahrzeit lamp for the
Six Million, by Moshe Zabari (Tobe Pascher
Workshop). Brass, height 6″. From the
base, which suggests a link in the chain
of humanity, rises a shape that evokes the
image of a neck being throttled and a
mouth crying out in anguish.
Jewish Museum, New York

the yahrzeit, the family comes to the synagogue to install this plaque and to light a candle in the niche provided for the purpose.

The massacre of six million Jews, during World War II, has called for a special memorial light dedicated to them. A competition sponsored by the Government of Israel produced two such lamps; one by Moshe Zabari, designed for oil burning, suggests an anguished cry for help (fig. 65). The other, intended for synagogue use, consists of six slender brass rods which curve upward, ending in six cups to hold six candles; the base is of wood.

66. *Traustein* (marriage stone). 1700.
Red sandstone; height 20¾″, width 28¼″.
Inscribed with the initial letters of "The
voice of mirth and the voice of gladness, the
voice of the bridegroom and the voice of the
bride" (Jeremiah 7:34, 16:9, 25:10) and the
verse "This is the gate of the Lord; the
righteous shall enter into it" (Psalms 118:20).
From the courtyard of the synagogue in Bingen,
Germany. Israel Museum, Jerusalem

VI. WINE IN JEWISH CEREMONIAL

The drinking of wine in religious observance had its beginning in
ancient beliefs regarding the potency of godly fluids. Primitive man
thought he acquired divine attributes by drinking these liquids, just
as he drank the blood of a vanquished foe to bolster his own valor.
In the earliest times water and milk were accepted as symbols of these
godly secretions, and it is significant that after Adam had eaten the
forbidden fruit God reflected: "The man has become like one of us"
(Genesis 3:22). Ultimately, however, wine, as the blood of grapes and
resembling the blood of God, gradually gained pre-eminence. The
change and heightened sense of power which the wine induced—a
sense of divinity itself—eventually brought man to the revelries of
drinking orgies, which were the feature of ancient pastoral wine festi-
vals. The Hebrews abandoned these crude and idolatrous debauch-
eries; wine was never consumed in the Temple as part of the service,
but was poured over the altars as a libation.

The earliest mention in the Bible of wine as a ceremonial item occurs in Genesis 14:18–19: King Melchizedek, in greeting the victorious Abraham, offered him bread and wine and blessed him—and then, according to the Talmud, taught him Torah. In Genesis too (27:25) we read that Jacob brought wine to his father and that Isaac "drank wine and blessed Jacob." In poetic legendry, Israel is likened to a vine, which, brought to Palestine, took deep roots and prospered (Psalms 80:9–10); a good wife is like a "fruitful vine" (Psalms 128:3); the Psalmist pictures "a cup with foaming wine in the hand of the Lord" (Psalms 75:9). When there is prosperity, every man sits under his vine and his fig tree (I Kings 5:5). Wine not only "maketh glad the heart of man" (Psalms 104:15) but it also "cheereth God and man" (Judges 9:13); it revives "such as are faint in the wilderness" (II Samuel 16:2) or are "bitter in soul" (Proverbs 31:6). In the Talmud the Torah is often compared to good wine, and in one legend the various books are identified as individual wells of wine. Wine figures in several ancient legends. In one, a river of Eden flows with wine; others tell of angels straining wine for Adam and of the angel Michael bringing wine to Isaac, who by drinking it was filled with virtue.

Wine in ancient Palestine was not only abundant but good; both Plutarch and Pliny testify that its quality was highly esteemed throughout the entire Mediterranean region. The talmudic rabbis, in their playful exaggeration, often expanded the land-of-wine theme. One of them explained a three-day absence by recounting the details of a harvest made from a single vine branch. On the first day, he said, three hundred clusters of grapes were harvested, each yielding a barrel of wine; on the second day there were still three hundred more clusters of grapes, each yielding a half barrel; while on the third day the same vine yielded an additional one hundred barrels—and there was still half a crop remaining when he left! Along with the fig tree, the palm tree, and to a lesser extent the pomegranate and the olive tree, the vine was a predominant symbol of agricultural Israel.

The talmudists believed in the medicinal effects of wine: "Where wine is lacking, drugs are necessary." They also considered it psychologically beneficial: "Wine helps to open the heart to reasoning"; but they were well aware of the dangers. The common Hebrew word for aged wine of high alcoholic content is *yayin*, a word similar to that meaning lamentation or wailing. The word for sweet wine is *tirosh*, which if pronounced *tiroash* means "to be poor"—a man's fate if he drinks too much. However, if pronounced *tirosh*, the word means "be the head, or leader," the effect produced if wine is drunk in moderation.

The drinking of wine as a religious duty came about under the influence of Hellenism, and since the destruction of the Temple, it has become a feature of many Jewish ceremonies. The first mention in the Talmud of the wine benediction occurs during a protracted dis-

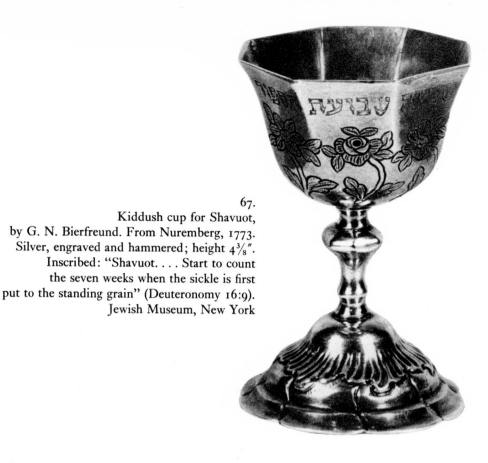

67.
Kiddush cup for Shavuot,
by G. N. Bierfreund. From Nuremberg, 1773.
Silver, engraved and hammered; height 4⅜".
Inscribed: "Shavuot.... Start to count
the seven weeks when the sickle is first
put to the standing grain" (Deuteronomy 16:9).
Jewish Museum, New York

cussion between Hillel (head of the Jerusalem Sanhedrin during the period 30 B.C.E. to 10 C.E.) and Shammai (vice-president of the Sanhedrin during Hillel's tenure) concerning the order of benedictions. (Hillel's view, giving precedence to the wine benediction, prevailed.) Since then, tasting wine after a benediction is the most often repeated ritual in Jewish life. The male infant tastes it first at eight days of age, when he enters into the covenant of Abraham by the ritual of circumcision. As a child, he looks forward to the four Passover cups. His marriage is sanctified when he and his bride sip wine together. The initiation of every Sabbath and every festival is marked by a sacramental sip; so is the close of the Sabbath and the festivals. And in the fullness of time, when he enters to his reward in Paradise, he will drink of wine perpetually preserved in its grapes since the six days of Creation.

The drinking of wine at most meals was common in ancient days, and there is a passage in the Manual of Discipline of the Dead Sea Scrolls which explicitly prescribes the proper ceremonial benedictions over wine (and bread) at the communal meals. Later the ceremony was reserved for the Sabbath and festivals, as the kiddush: the kiddush ceremony initiates the Passover, Shavuot, and Sukkot festivals. Four cups are ceremonially sipped on the Passover. The first cup serves

85

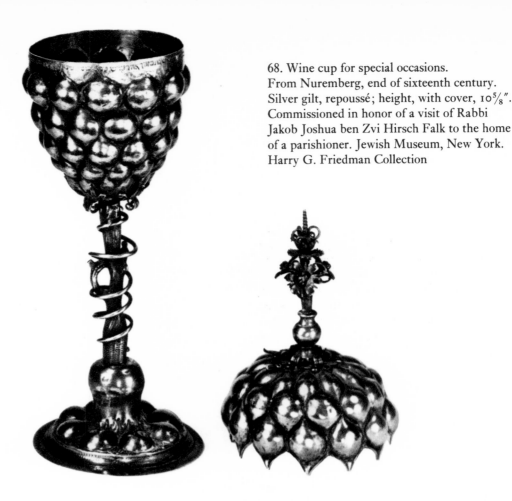

as the traditional kiddush, or sanctification, to initiate the seder. The second cup is drunk in the hope that the next celebration of Passover may take place in the Messianic kingdom. The third is part of the grace after meals, while the fourth looks to ultimate redemption. In addition to the three festivals, there is also a kiddush for Rosh Hashanah eve.

The kiddush is essentially a home ceremony. It is recited in the synagogue, however, to recall the era when wayfarers sojourned in the synagogue. Wine is also taken ceremonially at the completion of every meal. After the opening words of grace are spoken ("Let us praise Him. . .") the tradition is to pass a portion of the wine on to the hostess.

The cup of benediction plays a part, as has been indicated, in the ritual of circumcision. In the course of the service the mohel, or circumciser, pronounces the benediction, recites a long succession of blessings on the baby, then drinks of the wine and places a few drops into the baby's mouth. He then sends the cup to the mother, who is always absent from this ceremony. In a part of the ceremony no longer followed, the ancient relationship of wine and blood was recalled when the mohel performed the rite of sucking *(mezizah)* and placed a few drops of wine, mixed with blood, into the infant's mouth.

destruction of the Temple there intervenes a period of several centuries in which there is no surviving evidence of special regard for the ceremonial cup. In a two-volume Vatican compilation of Jewish inscriptions on archaeological finds made throughout Asia, Africa, and Europe[3] there appears among the hundreds of photographs not a single grapevine or cup. Despite the heights of affluence and culture reached by the Jews in medieval Spain, there is not, among all the records of grave inscriptions and monuments, inscriptions from ceremonial objects, ceramics, rings, amulets, coins, medallions, seals, and plates, a single representation or description of a kiddush cup.[4]

The basic form of the ceremonial cup (Heb. *kos*) is necessarily circumscribed by its function. It is set apart as intended for religious use only by its inscriptions and decorations. The earliest kiddush cups still extant are those of Germany of the sixteenth and seventeenth centuries. The most popular form was a hexagonal or round cup on a slender stem, fixed on a hemispherical base (figs. 67–69). Occasionally the low goblet rests on a flattened hemisphere (fig. 70). Some wide cylindrical cups rest directly on ringstands (colorplate 4; fig. 71). Most of the cups with a cover or lid were designed as gifts or dedication mementos (figs. 68, 69). Kiddush cups have been made of glass (colorplate 5), cut glass, and even wood, but silver is the usual medium; one reason is the ritual requirement that the rim of the goblet be unflawed. Christian silversmiths who made these cups added Hebrew inscriptions from patterns prepared by their patrons. These inscriptions vary greatly. Most popular are "For the holy Sabbath" and "Remember the Sabbath day and keep it holy." The double injunction "Remember" and "Observe" is seen frequently (fig. 82). A contemporary cup says simply, "My cup runneth over" (Psalms 23:5). Most contemporary cups are severely functional (figs. 72–74). Cups for the Passover are usually designated "For the holy Passover." Similar inscriptions make clear the purpose of some fine cups designed for the three festivals Passover, Shavuot (fig. 67), and Sukkot. More rarely there is an engraving of a Sabbath or festival scene. Sometimes the decoration may be quite irrelevant; in the Benguiat Collection in the Jewish Museum in New York there are seventeenth-century wine glasses with ordinary scenes —a woman at the loom, a harvesting scene, a rural landscape—and even one depicting a hunting scene. More characteristically, however, Sabbath cups are decorated with religious motifs (figs. 75, 76).

70. Kiddush cup with cover.
From Germany, c. 1695. Silver, with traces of gilding; height 7″, diameter 3″. Jewish Museum, New York. Harry G. Friedman Collection

One of the finest cups in the Jewish Museum of New York formerly belonged to the community of Frankfurt (colorplate 4). Fashioned of gold, it was dedicated in 1650. The beautiful late-Renaissance floral ornamentation frames three motifs in relief—the lion of Judah, the stag of Naphtali, and the fabled unicorn. The last was really meant to be the biblical *rem* (wild buffalo) but the Hebrew was translated incorrectly into Greek as "unicorn," a creature "which dwells in high places," and symbolizes spirituality.

The difference between the relatively simple kiddush cup and the elaborate chalice can be taken to symbolize the difference between the Jewish kiddush and the Catholic Mass. The latter celebrates the miraculous transformation of wine into the blood of Christ; the vessel in which so great a miracle takes place is usually richly decorated and made of precious metal. The kiddush in antiquity may have been a reminder of divine blood, but since early rabbinic days the ceremony has become a rather simple procedure not unlike a "thank-you" to God for His Sabbath and festivals, and for His material blessings to man on earth.

71. Elijah cup. From Moscow, c. 1776. Silver, with repoussé work; height 7″. Jewish Museum, New York. Mintz Collection

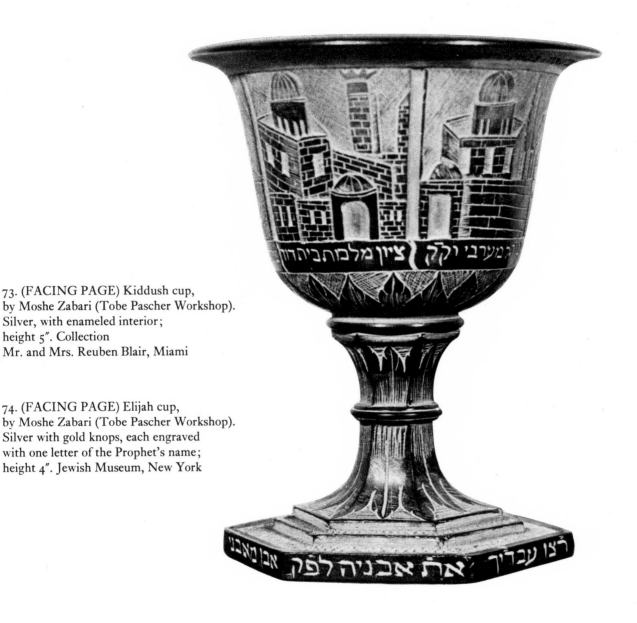

73. (FACING PAGE) Kiddush cup,
by Moshe Zabari (Tobe Pascher Workshop).
Silver, with enameled interior;
height 5″. Collection
Mr. and Mrs. Reuben Blair, Miami

74. (FACING PAGE) Elijah cup,
by Moshe Zabari (Tobe Pascher Workshop).
Silver with gold knops, each engraved
with one letter of the Prophet's name;
height 4″. Jewish Museum, New York

75. Kiddush cup. From Palestine, 1844.
Brown stoneware, height 6″. Carved decoration
shows western wall of the Temple, tombs of the
kings of Israel, tomb of Rachel, and Tower of
David. Inscribed: "For thy servants
cherish her stones. A stone from the holy
city of Jerusalem. Mayest Thou rebuild it and
establish it speedily in our day." Jewish Museum,
New York. Harry G. Friedman Collection

93

76. Cup for special occasions,
by Master Anton Katglasser. From Vienna,
1830. Glass, height 5″. Interior view of
the Seitenstettengasse Temple, Vienna.
Jewish Museum, New York. Harry G. Friedman
Collection

77.
Burial society goblet, by Master
Johann Conrad Weiss. From Nuremberg, 1712. Silver,
with inscriptions and names of members deeply
engraved; height 9¾″. Jewish Museum, New York.
Gift of Michael Oppenheim

94

79. Ushering In the Sabbath.
From Moritz Oppenheim, *Bilder aus dem altjüdischen Familienleben*

VII.

the sabbath:
light, wine, and spice

After six days of arduous creating, God rested; He hallowed the seventh day, commanding that it be a time of rest for all generations. Thus the Sabbath became the central day of Jewish life. An entire tractate of the Talmud *(Shabbat)* is devoted to the details of its proper observance: the various benedictions, the thirty-nine classes of forbidden activity, and the permitted and prohibited oils for the Sabbath lamps. Josephus explained the Sabbath to his Roman readers, who

אשת חיל מי ימצא ורחוק מפנינים מכרה:: בטח בה לב בעלה ושלל

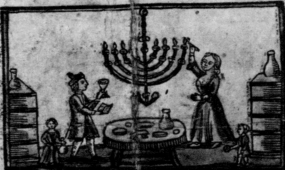

ברכת הנר של שבת ויום טוב

האשה בעלה אומרת קודם הדלקת נר שבת ויום טוב.

רבון כל העולמים גלוי וידוע לפני כסא כבודך
שאני באתי להדליק נר של שבת קדש
ושל יום טוב מקרא קדש הזה. לקיים מצות בוראי
באהבה ובגילה ובשמחה לבבי באשר צויתני
ברוך אתה יי אלהינו מלך העולם אשר קדשנו
במצותיו וצונו על הדלקת נר של שבת
קדש וביום טוב ושל יום טוב מקרא קדש הזה יי.

ואחר הדלקת אומר

יהי רצון מלפניך יי אלהי ואלהי ישראל ותן

לכל ישראל חיים טובים וארוכים בבריאות שלמה
בהצלחה מכל רע ובהצלחה נכל טוב הכרני
כי מרבה תקונו בפקדת ישועה ורחמים
ותברכנו ברכות גדולות ותשלים כל ולא יהיה
בנו לא עקר ולא עקרה לא מסל ולא עסקרה
לא אלמן ולא אלמנה ולא יהיה בנו ים רעים
וזכני ותעבני לחולדר בנים ובני בנים חכמים נבונים
וידעים אוהבי ייראי אלהים אנשי אמת זרע קדש
בי' דבקים שיאירו עולם בתורה ובמעשים
טובים ובכל מלאכת עבודת הבורא ותשמע נא
את תחינתי בעת ובעונה הזאת בזכת שרה ורבקה
רחל ולאה אמותינו וראר נרינו שלא ידעך ולא
יכבה לעולם ועד וחאר פניך ומשיעה ובכל עמך
ישראל בטובה בימני אמן סלה ועד יי

ברכה לחלה

ברוך אתה יי אלהינו מלך העולם אשר קדשנו
במצותיו וצונו להפריש חלה יי

ברכת טבילה

ברוך אתה יי אלהינו מלך העולם אשר קדשנו
במצותיו וצונו על הטבילה יי

Prima di accendere il lume del Sabbato e delle Festività dirà.

Patrone de' Mondi, è manifesto, e cognito avanti il Trono della tua gloria, che io mi presento per accendere il lume per il Santo Sabbato (ò per il buon giorno Festivo di questa Santa convocazione) per osservare il Precetto del mio Creatore con amore, giubilo, ed ilarità del mio cuore, come mi precetasti.

Segue la Benedizione.

Benedetto sia il Signor nostro Dio, Rè dell'Universo che ci hà santificate con suoi Precetti, e ci hà Comandate per accendere il lume del Santo Sabbato (e nelli Festività dirà) per il buon giorno Festivo di questa Santa convocazione.

Poi Sia à supplicdare questa Orazione.

Sia di tuo piacere, Dio Signore, di graziare à me (ò mio Marito, ò mio Padre, e mia Madre, e miei Figli) e ad ogni mio propinquo, una buona lunga Vita, con perfetta Sanità, e salvezza d'ogni malie, e prosperità in tutti gli beni.

Ramentati di noi con favore, e visita noi con Salvazione e pietà, e benedici noi, con esuberanti benedizioni, empiendo la nostra Casa de' molti beni consistenti. E faccia la tua Divinità, residenza frà noi, e non siavi sterilità nel Uomo, e nella Donna, nepure, Uomo Vedovo, nè Donna Vedova, nè siavi totalmente in noi quatunque cosa cattiva.

Rendemi meritevole di partorire Figli Maschi, e questi, e li Figli di essi siano sapienti, prudenti, conoscitori, ed amanti del Signore, tementi d'Iddio Uomini di fede e Santa Próle, congiunti con il Signore ed illuminino il Mondo in legge ed in buone opere, ed in ogni ufficio che tratti di Servigio verso il Creatore. Deh! esudisci la mia preghiera ora, e prontamente, per il merito di Sarà Rivcà, Rachel, e Lea nostre Madri, e fà risplender il nostro lume che non si oscuri, nè si smorzi per tutta l'eternità, e fà che risplenda la luce delle tue facie, per essere redente con tutto il tuo Popolo Israelitico, solecitamente, ai nostri giorni, e così sia, Sellà, ed In eterno.

Benedizione nel levare la Kalà della Pasta.

Benedetto sia il Signore nostro Dio Rè dell'universo, che ci hà santificate con suoi Precetti, e ci ha comandate di separare la Kalà.

Benedizione nel purificarsi prima d'infondersi nell'Acqua

Benedetto sia il Signore nostro Dio Rè dell'Universo che ci hà santificate con suoi Precetti, e ci hà comandate per purificarsi con la Tevilà.

98

found the idea of a prescribed day of sanctified rest an intriguing novelty, an excuse for laziness. Philo injected a note of mysticism: the Sabbath was for God and His rest; man observed the day because it was his duty to imitate God all his life. On this day man gains respite from the labors of the week, but, more important, it is meant as a day of active celebration of the completion of Creation. On the seventh day man is given an added, pure soul—*neshamah yeterah*—which is his until after the service (havdalah) that marks the end of the Sabbath. During the week, man as an individual is concerned with the problems of survival; on the Sabbath men worship together, and together contemplate the nature of God and His will. The Sabbath service quotes the Talmud: "I have a precious gift in my treasury, said God to Moses; Sabbath is its name; go and tell Israel I wish to present it to them."

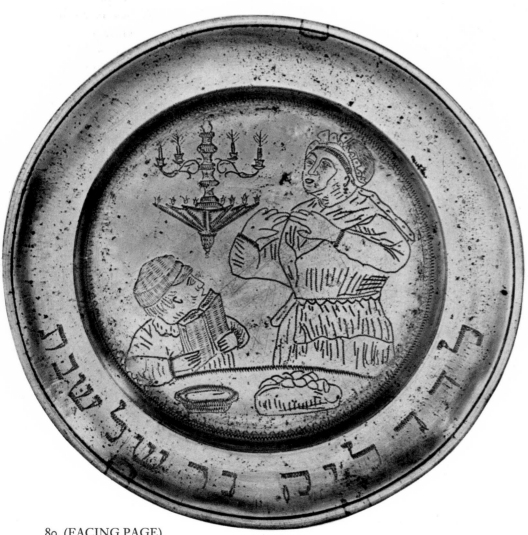

81. Sabbath plate.
From Germany, nineteenth century.
Engraved pewter, diameter 8½".
Jewish Museum, New York. Harry G. Friedman Collection

80. (FACING PAGE)
Benedictions for the Sabbath
and festival lights, in Hebrew and Italian.
From Italy, eighteenth century. Woodcut
on paper, hand colored; 15⅝ × 10½".
Jewish Museum, New York.
Harry G. Friedman Collection

Just as Creation began with the words "Let there be light," so the Sabbath begins with the kindling of lights, a custom whose origin a distinguished scholar has explained as follows:

In the Jewish religious calendar the observance of festivals begins a little before sunset on the preceding day. Because no fire is kindled on the Sabbath it has been customary from time immemorial for Jewish housewives to conclude all their household arrangements for the day of rest by preparing the lights, which have therefore become known as the Sabbath lights. The antiquity of this usage, and the significance which came to be attached to it, have sanctified it, and consequently in modern Jewish homes the Sabbath candles are lit even though other means of illumination are available, and in use.[1]

In Jewish tradition the Sabbath planted a heaven in every Jewish home, making the home a sanctuary, the father a priest, and the mother an angel of light. Lighting the Sabbath candles has naturally become the Jewish mother's foremost duty. The well-known interpreter of Jewish ceremonial life Moritz Oppenheim (1799–1882) has depicted the scene in a painting (fig. 79). While a woman should be dressed in her best for the ceremony, it is better to be on time than to delay. If there are several women in a household, candles should be lit by each. If the mother is incapacitated, the obligation devolves upon the father. At least two candles are customarily kindled, one for each variant of the commandment: "*Remember* the Sabbath day..." (Exodus 20:8) and "*Observe* the Sabbath..." (Deuteronomy 5:12). The two key words are often seen inscribed on kiddush cups (fig. 82). In Jewish

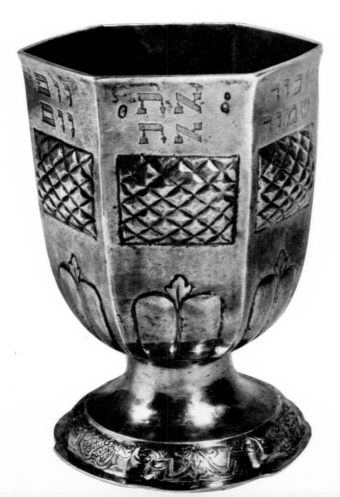

82. Sabbath kiddush cup.
From Augsburg, 1700. Silver gilt, height 5¼".
Inscribed: *zechor* (remember) and *shemor*
(observe). Musée de Cluny, Paris

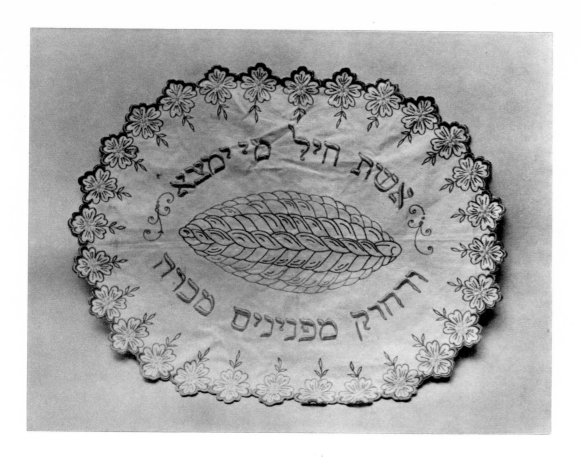

83. Hallah cover. From the
United States, nineteenth century. White
cotton; oval, $15 \times 18''$. Embroidered
inscription: "A woman of valor, who can
find? For her price is far above rubies"
(Proverbs 31:10). Jewish Museum, New York.
Harry G. Friedman Collection

folklore the two candles also represent joy and blessing, serenity and
peace. The pronouncing of the Sabbath benediction is an exception to
the usual order. Since it would be desecrating the Sabbath to strike
a match *after* the blessing had inaugurated the day of rest, the mistress
of the house lights the candles, then holds her hands before her eyes
while she recites the blessing (fig. 80); when she again sees the lights,
it is as though she had ignited them after the benediction.

Although the lighting of Sabbath candles takes place fifty-two times
a year, the ceremony seems never to lose its power to engender spirit-
ual vitality. The manner of its performance sets the tone for the entire
Sabbath. Bella Chagall describes it well:

Mother . . . quickly washes her face and hands, puts on a clean lace collar
that she always wears on this night, and approaches the candlesticks like a
quite new mother. With a match in her hand she lights one candle after an-
other. All the seven candles begin to quiver. The flames blaze into mother's
face. As though an enchantment were falling upon her, she lowers her eyes.
Slowly, three times in succession, she encircles the candles with both her
arms; she seems to be taking them into her heart. And with the candles, her
weekday worries melt away.

She blesses the candles. She whispers quiet benedictions through her fingers
and they add heat to the flames. Mother's hands over the candles shine like
the tablets of the decalogue over the holy ark.[2]

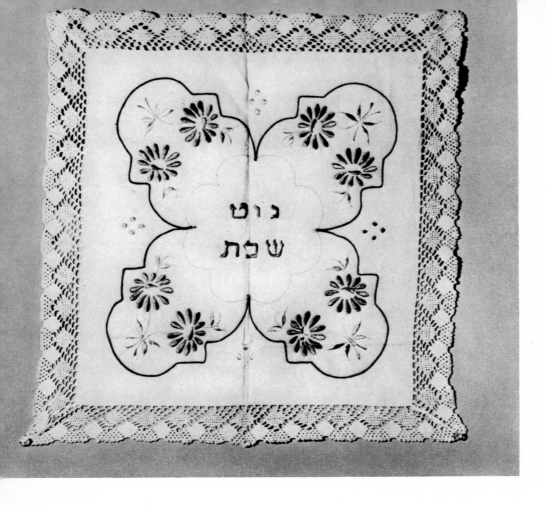

84. Hallah cover.
From Germany, nineteenth century.
Linen, embroidered, with cotton lace
border; 19×19″. Jewish Museum, New York.
Harry G. Friedman Collection

85.
Sabbath tablecloth,
by Helen Kramer (detail). White linen
with silver bands and inscription woven
in purple. Jewish Museum, New York

102

After a short Friday evening service in the synagogue, the Sabbath ritual is largely centered in the home, though it has already begun with the kindling of the lights before the evening service. The Sabbath meal is a festive affair. The tablecloth is usually snow-white. A unique cloth by Helen Kramer now in the Jewish Museum is especially fine (fig. 85). Beautifully textured of linen with wide parallel bands of silver thread along the long edges, it has woven in, in purple, at the father's end *L'cha dodi* ("Go, my beloved") and at the mother's end *l'chrat kallah* ("to greet the bride"), the opening words of a sixteenth-century hymn welcoming the Sabbath as a bride, traditionally sung on Friday night. The splendor of his wife's efforts prompts the husband to recite from the last chapter of the Book of Proverbs, "A woman of valor who can find? For her price is far above rubies. The heart of her husband doth safely trust in her. . . ." The candles glorify the foot of the table; at the head there is a full kiddush cup and, on a special Sabbath plate (fig. 81), two loaves of the twisted Sabbath bread, or hallah. The two hallot hark back to the time when only the Sabbath meal boasted two courses. The twin loaves may also commemorate the double portion of manna gathered for the Sabbath (Exodus 16:22), the two versions of the Sabbath commandment, the two lambs for the Sabbath sacrificial service (Numbers 28:9), and the double title of the Sabbath psalm (Psalms 92), which according to tradition was composed by Adam, and which begins with the words *mizmor shir*, both meaning "song". During the recitation of the kiddush the hallot are kept under a special cover, usually handsomely decorated (figs. 83, 84). This is done so as not to slight the staff of life: it is "absent" while the benediction over wine is recited; it is uncovered for its own benediction, addressed to Him "who brings forth bread from the earth."

Following the lighting of the candles and the benediction over the hallot there may be a hymn—*Shalom aleichem, malachei hasharet* ("Peace to you, ye ministering angels")—and then the father rises to recite the kiddush. Obedience to the injunction "Remember the Sabbath day to keep it holy" is fulfilled by the Friday evening synagogue service, but custom has decreed that the Sabbath be sanctified cheerfully and impressively at home by recitation of the kiddush over a glass

86. Sabbath lamps. From Persia, fifteenth to seventeenth century.
Brass, cast.
Jewish Museum, New York.
Harry G. Friedman Collection

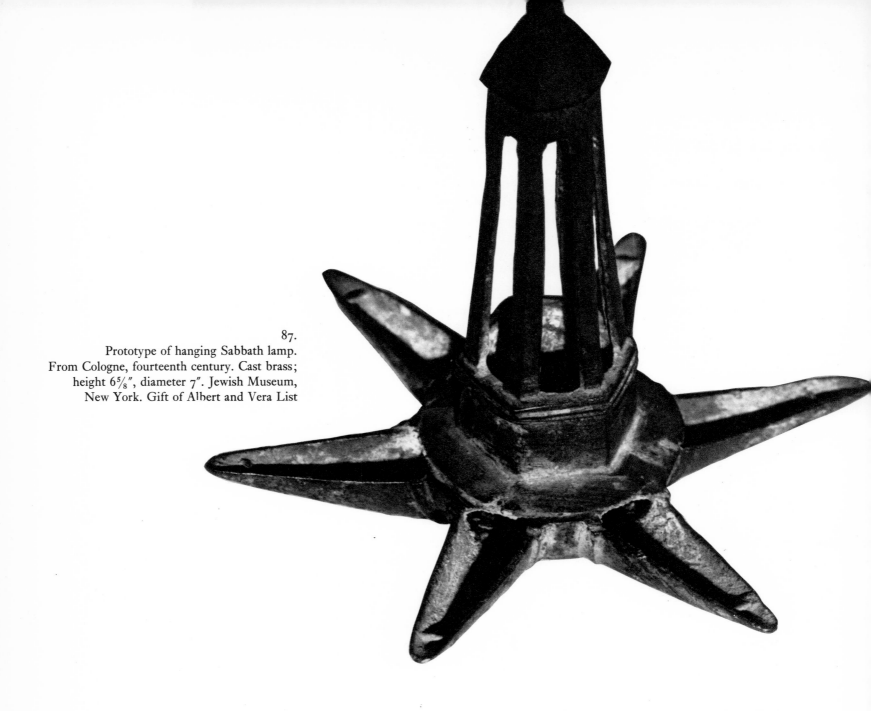

87.
Prototype of hanging Sabbath lamp.
From Cologne, fourteenth century. Cast brass;
height 6⅝″, diameter 7″. Jewish Museum,
New York. Gift of Albert and Vera List

of wine. In his recital, the father repeats the story of the original Sab-
bath and its sanctification by the Almighty (Genesis 2:3). Then follows
the benediction that praises the King of the Universe, who produces
the fruit of the vine, and thanks Him, who has given us the Sabbath
as a memorial of Creation and in remembrance of our deliverance
from Egypt. Father then drinks from the cup and passes it on to the
others at the table so that they may partake. In some parts of the world
brandy is used as a substitute for wine, but the hallah is more generally
blessed when wine is not available. It is of interest that the first
part of the benediction, ending with the words *borei pri hagafen,* is

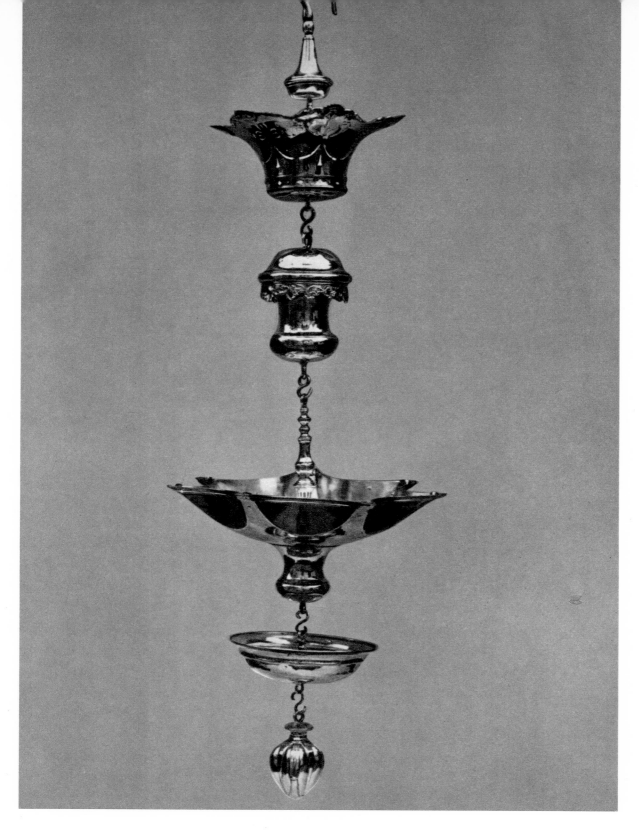

88. Sabbath lamp, by Otto Knoop. From Amsterdam, 1740.
Silver, partly cast; height 34″, diameter 10½″. Typical Sephardic
form, with open shallow container, knop, and crown on top.
Jewish Museum, New York. Harry G. Friedman Collection

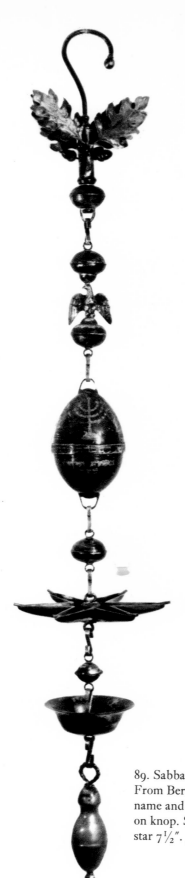

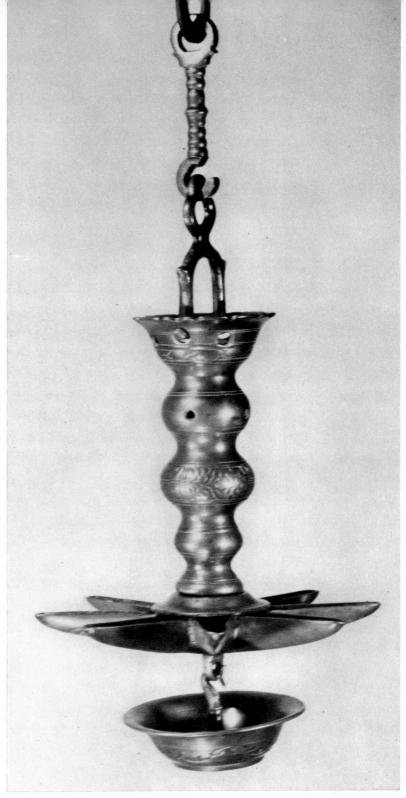

89. Sabbath lamp.
From Berdichev, Ukraine; 1811. Donor's
name and seven-branched menorah engraved
on knop. Silver; length 43″, diameter of
star 7½″. Jewish Museum, New York

90.
Sabbath lamp. Star-shaped, the
typical Ashkenazic form common in Germany
during the seventeenth, eighteenth, and nineteenth
centuries. Brass, length c. 20½″. Jewish
Museum, New York

not specific for the Sabbath but is to be pronounced before drinking wine at any time, while the second part of the benediction, that sanctifying the Sabbath, is specific for the seventh day. After the ceremonial washing of the hands, which may be done at the table perhaps from a special laver, and a benediction over bread which Father pronounces while he slices the hallah, with a special knife, the family begins to eat. The rabbis stressed an atmosphere of good cheer, and nothing is permitted to interfere with the relish of this meal. Sabbath table talk should be elevated and instructive; it is good on this evening to talk about Jewish events, books, and biblical learning. Discussion is the order of the day, but just as "Ye shall kindle no fires throughout your habitations on the Sabbath day, ye shall also kindle no fire of controversy nor the heat of anger." Grace should certainly be featured at the conclusion of this festive meal.[3]

The Sabbath day itself continues in the same vein: synagogue services, benedictions over wine and bread, rest, and study, especially of the Pirke Avot, which today may be enjoyed in several excellent translations. Another old custom, now renewed, is the *oneg Shabbat* ("joy of the Sabbath"), which affords the occasion for amusing, educational, and edifying conversation fortified by tea and cookies. The havdalah ceremony that the Sabbath ends with is performed at twilight.

Since lighting ceremonies highlight both the inauguration and the termination of the Sabbath, a lamp is the most important ceremonial object of that day. Earliest literary mention of a Sabbath lamp is found in writings of the Roman satirist Persius (34–62 C.E.): "But when Herod's day [i.e., the Sabbath] are come, and the lamps, carrying violets, put in the greasy window, emit their unctuous clouds of smoke; and when the tail of a tuna fish floats curled around in a red dish, and a white jar is bulging with wine, you move your lips in silence and turn pale at this Sabbath of the circumcised." The rabbis were quite specific as to the permissible kinds of oil and the acceptable materials for wicks but they were apparently indifferent as to the form of the lamp itself. The earliest lamps were doubtless of the ordinary Mediterranean type: a clay saucer or bowl with, perhaps, a fold or lip in which the wick rested while floating on the oil. These lamps were probably used throughout the week as well as for the Sabbath. From this primitive saucer type there developed an enclosed form with two holes, one for the wick, one for adding oil. These often were decorated with motifs which indicated their Jewish ownership and use (figs. 37, 46). The fold or lip developed into a spout, and thereafter lamps with multiple spouts for an increasing number of wicks were made. Lamps in which the multiple spouts were arranged in a row developed into the bench type of hanukiah. In other lamps the wicks were arranged in a circle at the periphery of a saucer. Eventually the central saucer, covered to keep the oil from spilling, was made of metal (fig. 86). In the Middle Ages it seemed desirable to have a special lamp for Sabbath and festi-

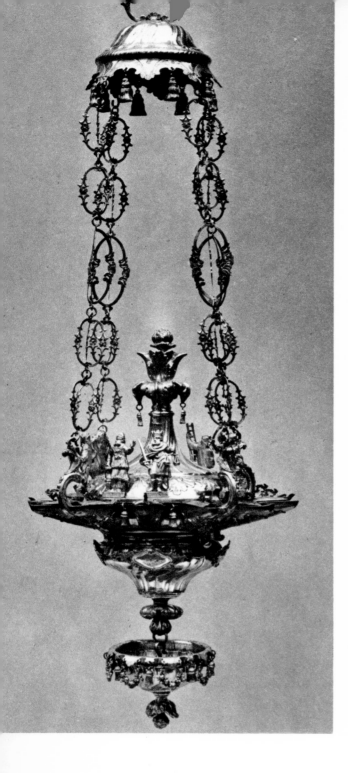

vals; the covered metal lamp with peripheral spouts became the prototype of the hanging lamp (fig. 87), familiar from pictures of Jewish life in that period and in succeeding centuries. It hung close to the ceiling all week and was lowered for the Sabbath.

Despite their essential simplicity, hanging lamps varied considerably in form, according to their place of origin. Those in the Sephardic tradition, which were carried by the exiled Spanish Jews first to Holland and then to England, were usually made with broad shallow spouts (fig. 88). Italian craftsmen deepened the central saucer into a bowl, added a drip pan for excess oil, and hung the lamp by four chains, converging into a top finial (fig. 91). In Eastern Europe the central bowl tended to be small, while the spouts were exaggerated (figs. 89,90); channels were often added to conduct overflow oil to the drip pan (fig. 95). In this type of lamp, especially popular in Germany, and known as the *Judenstern* because of its star shape, the long spouts protect the wicks and ensure a solemn, low-burning light. Some lamps were richly ornamented, often with tiny men carrying symbols of the various Jewish festivals (figs. 91, 91a, 91b). Many were constructed with a central shaft representing a fountain, a reference to the verse "For with Thee is the fountain of life; in Thy light do we see light" (Psalms 36:10; figs. 92, 94, 95). The star expressed the Messianic hope of liberation. Since the Sabbath and festivals are likened to the days of the Messiah, it is singularly appropriate that the special lamp for these days should have been developed into a star form.

Although tallow candles were sanctioned by the rabbis,[4] the use of oil lamps for the Sabbath persisted among Jews until the eighteenth century. An Amsterdam *minhagim* (customs) book of 1717 contains an early record of a hanging lamp. Apparently the use of candles and hanging Sabbath lamps went on side by side; indeed an illustration in a book on Jewish ceremonies published in 1724 in Nuremberg shows a woman blessing a group of three candles although a hanging lamp is nearby (fig. 96). The lamps shown in figs. 93 and 95, both of the *Judenstern* type, are of particular interest because they bridge the gap between the oil lamp and the candlestick: over the oil reservoirs there are holders for candles. It may be that the candles were used for illumination during the week, while both candles and oil were burned on the Sabbath to give the home a doubly festive appearance. Candlesticks had already come to the fore in common use during the seventeenth century, but hanging lamps were still in use for the Sabbath in the mid-nineteenth century, as can be seen from Oppenheim's Sabbath

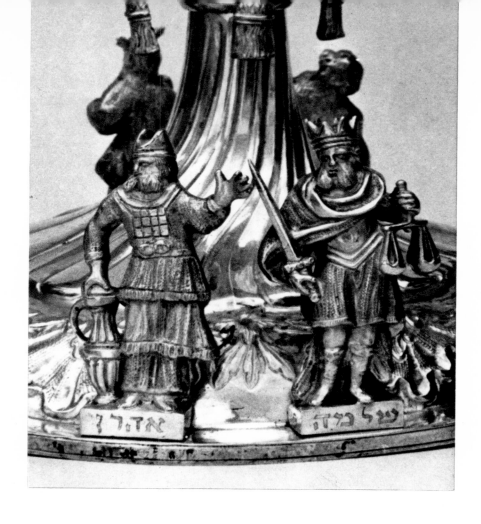

91a. Aaron and Solomon, details
of Sabbath lamp shown in Figure 91

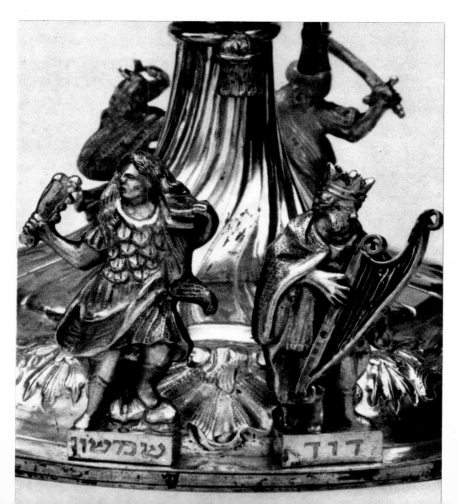

91b.
Samson and David, details of
Sabbath lamp shown in Figure 91

109

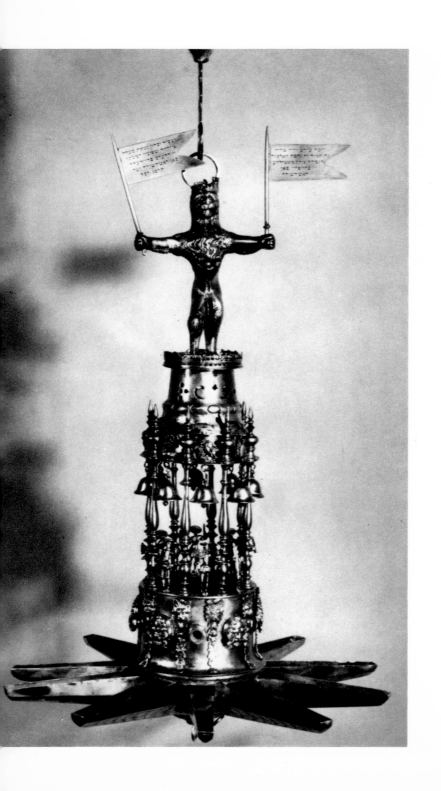

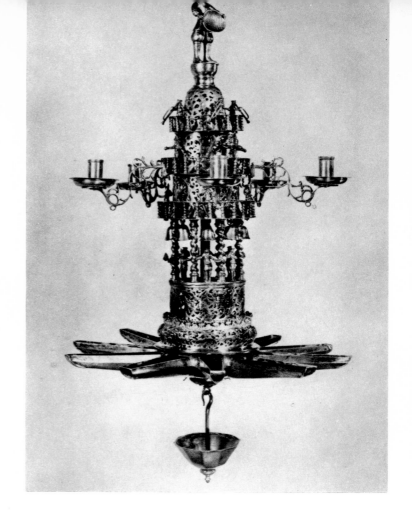

93.
Sabbath lamp, by Johann Adam Boller.
From Frankfurt, late seventeenth century. Silver,
with cast, cut-out, and engraved decoration;
height 30″. The candlesticks are a later
addition. Temple Emanu-El, New York.
Irving Lehman Collection

92. Sabbath lamp. From Frankfurt,
1680. Silver, with cast, cut-out, and engraved
decoration; height 22¼″. Statuettes between
columns hold objects associated with Sabbath
and festivals. Motifs include eagle, stag,
pelican, squirrel; eight bells. Jewish Museum,
New York. Gift of Jewish Cultural
Reconstruction, Inc.

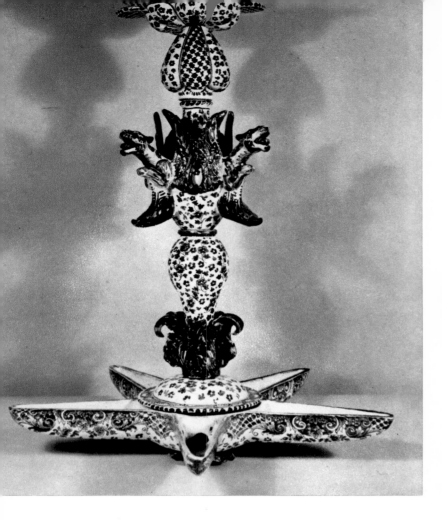

94. Sabbath lamp. From the
Netherlands, seventeenth century. Delft
faience, height 26″. Collection
Mr. and Mrs. Paul Simon, New York

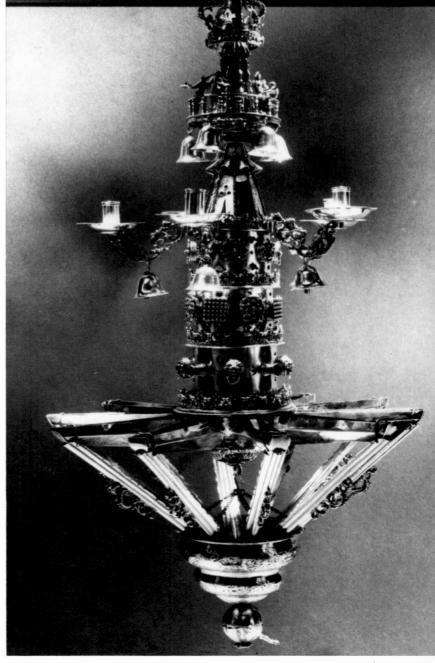

95.
Sabbath lamp, by Johann Adam Boller.
From Frankfurt, seventeenth century. Silver, partly
cast; height 28″, diameter 14″. Central-shaft
"fountain" and channels to conduct excess oil into drip
bowl. Figures on the uppermost balcony hold objects
representing the Sabbath and holidays: spice box and
havdalah candle for the Sabbath, shofar for Rosh
Hashanah, and lulav for Sukkot. Jewish Museum, New York.
Harry G. Friedman Collection

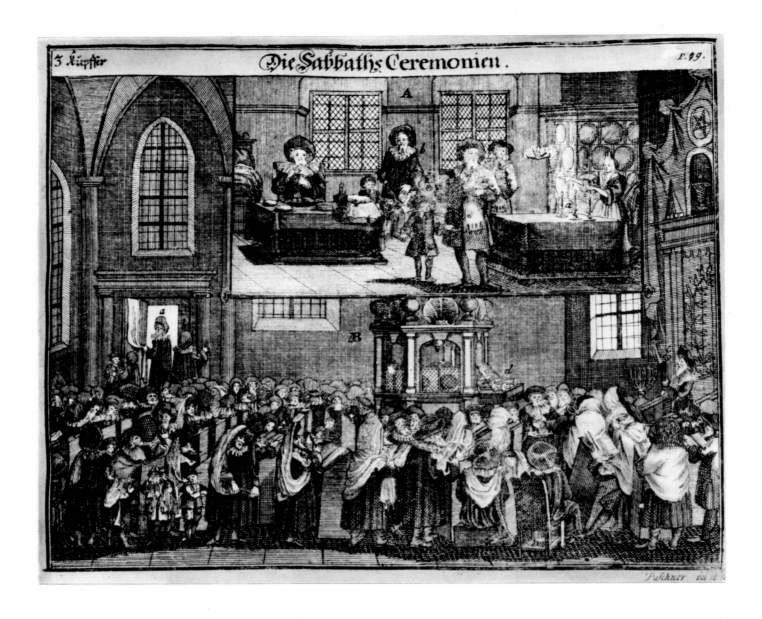

96.
Sabbath eve ceremonies in
German-Jewish home of the eighteenth
century. From Paul Christian Kirchner,
Jüdisches Ceremoniel

scene (fig. 79).[5] Candlesticks used for the Sabbath had the everyday forms of their Dutch, German, or Polish counterparts but were often inscribed with the words "For the Holy Sabbath" or with the Sabbath benediction. Other examples are engraved with the Hebrew names of the owner. Many candlesticks have richly ornamented bases; a pair of eighteenth-century candlesticks from Germany (fig. 97) are decorated with cartouches showing the sacrifice of Isaac, the judgment of Solomon, a woman blessing the Sabbath lights, Jacob's dream, Moses as a shepherd, and Samson and the lion. The shaft is a lion carrying a flower, which terminates in a candleholder. In some communities, particularly in Poland, four- and five-branched candelabra appeared; a wide variety of decorations is found on the stems of these branches: animals, plants, and geometric designs.

On the whole it can be said that candlesticks are preferred in the modern home and the candelabra are more frequent in the synagogue. The domestic candlestick lends itself especially well to the simple structural mood of contemporary design. A pair by Moshe Zabari, part of a Sabbath set, illustrates this trend toward pure functionalism (fig. 98); a similarly functional pair by Ludwig Wolpert nevertheless embodies the idea of Messianic hope in an abstract calligraphic Jacob's ladder, reaching hopefully toward heaven (fig. 99).

Other appurtenances of the Sabbath table also lend themselves to modern design. Moshe Zabari has coordinated into his Sabbath set (fig. 98) a kiddush cup, a bread plate, a knife, a salt cellar, and an alms box, into which Mother deposits a coin before the candle lighting (fig. 100). These pieces are of polished silver in pure functional form, and are distinguished by the elegant calligraphy of their inscription. Ilya Schor introduced a novel idea by designing a table bell specially for Sabbath use as well as a special wine cup for the "woman of valor" (fig. 101). Helen Kramer's Sabbath tablecloth (fig. 85) has already been mentioned. The occasional "Sabbath dish" favored in earlier periods (figs. 81, 102, 103) might well be emulated today.

The ceremony that ends the Sabbath somewhat regretfully notes the separation (Heb. *havdalah*) of Sabbath sanctity from workaday banality. Like the Sabbath eve ceremony, the havdalah is a ritual that has been observed in the home since talmudic times. It begins as soon as three stars have appeared in the evening sky. The head of the house raises his wine cup, pronounces the benediction, sips, and sets it down.

97.
Sabbath candlesticks.
From Germany, eighteenth century.
Silver, height 9″. Cartouches show (left)
the sacrifice of Isaac, the judgment of
Solomon, woman blessing the Sabbath candles;
(right) Jacob's dream, Moses as a shepherd,
Samson and the lion. Jewish Museum,
New York. Harry G. Friedman Collection

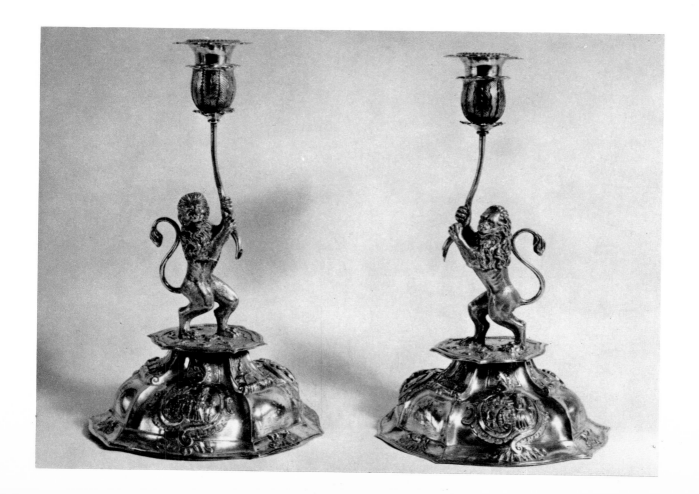

113

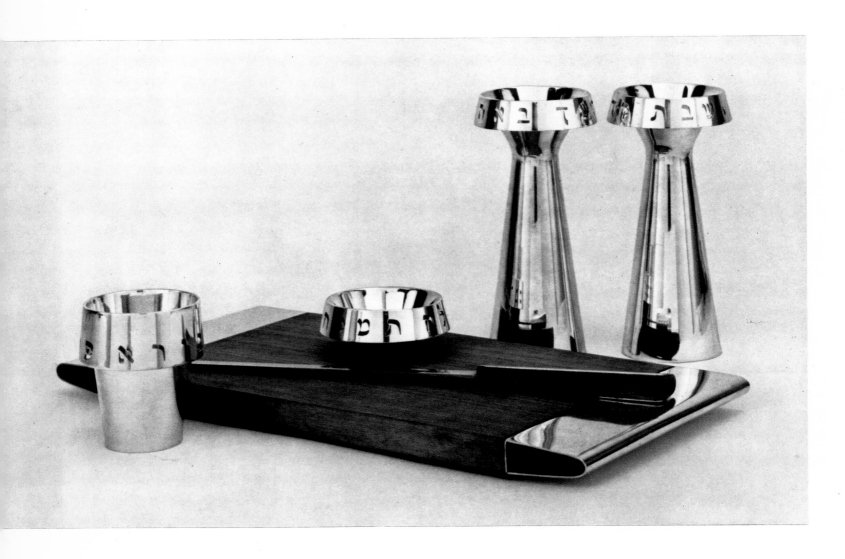

98.
Sabbath set (candlesticks, wine cup, salt cellar,
hallah knife, and hallah tray), by Moshe Zabari. Silver and walnut.
Collection Rabbi Bernard Raskas, St. Paul, Minnesota

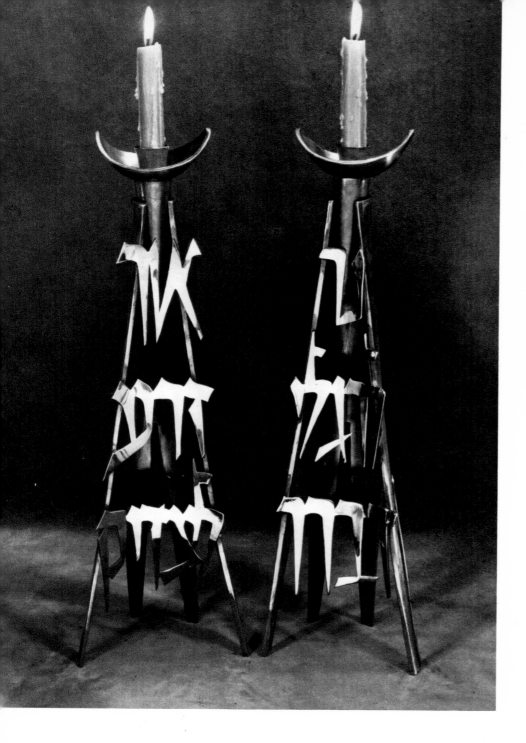

100. Alms box, by Moshe Zabari. Silver, height 6¼″. Inscribed: "With grace, with loving-kindness, and tender mercy." Museum of Modern Art, New York

99.
Sabbath candlesticks, by Ludwig Wolpert
(Tobe Pascher Workshop). Silver, hammered and cut-out;
height 20″. Lettering: "Light is sown for the righteous"
(Psalms 97:11); "A lamp unto my feet" (Psalms 119:105).
Jewish Museum, New York

101.
Sabbath dinner bell and kiddush cup,
by Ilya Schor. Silver. Bell, height 2¾″;
cup, height 4½″. Bell engraved with excerpts
from Psalms; engraved panel of cup (shown
also in Figure 78) shows the blessing
of the Sabbath candles. Collection
Dr. and Mrs. Abram Kanof, New York

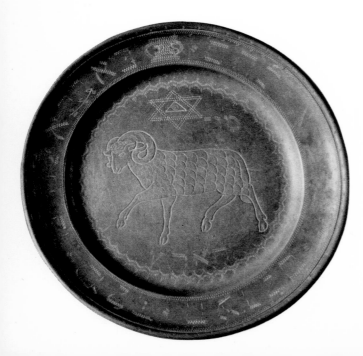

Taking the fragrant spices carefully housed in an appropriate container, he inhales their fragrance and pronounces a prayer of gratitude for the sense of smell. He lights the plaited havdalah candle, and because he is thus in a sense necessarily violating the Sabbath, he looks not at the flame but at its reflection on his fingernails. He then blesses God, who has bestowed upon mankind the lights of fire. Finally, he lifts his wine cup again and comments on the distinction between light and darkness, between the sacred and the secular, between Israel and the nations of the world, and between the day of rest and the days of the week.

The bittersweet quality of the havdalah ceremony has been captured by Isaac Bashevis Singer:

Sabbath night has always had a holiday-like quality in our house, especially in the wintertime. At dusk my father would sit with his congregation at the closing Sabbath meal. The house was unlit. The men sang "The Sons of the Mansion" and other table chants.... my father... now preached to his followers.... He would extol the joys of the pious in heaven, seated on golden chairs with crowns on their heads.... And while my father talked, the first stars came out.... The mysteries of the Torah were one with the mysteries of the world.... Our home at this time was permeated by the spirit of God, of angels,... filled with a special longing and yearning....

And finally the beloved Sabbath was over and a new week began.... lamps were lit, the evening prayers said, and the braided valedictory candle lit. After my father said grace over the wine, the men dipped their fingers in it and daubed their eyes as a charm to insure a prosperous week.[6]

Wine, light, and the fragrance of spices thus combine to mark the end of the Sabbath. In the havdalah the use of wine is modified by local custom and enriched by folklore. If a little of the havdalah wine overflows or is sprinkled onto the tablecloth, a full life is envisaged. If the havdalah candle burns until consumed, the observer will attract a good son-in-law. But a girl must not drink of the ceremonial wine; if she does, the old wives say she will grow a mustache! Some Russian Jews used schnapps instead of wine; part of the unconsumed liquor was poured into a pan and set afire with the havdalah candle. If it burned out completely, good luck was assured. To mystics, the libation of the liquor acted as a sort of offering to placate the envious evil spirits that abound during the Sabbath. As the smoke of the burning liquor ascended, they also saw in it the departing angels that guard the homes of the pious on the Sabbath. Some dipped their fingers into the burning liquor and then into their pockets, assuring themselves well-filled pockets for the week to come. Talmudic legend has it that Elijah when he returns will do so after a havdalah service, as a reward for the strict Sabbath observers.

102. Sabbath plates. From Germany, eighteenth century. Pewter. Middle plate engraved with the havdalah benedictions. Collection Jakob Michael, New York

Some religious rites have their origin in divine command, others are decreed by religious leaders, still others originate in the ancient customs of a people. The recitation of the havdalah benedictions over wine is in obedience to a religious decree, but the use of spices follows an old tradition. It was the custom at festive meals to have a censer of burning incense at the table. Since this was impossible on the Sabbath, owing to the prohibition against the kindling of fire, flowers and pleasant herbs were substituted. From this worldly custom arose the inclusion of fragrant spices in the closing Sabbath ceremony. Since the plural, "spices," is used in the benediction, a multiplicity of fragrances is required; this also increases their potency, so that the aroma of Sabbath sanctity can be prolonged into the workday week. Spices, of course, have their benedictions, as well as wine and lights, for the rabbis attributed to smell a high place in the order of human sensations: "Let everything that has breath praise the Lord; and what is it that only the soul and not the body derives pleasure from?—it is the fragrant odor," says the Shulchan Aruch.

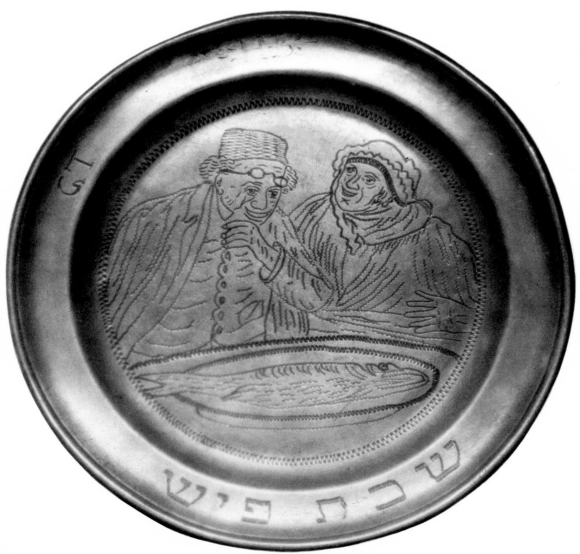

103. Sabbath plate.
From Germany, eighteenth century. Pewter, diameter 8⅜". Engraved after a lithograph by Alphonse Levy, in Léon Cahun, *La Vie juive,* Paris, 1886. Jewish Museum, New York. Harry G. Friedman Collection

117

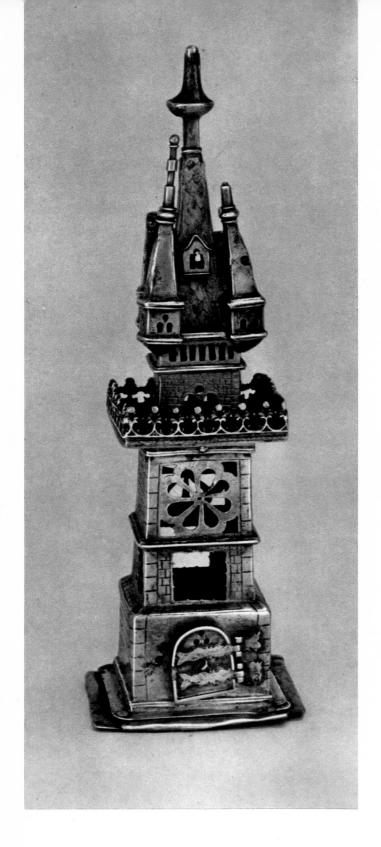

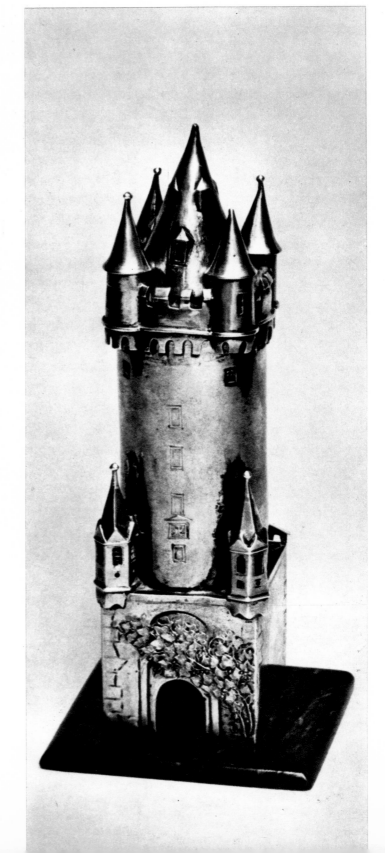

105. Spice container, by Lazarus Posen.
From Frankfurt (modeled on the Eschenheimer Tower
in that city), nineteenth or early twentieth century.
Silver, height 7½″. Jewish Museum, New York.
Harry G. Friedman Collection

104.
Spice container. From Frankfurt
(originally in the synagogue of Friedberg), c. 1550
(restored 1651). Silver, height 9⅜″. Multiple
towers and rose window; parts missing.
Jewish Museum, New York

The appeal to the sense of smell in religious ceremony reaches back to antiquity. The monuments of ancient Egypt frequently picture Pharaoh offering his favorite deity not only food but also elaborate containers of spice. The Greeks described in some detail the offering of specific herbs to the gods. The Romans commonly presented incense to the gods in both public and domestic worship. The Hindu sacred books indicate the use of spices from the remotest times to the present. As for the havdalah, the sophisticated explanation for the use of spices is that it substitutes, in a contemporaneously acceptable manner, for the burnt offerings of animal flesh and fat, perfumed with spices, vegetable oil, frankincense, and musk in the Temple service. While most talmudic references to incense allude to priestly usages, there are passages which suggest that it also acted as a substitute for animal sacrifice before the destruction of the Temple. Among the Yemenite Jews the use of incense in religious ceremony has survived to recent times, and, at least until they migrated to Israel, incense was used by them in marriage ceremonies, at the birth of a baby, and during the period of mourning.

The invocation over the rekindling of the fire is the most dramatic part of the havdalah ceremony. It recalls the Hebrew word for light, *esh,* which indicates elemental fire. The havdalah benediction for the candle light reads *borei moreh ha'esh,* expressing thankfulness for the creation of the lights (plural) of fire, rather than *l'hadlik ner,* the usual form on other occasions. In this way the Jew, after a fireless day, starts the new week with thankfulness for the domestication of fearsome fire.

There is a legend that the light created on the first day illumined the world until the first sunset. Then came darkness and fear. God saw man's fright and gave him the wisdom to produce fire by rubbing two sticks together, whereupon Adam pronounced the first havdalah benediction. There is a discussion in the Talmud as to whether one has to rekindle the new fire each week by this same primitive method. The rabbis commented that since God began the first week with the creation of light it is natural for us to commence each week with a prayer of thankfulness for the beneficence.

It was in some places the custom in examining the reflection of the havdalah light in the fingernails to seek good omens for health in their color. Such a superstition had no talmudic sanction; in fact there was much rabbinic opposition, since practitioners of divination were wont to fix their gaze on a bright, shiny object, such as a sword, or a mirror, or the shiny surface of an animal's liver—or, indeed, upon the fingernails.

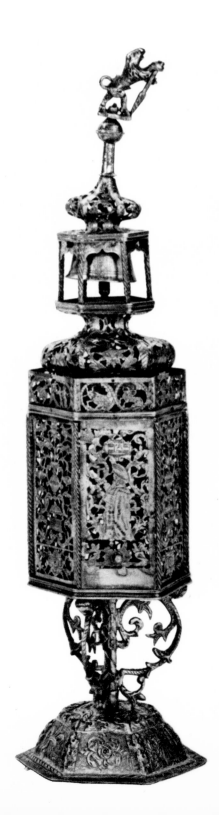

106.
Spice container. From Eastern Europe, eighteenth century. Silver, with engraving and openwork; height 12″. Decoration includes figures of men holding spices, lights, and wine (each inscribed with the appropriate blessing), signs of the zodiac, the tree of life, and various plants and animals. Jewish Museum, New York. Harry G. Friedman Collection

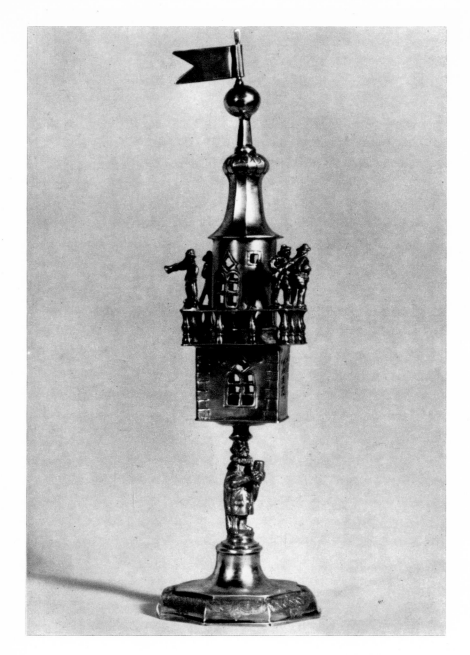

107. Spice container. From Germany, c. 1710. Silver, with embossed, cut-out; and cast ornaments; height 11″. Tower form rests on the head of a figure of a man holding a cup; soldiers and flag on turret. Jewish Museum, New York. Gift of Jewish Cultural Reconstruction, Inc.

The triple ceremony of wine, herbs, and candle has given rise to a large, interesting, and history-laden family of ceremonial objects. The twisted candle is "plural" not only to accord with the plural form in the benediction but also to give the appearance of a torch. According to the Shulchan Aruch, "It is mandatory that the light for havdalah should be made of wax and consist of several strands twisted together like a torch." According to some authorities, the havdalah candle was held in the hand because it is not allowed to burn out but is extinguished after the ceremony. It seems that originally the spice was also held in the hand and not kept in a container: the Talmud tells of an aged man, with two bundles of myrtle in his hand, preparing to mark the close

Colorplate 9.
Spice container. From Rome (?), c. 1750.
Silver and silver gilt, set with coral beads.
Collection Jakob Michael, New York

of filigree come from Hungary and the Venetian Republic; often these have designs recalling the tree of life. Special mention should be made of the French and Italian filigree containers with biblical scenes in colorful enamel miniatures (colorplate 7).

Sometimes spice box and candle holder are combined in a unit (figs. 111, 112). Perhaps the finest example of this type is constructed on three levels: a bell-shaped base supports a square compartment with a four-part drawer for the spices; rising from this compartment are four vertical rods on which rests a platform for the candle, so designed that it can be elevated between the rods as the candle grows shorter with weekly use. There are also combination spice boxes and wine cups; in one such piece, the handle of the cup's cover acts as a container for the spices.

In a modern havdalah set by Ludwig Wolpert the spice container is pear-shaped, set on a conical base; it is perforated by slots that are opened with a twist of the stem when the havdalah service begins. The conical bases of the wine cup and candle holder are decorated with cut-out Hebrew letters spelling words of the havdalah benedictions

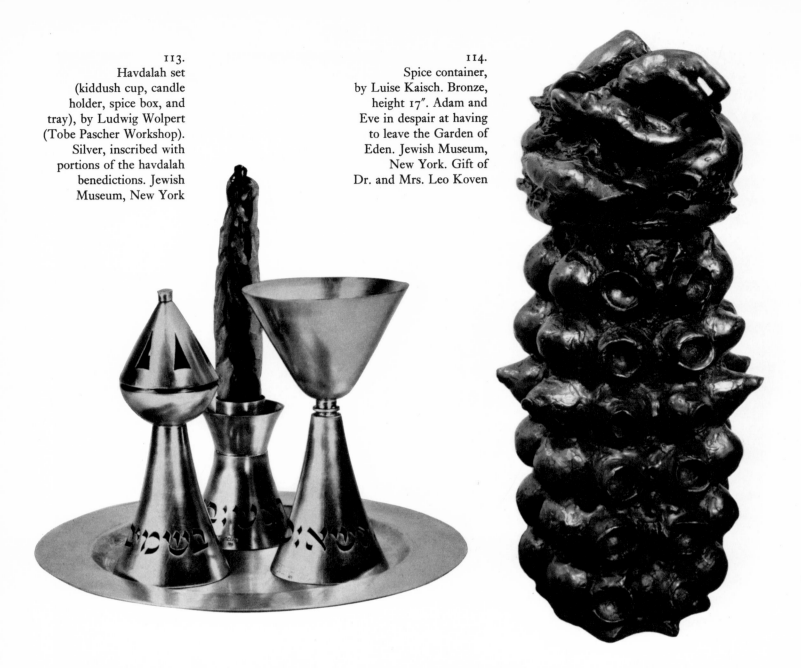

113.
Havdalah set (kiddush cup, candle holder, spice box, and tray), by Ludwig Wolpert (Tobe Pascher Workshop). Silver, inscribed with portions of the havdalah benedictions. Jewish Museum, New York

114.
Spice container, by Luise Kaisch. Bronze, height 17″. Adam and Eve in despair at having to leave the Garden of Eden. Jewish Museum, New York. Gift of Dr. and Mrs. Leo Koven

(fig. 113). An entirely original piece by Luise Kaisch (fig. 114) takes its decorative theme from the talmudic legend that Adam and Eve, banished from the Garden of Eden, requested one favor, that they might take with them the scent of holiness; standing on the cylinder-shaped container are the first couple, anguished in departure but savoring the odor of the herbs. Another contemporary spice box, by Moshe Zabari, is a gently tapered column of silver. The Hebrew word *bsamim* is cut out of the top, and when the piece is lifted during the ceremony the letters drop, leaving a space through which the scent is wafted (fig. 115).

115. Spice container, by Moshe Zabari.
When the cylinder is lifted, the elevated letters of the word *bsamim* drop, leaving an opening to release the scent of the spices. Silver, height 3½″. Spertus Museum of Judaica, College of Jewish Studies, Chicago

may have developed into the Hebrew custom of marking with a banquet the Temple sacrifice offered as thanksgiving. Occasions for religious banquets *(se'udot shel mitzvah)* are enumerated in the Talmud. Betrothal and wedding; circumcision; pidyon haben (redemption of the first-born) and bar mitzvah; the *siyum,* marking the completion of a talmudic treatise; the Sabbath and holy days; festivals of joy and thanksgiving such as Hanukah; and the comforting of mourners—all these are heartily approved by the Talmud as worthy of a "meal of the commandment." A high plane of grateful piety is reached at Sabbath and holiday meals, but no feast in Jewish life exceeds the ceremonial elegance, the culinary splendor, the expansive loquacity, and the hearty nationalism of the seder, the festive meal commemorating the Exodus from Egypt (fig. 116).

The use of the word *seder,* meaning "order," derives from the strict sequence of ritual observed in the course of the Passover evening. biblical injunctions (Exodus 12:14, 24; Deuteronomy 16) command that every generation in turn consider itself similarly rescued from slavery and be grateful accordingly. While the Temple stood, the literal injunctions were followed: the paschal lamb was sacrificed, its blood was spattered with a hyssop branch over the doorposts (Exodus 12:12), and its flesh was eaten hurriedly by the master of the house as if poised for the Exodus. Since the paschal sacrifice had to take place in Jerusalem, it was usually the male members of the family who "went up" to the Holy City, so that the seder as a family affair was practicable only for those who lived there. After the destruction of Jerusalem the seder became a universal home celebration among Jews. In time, the sacrificial lamb came to be represented by a roasted shankbone, but the biblical injunction (Exodus 13:8) "And you shall explain to your son on that day. . ." gained ascendancy as the outstanding feature of the evening. As a result of the Exile the festival took on messianic overtones expressing all the hopes and yearnings for a return to the Holy Land.

The didactic aim of the seder is carried out by the recitation of a traditional text retelling the story of the Exodus—the Haggadah—and by the demonstration of objects that serve to fix the events of that story in the memory. The vessels and appurtenances used in the seder have certain characteristics in common with other Jewish ceremonial objects. In the first place, they are intended primarily for domestic use. Secondly, most of them have an everyday as well as a holiday function. Thus the dishes and wine cups have no unique or special form; only their elaborateness, their formalized decorative motifs, and their inscriptions mark them as objects intended for religious use. Thirdly, while the objects used in the Passover ritual are essential for the proper celebration of the holiday, they are not described in scriptural sources. The craftsman, then, enjoys a freedom in regard to form limited only by the functional needs of the object.

117.
Illustration from *Passover Seder Service,* Munich Enclave
(Munich, April 15–16, 1946). The seder was held in the Deutsches
Theatre Restaurant, Chaplain Abraham J. Klausner conducting.
Legend: "For not one man only has risen up against us to destroy
us." Collection Dr. and Mrs. Abram Kanof, New York

The word *haggadah* means "narration." The motivation for telling the story is the answering of four questions, usually asked by the youngest participant in the seder. The replies to these questions, and a variety of commentary, take up most of the evening, with a midway interval for the festive meal. Interspersed throughout the story are references to the hopes of redemption to come.

The earliest reference to the Haggadah occurs in the Mishna, which places its origin in the early years of the Dispersion. Its contents and arrangement have hardly changed since. Until about the thirteenth century, the Haggadah was usually bound together with other manuscripts. However, the need for its use by a large group of people reciting from it simultaneously prompted its treatment as a separate work. Of the approximately 150 medieval manuscript Haggadot still extant, the most important are two Spanish codices of the fourteenth century—the Sarajevo Haggadah, mentioned earlier, and the Crawford Haggadah, in the John Rylands Library in Manchester—and the Darmstadt Haggadah, of the fifteenth century, now in the Darmstadt Landes-Bibliothek, the first medieval edition to be reproduced in full-color facsimile.

The first printed Haggadah was issued in 1482 in Guadalajara, Spain; the single remaining copy is now in the Schocken Collection of the library of the Hebrew University, in Jerusalem. The earliest printed and illustrated Haggadah is thought to have been produced in Turkey; the few surviving fragments are in the library of the Jewish Theological Seminary of America, in New York. Italy, however, was the most prolific source of printed Hebrew Haggadot, the earliest being produced by Joshua Solomon Soncino in 1486. The Italians first furnished ready-made wood-block prints to which handwritten texts could be added. It was then an easy transition to the production of a book whose text and illustrations were printed in one process. The earliest printed and illustrated Haggadah that survives *in toto* was published by Gershon Cohen in Prague (1526). Thirty years later a Haggadah was produced in Mantua by the Christian printer Rufinelli, who borrowed generously from Gershon Cohen, reproducing both the well-known series of pictures illustrating the ten plagues and the small pictures depicting the complete preparations for the seder. Subsequently, Moses Parenzo of Venice published three editions of Rufinelli's version, translating the Haggadah, for the first time, into the vernacular of the German, Spanish, and Italian Jewish communities. In 1695 the House of Prutes, influential printers in Amsterdam, produced a Haggadah illustrated in the new technique of steel engraving by Abram ben Jacob, a convert to Judaism. His illustrations, which became the prototype of countless imitations, were copied partly from Parenzo's Venice issue and partly from an illustrated Bible published in Germany and in Amsterdam by Matthew Meriani. Thus the traditional illustrations that have appeared in numerous Haggadot all over

the world were pirated in Amsterdam by Abram ben Jacob from Gershon Cohen's unknown artist in Prague and a Christian Bible published in Germany.

The dominant theme in Haggadah illustrations is naturally the miraculous events surrounding the Exodus. The incident of the five zealous rabbis conversing about the Exodus all night in B'nai Brak is also a popular subject, as is the parable of the four sons. The punishment of the Egyptians with the ten plagues, the details of the preparation for the feast and the ceremonials attending it, various episodes in early Hebrew history, and finally the song *Had Gadya* ("The Kid") are all traditionally subjects for illustration. A motif such as the hare being chased, which appears in some of the German illustrations, is difficult to explain.[2] In many Haggadot the coming redemption is depicted in the person of the Messiah, riding on a white donkey through the gates of Jerusalem, heralded by Elijah and followed by columns of returning exiles. The idea of redemption is symbolized in other versions by a picture of the Temple restored or a map of Israel. Nine editions contain such a map; one of these, by Abram ben Jacob, is the first map of Israel we have bearing Hebrew letters.

Modern Haggadah illustration has been influenced by recent Jewish history and by the increasing use of photographs in bookmaking. In Haggadot from Palestine and from the State of Israel, photographs of the land and its people are often seen. The passages in which God is praised for the good land He has given His people are often illustrated with photographs of verdant Israeli landscapes. A number of Haggadot, some quite crude, remind us of the Nazi terror: one of the most poignant is a mimeographed booklet produced in 1937 by a group of German-Jewish boys who had been rescued from concentration camps

118.
Covers of two mimeographed Passover Haggadot, prepared by American troops during the Korean War. Collection Dr. and Mrs. Abram Kanof, New York

and were preparing to migrate to Palestine.[3] At least two were produced
for French Jews imprisoned during the Vichy regime, and there are
a number printed by the prisoners themselves, some dedicated to the
memories of relatives and friends murdered by the Nazis. A picture of
the German terrorists is sometimes used to illustrate the prophetic
passage "For not one man only has risen up against us to destroy us"
(fig. 117). A sizable group of Haggadot has been produced by, or for,
Jewish soldiers in the armies of the world. The National Jewish
Welfare Board has a good collection of Haggadot for the military. Most
of these were published by welfare groups, but some were produced by
the men themselves, often at the front lines. There is a fine Casablanca
Haggadah dated 1943 intended for American Jews in the European
theater; soldiers in the Pacific area produced one in Melbourne,
Australia, in 1945. During the Korean War, our soldiers produced their
own separate versions (fig. 118). There are many Haggadot published
for the army of the State of Israel; of particular interest is the "Uni-
form Version," designed for use by all members of its armed forces.
Since the army of Israel is made up of Jews from all over the world,
this Haggadah takes on a new, unifying function.

The early Zionist and Socialist settlers in the kibbutzim modified
the Haggadah text to conform to their ideologies. For example, they

119. Covers and selected
pages of kibbutz Haggadot. From Israel.
Collection Dr. and Mrs. Abram Kanof,
New York

133

eliminated the passage beginning "Pour out thy wrath on the nations" because it violated the principles of liberalism and fraternity that, they held, had at last, in the nineteenth century, triumphed. Later, as their optimism faded, they reinstated the passage and added to the traditional four questions the bitter query "Why is Israel hated more than any other people?" But the rise of the State has stimulated a whole new trend. The Haggadot of the various kibbutzim (fig. 119) are especially diverse; while they all basically celebrate the Passover as such, they range in treatment from extreme Orthodoxy to a view of the holiday as a purely civil affair. For the American home two contemporary editions are especially suitable. In one—issued by the Hebrew Publishing Company—the translation by Maurice Samuel is exceptionally good, while the introduction by Rabbi Louis Finkelstein is lucid and absorbing. Another, translated by Morris Silverman, and published by the Prayer Book Press, has a clear text with concise explanations and pleasant illustrations. Two recent popularly priced reprints are worth mentioning. The Sarajevo Haggadah, with the magnificent original illustrations reproduced in full color, follows the Spanish custom of keeping all the illustrations together at the beginning of the book. The other, a beautifully illustrated work by Ben Shahn—available in a trade edition—is the most recent in a long and venerable series of fine Haggadot. Each of these volumes has an excellent introduction by Cecil Roth, master interpreter of this ancient story. A more expensive facsimile edition, in collotype, has recently been issued in Israel. This is the "Bird's Head" Haggadah, in which the artist illustrated the story of the Egyptian enslavement, the Exodus, and the details of the Passover ritual with figures having bird heads instead of human heads, in order not to contravene the traditional injunction against representing the human figure.

The two largest Haggadah collections are in the library of the Hebrew University, in Jerusalem, and the library of the Jewish Theological Seminary of America, in New York. The first bibliography was compiled in 1902 by Samuel Wiener, librarian of the Friedland collection in the Asiatic Museum of the Russian Academy of Sciences, in St. Petersburg. A shorter bibliography, based on the collection of the Jewish Theological Seminary of America, in New York, was drawn up by Abraham Duker in 1930. The latest and most complete list contains 2,713 items; it was compiled by Abraham Yaari and published in Jerusalem.

In order to dramatize his answer to the four questions, the seder leader will have occasion to point to three items: unleavened bread (matzoh), bitter herbs (moror), and a roasted lamb shank (pesah). The matzot recall the frenzied preparations for departure. The bitter herbs serve to remind us of the bitter slavery our ancestors endured. The lamb shank represents the ancient paschal lamb whose blood was sprinkled on the doorposts of Israelite homes before the Exodus. In

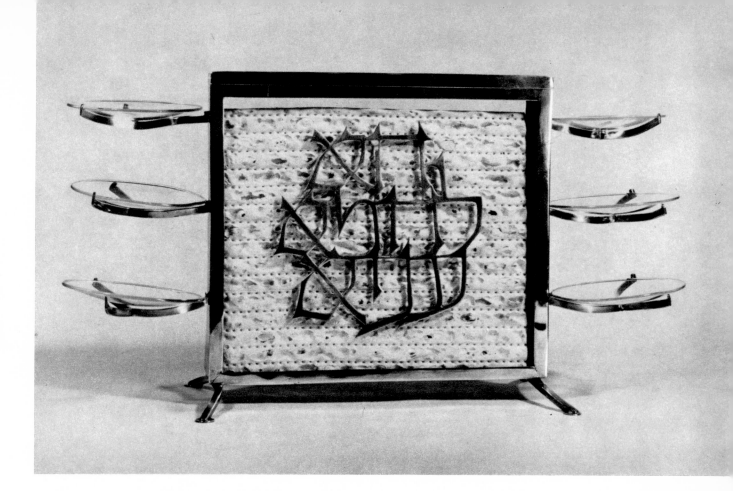

122.
Seder plate,
by Moshe Zabari
(Tobe Pascher Workshop).
Silver, glass, and
lucite; height 7½″,
width 14″. Jewish
Museum, New York

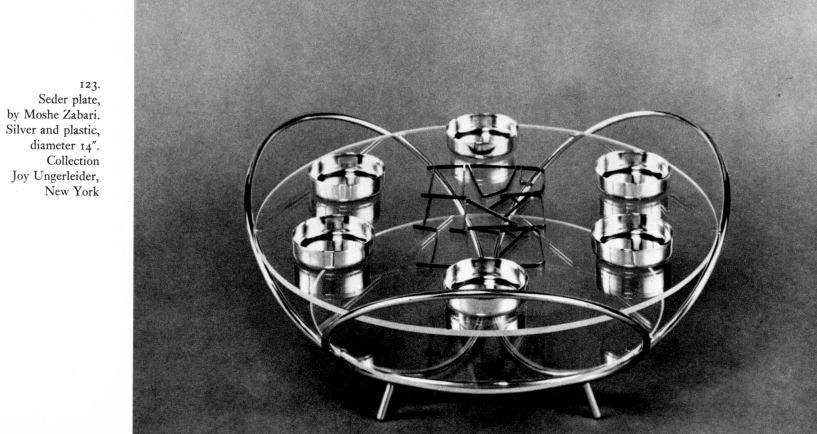

123.
Seder plate,
by Moshe Zabari.
Silver and plastic,
diameter 14″.
Collection
Joy Ungerleider,
New York

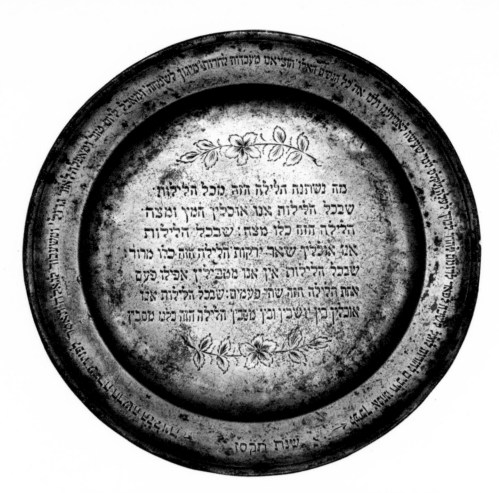

124.
Seder plate. From Germany, eighteenth century. Pewter. Inscribed with the *Ma nishtana* ("Why is this night different. . . ?"); flower decoration. Collection Jakob Michael, New York

The middle matzoh is broken at the outset of the seder and secreted behind the pillow against which, on this occasion, the father leans in lordly ease. Called the afikomen, it is eaten only at the conclusion of the meal. But since the seder cannot be properly terminated without the entire family eating a piece, Father must offer a prize for the return of the afikomen, the hiding place of which the children of the household do not—traditionally—know. It is a common witticism to say, "Eating afikomen for many years results in long life," or when a man dies at an advanced age to say, "He ate too much afikomen." A piece of afikomen used to be preserved in every Jewish house from year to year; in Eastern countries it was supposed to guard against the evil eye. An interesting use for the afikomen was made by the Jews of Russia and Poland, in accordance with a rabbinic enactment—called *erub hatserot* (lit. "blending of courtyards")—designed to ease the Sabbath restrictions and thus promote its observance. Since travel and the carrying of objects outside the house was prohibited during the Sabbath, they would hang a dish containing a piece of afikomen from the center of the roof of an enclosed courtyard. This transformed all the houses opening on the court into a common domain, in which it was then permissible to carry things about freely.

The matzoh, symbol of urgency, has enjoyed a unique history. It was throughout the East, and still is, a type of bread prepared hastily for unexpected visitors. When the three angels came to predict the birth of a son to Abraham, he instructed Sarah: "Quick, three measures of choice flour! Knead and make cakes!" (Genesis 18:6). Later, when the angels visited Lot in Sodom, he too offered them food: "He prepared a feast for them and baked unleavened bread, and they ate" (Genesis 19:3). The woman, or witch, of En-dor, when Saul visited her, "took flour, and kneaded it, and did bake unleavened bread thereof" (I Samuel 28:24).

In olden times matzot for the seder were baked with highly decorative patterns instead of the straight lines of perforation we know today. An elaborate design illustrated in a manuscript Haggadah in the Bodleian Library at Oxford shows series of twisted chains, symbolizing the Egyptian bondage. Sometimes the three matzot used at the seder were inscribed "Kohen, Levite, and Israelite," the ancient designations of the three divisions of the Jewish people, or with a simple *aleph, beth, gimel,* the first three letters of the Hebrew alphabet (and the first three numerals). In the Middle Ages matzot were almost an inch thick, and usually round, to conform to the biblical term *uggot matzot,* which means "circles of unleavened bread." Until the 1850s all matzot were, except in the large urban centers, baked by hand. Each householder baked his own, in the local bakery or even

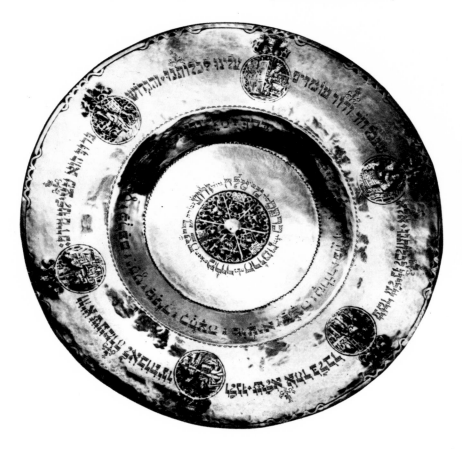

125.
Seder plate, by Ilya Schor.
Silver, with hammered and cut-out decoration; diameter 17″. Scenes of preparation for the seder; inscribed with the order of the seder, names of objects to be put on the plate, and passages from the Haggadah. Collection Dr. and Mrs. Abram Kanof, New York

139

in the synagogue, arriving with his family before dawn on the allotted day to participate in the mitzvah (figs. 127, 128).

The first machine for making matzot was invented in 1857 in Austria. The machine kneaded the dough and spread it between two metal rollers which shaped it into round, thin, perforated disks. This machine left unused particles, which bakers were sometimes tempted to use despite the possibility that leavening might have occurred, owing to the presence in the air of natural, "wild" yeasts; later machines produced square matzot and no leftovers. Many rabbis prohibited the use of machine-made matzot, arguing that this "automation" kept the poor—who usually were employed as matzoh bakers—from earning the money to meet their Passover needs. Advocates of the machine pointed out that the printing of prayer books put many pious scribes out of work, yet no one thought of forgoing the use of printed books on that account. Until the middle of the nineteenth century matzoh baking in larger cities was carried out under the supervision of the sexton in the synagogue; the matzot were then sold by the congregation, which always set aside a quantity for free distribution to the poor.

The seder plate, as we have noted, dominates the seder table, along with the wine cup for kiddush and a special cup for the Prophet Elijah. Most generally used are open plates, on which the three matzot and the symbolic food are placed. These plates have been made of practi-

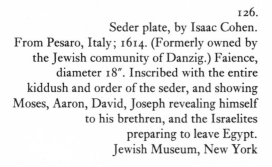

126.
Seder plate, by Isaac Cohen. From Pesaro, Italy; 1614. (Formerly owned by the Jewish community of Danzig.) Faience, diameter 18″. Inscribed with the entire kiddush and order of the seder, and showing Moses, Aaron, David, Joseph revealing himself to his brethren, and the Israelites preparing to leave Egypt. Jewish Museum, New York

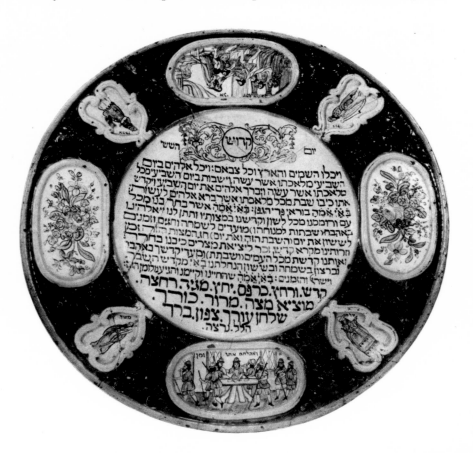

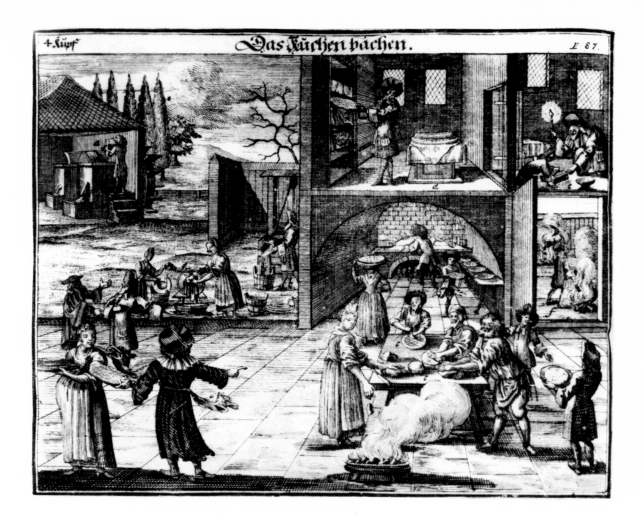

cally every material: wood, copper, brass, pewter, silver, porcelain, faience, stoneware, glass, and plastics. Pewter was especially popular because it could be polished to gleam like silver, yet was much cheaper; furthermore, it is a relatively soft metal, and folk craftsmen could, by scratching or engraving their own designs on the commercially available pewter plates, convert them into seder plates (figs. 129–133).

Favorite themes or motifs for the decoration of the seder plate depict the Exodus and illustrate other narratives related in the Haggadah, especially the story of the five sages studying all night at the seder table in B'nai Brak, the parable of the four sons, and the tale of *Had Gadya*. Common also are representations of the symbolic foods, of biblical characters, of the signs of the zodiac, of eagles, lions, and stags, and of either the messianic five-pointed star or the crossed triangles of the Shield of David.

Landsberger, among others, has emphasized the decorative possibilities of the Hebrew alphabet.[4] Actually this appreciation goes back into the past, as can be seen from the frequency with which the seder plate was so beautified (figs. 124–126, 129–133). The favorite inscrip-

127. Preparations for Passover: cleaning the kitchen utensils, gathering and burning crumbs of unleavened food, baking matzot. From Paul Christian Kirchner, *Jüdisches Ceremoniel*

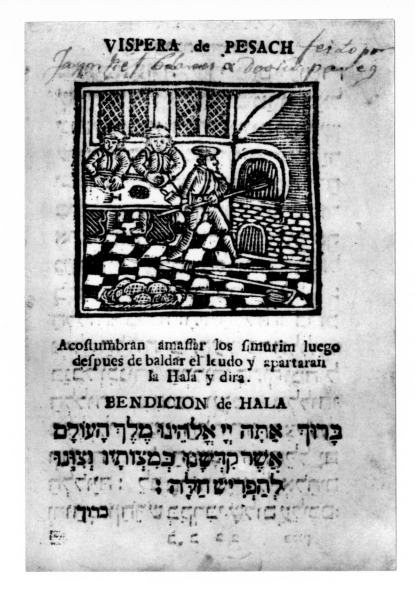

128.
Preparations for Passover.
From the 1768 *sefer minhagim* (book of customs)
by Shlomo Maduro, *Ma'aseh Bereshit*

tion, usually placed in the center, is the kiddush. Various other inscriptions are found: a passage from the Haggadah, most frequently the opening words, *Ha lachmah ania* ("Behold the bread of affliction"); a well-loved psalm; the grace after meals; the order of the seder. Occasionally the owner's monogram or "coat of arms" is found inscribed on a seder plate.

Decoration in relief, hammered or cast, is not seen on seder plates before the nineteenth century, and then generally on silver plates; most of these are from Italy and Germany. The Italian silver seder plates come chiefly from Venice and Padua and are in the Baroque style. The German examples are usually modeled on the Italian.

Of ceramic plates, the most important originated in Italian workshops of faience. There are fourteen such plates known, all dark brown decorated with colored pictures. The center is white, with black inscriptions, and the rim depicts the Passover story in relief (fig. 126).

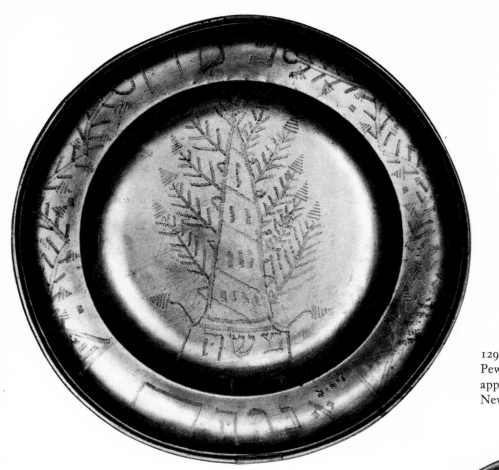

129. Seder plate. From Germany, 1682.
Pewter, diameter 15¼″. Tree of life, with
appropriate inscription. Jewish Museum,
New York. Harry G. Friedman Collection

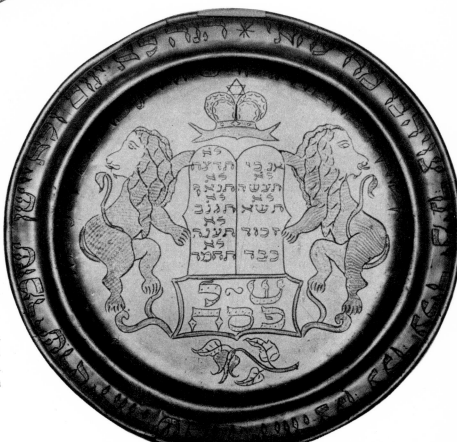

130.
Seder plate. From Germany, eighteenth century.
Pewter, diameter 12½″. Jewish Museum, New York.
Harry G. Friedman Collection

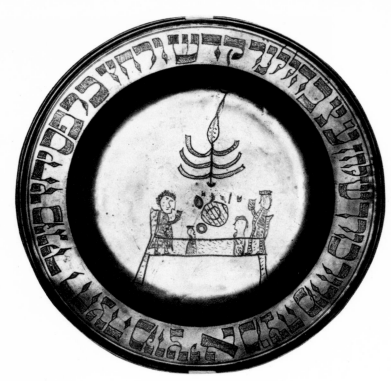

131.
Seder plate. From Germany,
1704. Pewter. Jewish Museum,
New York

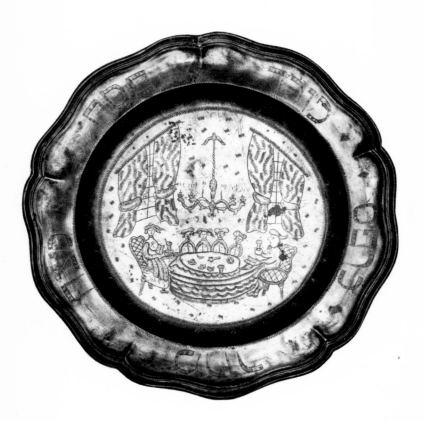

132. Seder plate. From Germany,
eighteenth century. Pewter, engraved: pesah,
matzoh, maror, karpas (the four elements pointed
out during the recitation of the Haggadah).
Jewish Museum, New York

133.
Seder plate. From Western Europe, eighteenth
century. Pewter, diameter 13½″. In the upper
section: (right) hands raised in the priestly
blessing; (left) a Kohen having his hands washed
by a Levite. In the arcades: (right) a man holding
a knife and a lamb (paschal sacrifice); (center)
a man holding a matzoh; (left) a man holding
bitter herbs. Jewish Museum, New York.
Harry G. Friedman Collection

144

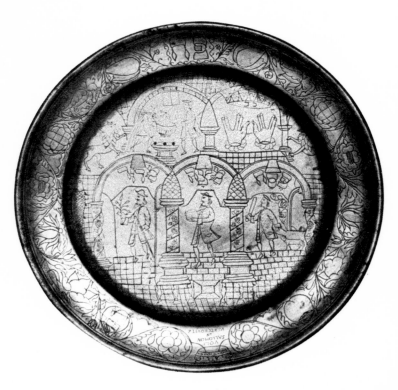

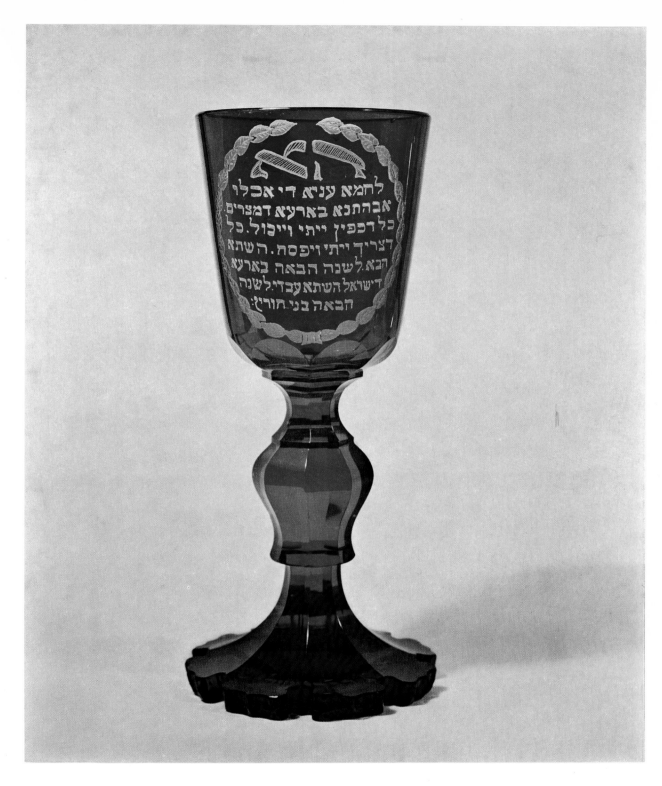

Colorplate 12. Elijah cup. From Bohemia, mid-nineteenth century.
Ruby glass, engraved; height 8⅜″, diameter 3¼″. Inscriptions include
the entire opening passage of the Haggadah, *Ha lachmah ania*
("Behold the bread of affliction"). Jewish Museum, New York.
Harry G. Friedman Collection

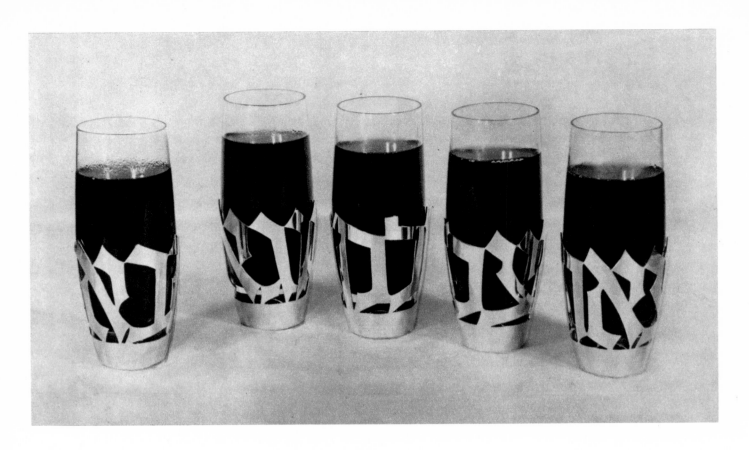

134.
Set of wine cups for the seder,
by Ludwig Wolpert (Tobe Pascher Workshop).
Silver, cut-out, and glass;
height 5¼″, diameter 2¾″.
Jewish Museum, New York

The first "modern" seder plate, made of modern materials, is described by Karl Schwarz in the catalogue of an exhibit organized by the Jewish Community of Berlin in 1931. It was the work of Ludwig Wolpert. A silver frame supports three glass partitions for the three ceremonial matzot; in addition, accommodation for moror, haroset, the roasted egg, and the lamb shank is provided in glass dishes that rest on top of the upper partition (fig. 120). This was the first of a series of such pieces created by this artist. A similar plate, square in shape, is designed to accommodate the squared matzot on partitions of transparent plastic (figs. 121, 122). In a more flamboyant construction, three round shelves for the three ceremonial matzot rest on three intersecting arched rods of silver (fig. 123).

Kiddush cups designed especially for the seder are not numerous. An exceptional beauty is a ruby-glass goblet engraved with the *Ha lachmah* (colorplate 12). In an unusual set of five wine cups (fig. 134) each glass cup is inset into a silver framework formed by one of the five phrases that the Haggadah uses to relate God's intervention in behalf of His people: *V'hotzianu* ("He brought us out"), *V'lakahti* ("I took you"), *V'gamalti* ("I redeemed you"), *V'hitzalti* ("I rescued you"), and *V'hereti* ("I brought you out").

The most splendid of all cups is reserved for the Prophet Elijah, who will herald the coming of the Messiah and, with him, redemption.

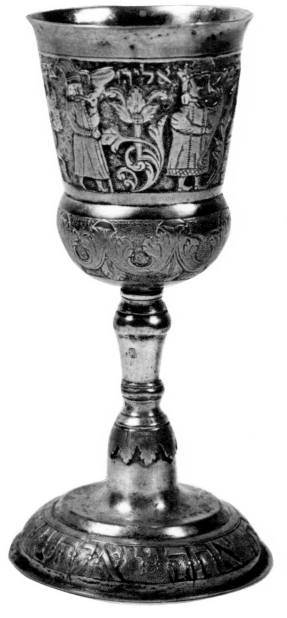

135. Elijah goblet. From Poland,
eighteenth century. Silver, repoussé; height 7″.
Jewish Museum, New York

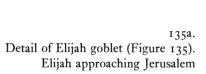

135a.
Detail of Elijah goblet (Figure 135).
Elijah approaching Jerusalem

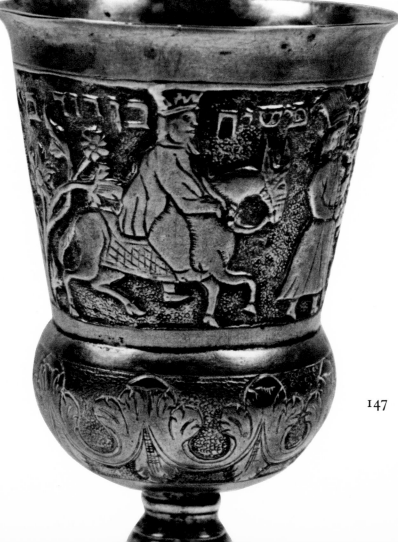

147

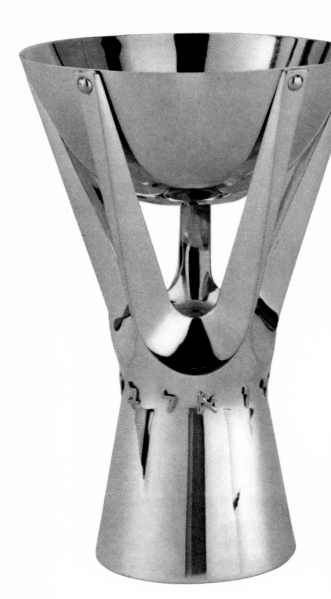

136. Elijah cup, by Moshe Zabari
(Tobe Pascher Workshop). Silver and gold, height 6″.
Jewish Museum, New York

Like the star-shaped Sabbath lamp, the Elijah goblet dramatizes the
eternal Jewish readiness for the dawn of the Messianic era. Elijah's
cup, brimful of wine, stands apart, in awesome glory, in the center of
the table throughout the seder. After the meal, grace having been said,
the door is opened for the invisible Prophet and all rise: *Shefoh cha-
mat'cha* ("Pour out thy wrath. . ."), they chant, and the wine quivers
in its cup at the imminence of redemption. The decorative theme
favored on Passover wine cups is of course the return to Zion. On one
cup (figs. 135, 135a) the Messiah is seen entering Jerusalem on a don-
key, led by Elijah blowing a ram's horn, while David plays his harp.
Two modern cups are of special interest. The first (fig. 74) is a simple
tumbler of silver encircled by a row of gold buttons. The second has
a shaft of silver rods curved to form fingers that grasp a glass cup;
the rods curve outward at the base to form the stand (fig. 136).

The seder inspires other ceremonial objects of particular artistic
quality: a special matzoh cover (colorplate 11), a hand towel for the
ceremonial washing of hands, china service plates for the Passover
dinner, an embroidered pillowcase for the head of the household to
lean on in the traditional lordly manner (colorplate 11), and, to com-
plete the picture, a snow-white robe to wear in imitation of the ancient
Israelites, who stood garbed and ready to move on Moses' command.
These accessories, together with the Haggadot, the wine cups, the
seder plates, and—above all—the expectant faces of happy children,
make Passover the high point of the Jewish year.

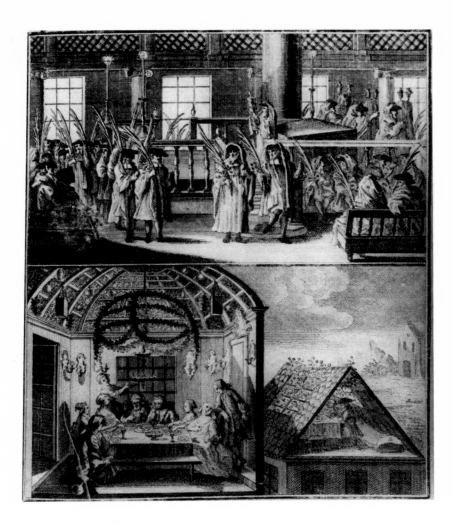

137.
Sukkot at home and in the synagogue.
From Johann Christian Bodenschatz,
Kirchliche Verfassung der heutigen Juden

IX. sukkot, hanukah, purim

SUKKOT

On Sukkot, the holiday of tabernacles (or booths), as on Passover and Shavuot, Jews from all over ancient Palestine converged upon their holy city, Jerusalem. The week-long celebration is, to this day, a harvest festival observed "after the ingathering from . . . threshing floor and . . . vat" (Deuteronomy 16:13). The agricultural origins of the festival are clear from the regulations for its observance—involving a sojourn in the sukkah (booth), and the traditional display of the "four species" represented by the lulav and the etrog: "On the first day you shall take the product of goodly trees, branches of palm trees, boughs of leafy trees, and willows of the brook, and you shall

rejoice before the Lord your God, seven days" (Leviticus 23:40). The sukkah, the lulav, and the etrog are still the central features of the observance of Sukkot.

The lulav is a bundle of several long palm shoots tied together at their lower end, and bound together with three twigs of myrtle, two willow branches, and a few palm tendrils. The willow branches, the myrtle twigs, the palm branch, and the etrog constitute the four species required by tradition. In one Midrashic interpretation they are said to represent four important elements of the human body; thus in offering the lulav and etrog the Jew is offering himself as well to God. The four items have also been interpreted as representing the matriarchs Sarah, Rebecca, Leah, and Rachel, and the patriarchs Abraham, Isaac, Jacob, and Joseph. The etrog, or citron, "the fruit of the goodly tree," is an oval-shaped yellow citrus fruit grown chiefly in Israel and in the southern United States; it has a tough, warty skin and a thick acid pulp. This ceremonial fruit is mentioned by Josephus: Alexander Jannaeus (r. 102–76 B.C.E.) was pelted by the populace with etrogim because, being the son of a captive woman, he was considered unfit to serve as a high priest.[1] The Talmud relates an incident in which an unfortunate Sadducee was similarly pelted when he committed a ritual error.

138. Plate. From Galicia, c. 1900.
Pewter, with decoration in relief; diameter 12″.
Sukkot scene; open etrog container and lulavim.
Jewish Museum, New York.
Harry G. Friedman Collection

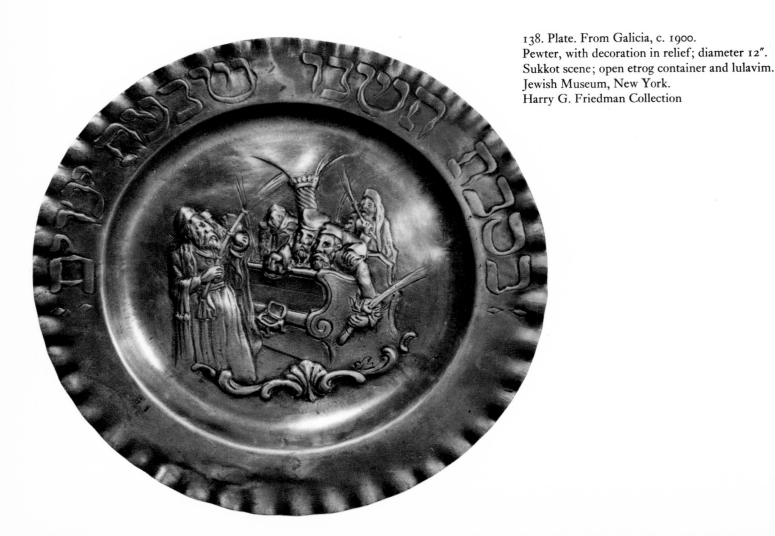

139.
Coin of the Jewish War (66–73).
Obverse: etrog. Reverse: two lulavim.
From L. Kadman, *Coins of the Jewish War of 66–73 C.E.*

In Temple times the lulav and etrog were carried in procession on the Temple grounds once on each of the first six days of the festival and seven times on the last day; all over the world the same procedure is still followed in the synagogue (figs. 137, 138). The lulav and etrog, often in conjunction with the shofar, became—after the menorah—the most characteristic and far-flung symbol of Judaism (figs. 19, 24, 28, 139–41). Even today many regard handling the etrog and lulav as an inspiring act, and it is to such fortunate hands that the Psalmist might have been referring when he said, "In Thy right hand, bliss for evermore."

So far as is known, the earliest representation of the etrog and lulav is on a Maccabean coin[2] (fig. 139); currently it appears on an Israeli banknote (fig. 140). It would seem that actual containers for the etrog were a late development. The commonest form is a rectangular box, ranging in style from extreme simplicity to the elaboration of the Baroque (fig. 141). An unusual variation is the box in the form of the fruit (fig. 142), usually featuring a prominent stem, to protect the stem of the etrog, which must remain intact during the entire holiday.

140. State of Israel bank note (back) for fifty lirot. Menorah from the mosaic in the synagogue at Nirim, a lulav, two etrogim, and a shofar

151

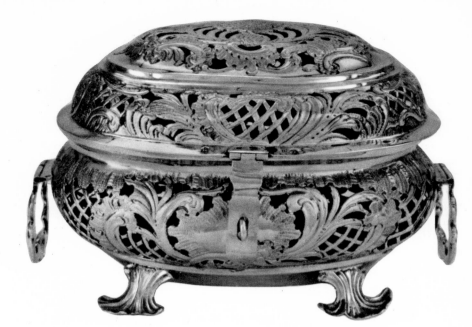

141.
Etrog container. From Germany, eighteenth century.
Silver gilt; height 4¾", length 7".
Pierced with leaf scrolls; etrog engraved on
the center of the cover; scroll feet.
Collection Mr. and Mrs. Joseph B. Horowitz,
Cleveland

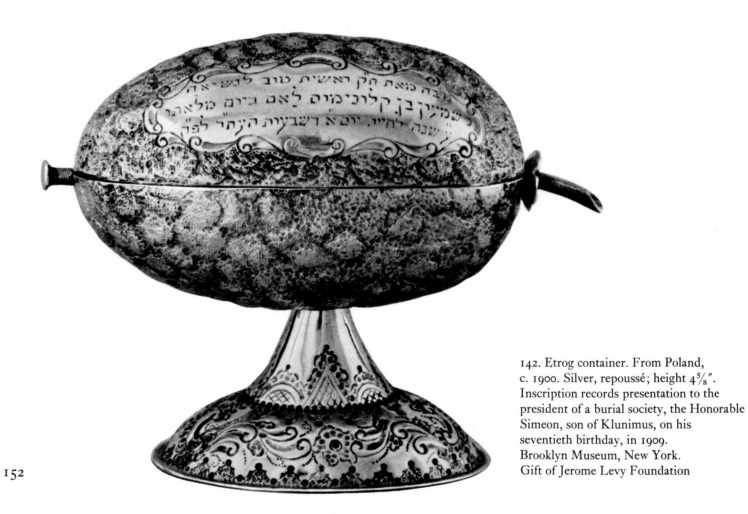

142. Etrog container. From Poland,
c. 1900. Silver, repoussé; height 4⅝".
Inscription records presentation to the
president of a burial society, the Honorable
Simeon, son of Klunimus, on his
seventieth birthday, in 1909.
Brooklyn Museum, New York.
Gift of Jerome Levy Foundation

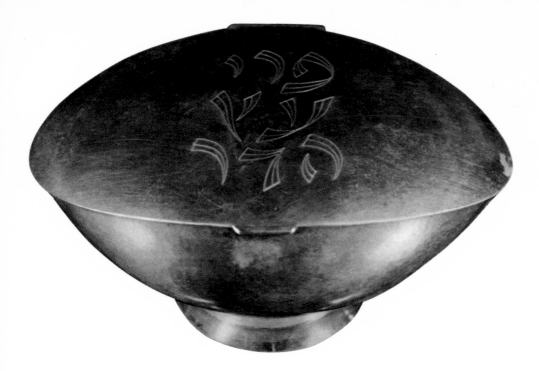

143. Etrog container, by Ludwig Wolpert
(Tobe Pascher Workshop). Silver;
height 3¾″, length 6¼″. Engraved: "a goodly fruit."
Jewish Museum, New York

144.
Etrog container, by Moshe Zabari (Tobe Pascher Workshop).
Green onyx top symbolizes the stem of the etrog.
Silver, height 7″. Jewish Museum, New York

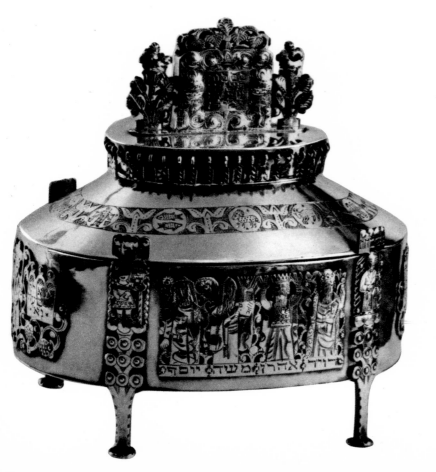

145. Etrog container,
by Ilya Schor. Silver, height c. 7″.
Abraham, Isaac,
Jacob, Joseph, Moses, Aaron, David;
the signs of the zodiac; at the top,
a family in a sukkah.
Collection Mr. and Mrs. David M. Levitt,
Great Neck, New York

153

146.
Mizrach for use in sukkah.
From Tel Aviv, 1940. Colored lithograph,
19⅝ × 27⅜″. In the margin,
the *ushpizin* (traditional formalized
greeting to Abraham,
Isaac, Jacob, Joseph, Moses, Aaron,
and David, welcoming them, in spirit,
as guests in the sukkah).
Jewish Museum, New York

147. Sukkah decoration,
by Israel David Luzzato. From Italy, c. 1700.
Paper pasted on canvas, 20 × 15½″.
Complete Book of Koheleth
(Ecclesiastes; read on Sukkot), in minute script
arranged to form fanciful shapes.
Jewish Museum, New York. Benguiat Collection

154

Contemporary examples vary from angular (fig. 144) to fanciful (fig. 145). A fine modern box, a skillful combination of curved planes, has the Hebrew characters for "a goodly fruit" engraved on its cover (fig. 143).

Whether during the seven days of the Sukkot holiday the celebrant lives, or dines, or—at the very least—recites the kiddush in a sukkah, in accordance with the injunction "You shall live in booths seven days" (Leviticus 23:42), he cannot but reflect upon its implications. From earliest days this custom has been the subject of philosophical and theological speculation. Some have noted that the farmer, after a summer's work outdoors, can now take his ease under a roof. For most of us this fragile shelter is a reminder of the evanescence of earthly existence. Life in a sukkah recalls, too, our humble origins in the desert and the days of conquest in Canaan. Further, it brings to mind the ultimate sukkah in the time of the Messiah, which will be made of the hide of the leviathan, whose flesh will also provide a feast for the righteous.

Colorplate 13. Sukkah, in the courtyard of the Jewish Theological Seminary of America, New York

155

Despite its austere connotations, the sukkah has always been richly ornamented with fruits, flowers, and foliage. There were often also other decorations, including tapestries and pictures (called *ushpizin*) of Abraham, Isaac, Jacob, Moses, Aaron, Joseph, and David, who were "invited" on successive days as guests (figs. 146, 147).

Perhaps the most famous sukkah is one built in Germany and now in the Bezalel Museum, in Jerusalem. It is a complete structure elaborately decorated with a beautiful mural showing Jerusalem, the Temple, and the Wailing Wall. Some of the most impressive sukkot are those erected adjacent to synagogues; they are often a real com-

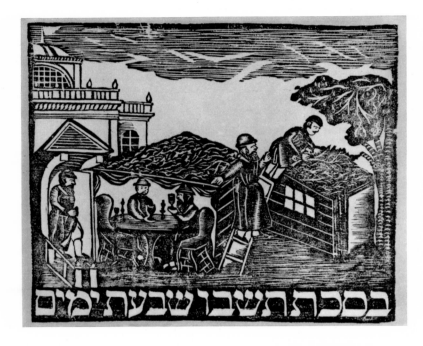

148. Simhat Torah flag.
From Poland, nineteenth century.
Lithograph, black on light blue paper,
framed under glass; 6¼ × 7½".
Jewish Museum, New York

149.
Simhat Torah flag. Lithograph on paper,
6⅛ × 7½". Inscribed: "Be swift as a stag,
strong as a lion."
Jewish Museum, New York

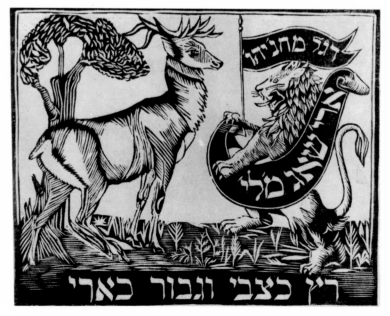

156

munity effort, engaging the efforts of many hands. One glorious example, made entirely of evergreen branches embellished by hundreds of different fruits, is decorated each year by faculty wives in the courtyard of the Jewish Theological Seminary of America, in New York (colorplate 13).

The Sukkot festival is closed with the holiday of Simhat Torah, "Rejoicing of the Law." As the scrolls are carried about the bimah, there is general hilarity, including the waving of candles and of gay flags (figs. 148–151), the making of which afforded folk artists opportunity for felicitous achievement.

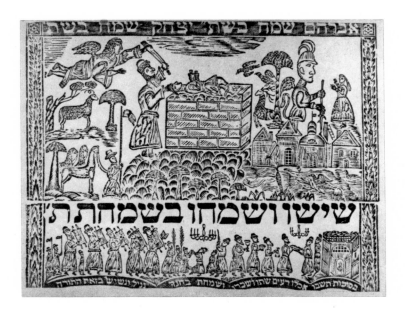

150.
Simhat Torah flag. Sacrifice of Isaac.
From Poland, nineteenth century.
Lithograph, black on light blue paper; 5½ × 7½″.
Jewish Museum, New York

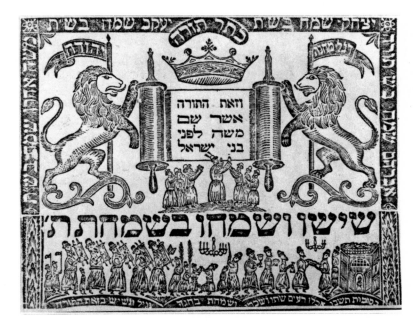

151. Simhat Torah flag.
From Poland, nineteenth century.
Lithograph, woodcut on paper; 6⅛ × 7½″.
Crown of the Law and Torah scrolls,
guarded by lions. Jewish Museum, New York

157

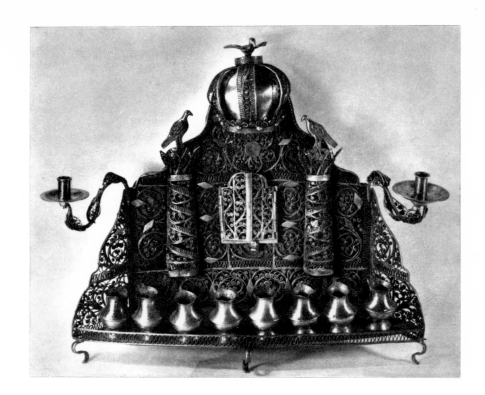

HANUKAH

The theme of light dominates the holiday of Hanukah. The memory of victory, rededication to Torah, and a renewal of hope for the future highlight the celebration. In the second century B.C.E. Judaism was under assimilative pressure from within and from the outside. A party under the leadership of the high priest Menelaus was urging a synthesis between Hellenism and the Jewish heritage. The conservatives resisted, and this resistance took on a nationalistic temper when Greek armies tried to reinforce the drive toward assimilation. In 163 B.C.E., the Jews, under Judas Maccabeus, revolted against the attempts of Antiochus IV to force Hellenism upon them. Victorious, they rededicated the Temple to the service of God. Talmudic legend has it that when they were searching for undesecrated oil with which to light the Menorah, they found only a small quantity, enough to last for a single day; this nevertheless illuminated the refurbished sanctum for all of eight days, until new, properly sanctified oil became available. It was with the rekindling of the seven-branched Menorah that the Maccabees celebrated the rededication *(hanukat)* of the Temple, and it is a symbolic repetition of this act that now forms the core of the Hanukah celebration.

The dedication of the original desert Tabernacle, and later that of Solomon's Temple, was celebrated for only seven days. The eight-

153. Hanukah lamp. From France,
fourteenth century. Bronze; height 5⅞″, width 5½″.
The triangular shape was perhaps suggested
by the old abbey church of Saint-Martin-des-Champs
in Paris; further Gothic influence
is seen in the rose-window design.
Musée de Cluny, Paris

day celebration of Hanukah followed the precedent of Hezekiah (726–697 B.C.E.) in his rededication of the Temple, which had long been neglected (II Chronicles 29:1–5). In the two ancient dedications the celebration lasted the entire week, without interruption. By the time of Hezekiah the Sabbath had assumed more of its rabbinic character, and the lighting of lamps was prohibited. Active celebration was halted for the Sabbath and resumed the following day, making a total of eight holidays. Some historians contend that the eight-day celebration derives from a Dionysian festival or from a Syrian celebration of the winter solstice. It is even held that the eight-branched candelabrum was borrowed from pagan sources by Judas. However, as one authority points out,[3] it seems inconceivable that the Maccabees—opposed as they were to Hellenism—would have chosen a pagan candelabrum for their celebration.

The Talmud enumerates three ways in which the Hanukah lights may be lit. Some authorities ruled that one each day for each member of the household was proper; some opted for eight candles each night for each member of the family. The school of Hillel prescribed that in each home one light be ignited on the first day and the lights be increased by one daily, to eight; the school of Shammai ordered that eight lights be lit on the first night and the number be reduced daily by one. There was general agreement that, unlike the Sabbath lights, Hanukah lights must not be used for ordinary illumination, since "these lights are holy." Hence a ninth light was added; ostensibly it is

the only one by which we may read and work on the long winter nights. Gradually, however, this light became the one with which the others were ignited, hence it was called the shamash, or servant. An occasional Hanukah lamp is seen with what appear to be two shamash candles; these lamps were used on the Sabbath, thus combining two functions (colorplate 14; figs. 152, 162).

The Talmud is concerned with ritual details such as the purity of the oil and the type of material used for the wick. It also specifies the appropriate place in the house to display the lights, whether hanging on the doorpost opposite the mezuzah or in the window, for all to see. As usual, the Talmud is not concerned with the form of the object. We may assume that the earliest hanukiot were similar to the well-known Mediterranean oil dish. Single-wick lamps were probably used in the beginning, pear-shaped, with an aperture in the stem for the wick; one lamp was lit on the first day, two on the second, and so on, up to eight on the last. In the course of time the individual lamps were joined into a continuous row, mounted on a base. The bench type of lamp as we know it today emerged when eight metal oil reservoirs were set on a base and a backpiece, or shield, was added for the sake of safety, to

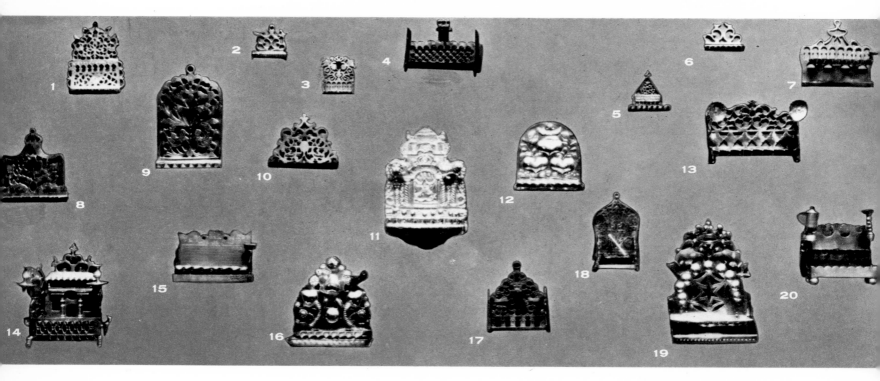

154 Exhibit of Hanukah lamps in the Jewish Museum, New York 1 From Morocco 2 From Poland, eighteenth century. Yellow copper 3 From North Africa, eighteenth century. Brass 4 From Italy, seventeenth century. Bronze 5 From North Africa, nineteenth century. Brass, cast and cut-out 6 From North Africa, nineteenth century. Brass 7 From North Africa, nineteenth century. Brass 8 From Italy, sixteenth century. Brass, with cut-out work 9 From Poland, eighteenth century. Yellow copper 10 From Italy, sixteenth century. Cut-out work 11 From Peru, twentieth century. Silver, hammered work 12 From the Netherlands, eighteenth-nineteenth century. Brass, hammered 13 From Eastern Europe, nineteenth century. Brass, with cut-out work 14 From Poland, seventeenth century. Brass 15 From Bohemia, 1775. Pewter 16 From the Netherlands, c. 1700. Brass, hammered 17 From Morocco, seventeenth–eighteenth century. Brass 18 From North Africa, eighteenth century. Silver, with cut-out work, engraved decoration 19 From the Netherlands, eighteenth century. Brass, with cut-out work 20 By Johann Philip Henschel. From Frankfurt, late eighteenth century. Pewter

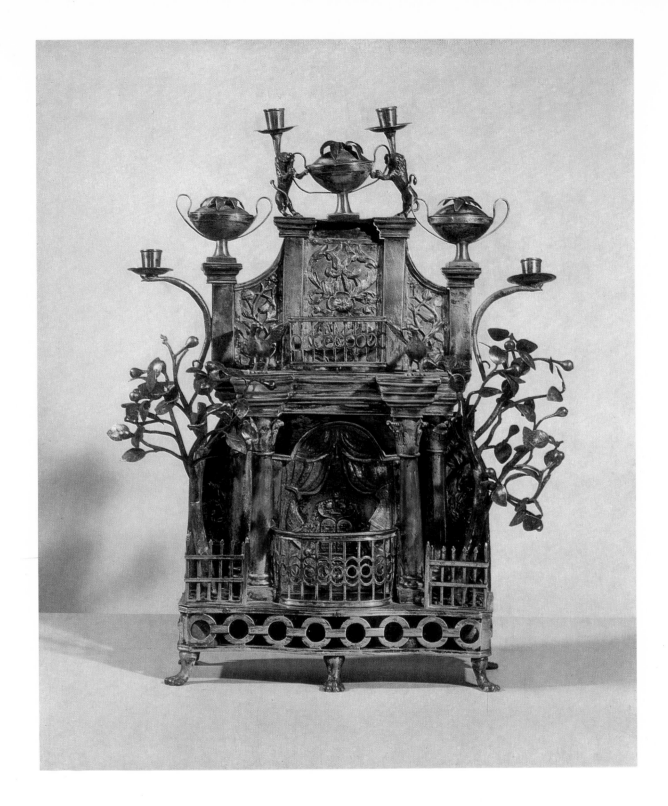

Colorplate 14. Hanukah lamp. From Polesie, U.S.S.R.; early nineteenth century.
Silver and silver gilt. The façade of the Temple; within are seen the Tablets of the
Law, flanked by rampant lions and surmounted by a Shield of David.
At the sides, pomegranate trees and a pair of pillars;
on the entablature, two phoenixes. The upper section is crowned
by three covered urns, the center one flanked by lions,
and four candle holders. Collection Jakob Michael, New York

hold the shamash and to afford space for ofttimes rich ornamentation. Probably the earliest example of this type is the lamp dated 1394, now in the Musée de Cluny (fig. 153). Although fashioned of bronze, it clearly shows its derivation from a row of clay lamps. In this lamp the backpiece allows for a typically Gothic form, including a rosette.

By the end of the twelfth century it became the custom to kindle the Hanukah lamp in the synagogue for the benefit of strangers. The bench type seemed inadequate for this purpose, and there came about an adaptation of the Temple Menorah form. As we have seen, the sacred candelabrum was known to the Jews for centuries only as a symbol. But eventually craftsmen elaborated similar lamps which evaded the proscription by the addition of an eighth branch, plus a shamash. By the fifteenth century, the menorah for Hanukah use was common in Europe's synagogues. Generally, the Hanukah menorah is placed to the right (south) of the Torah Ark. From the large synagogue menorah it was but a short step to a smaller version for the home.

The design and decoration of Hanukah lamps are very diversified. Unhampered by scriptural restrictions, the Hanukah lamp has pursued an independent course in its development, absorbing, more than any other Jewish ceremonial object, art concepts from its immediate environment. Thus in Islam the backpiece of the bench type is arched, fan-shaped, or domed (figs. 154, 155) and may even display the guardian hand of the superstitious East (fig. 156). In Gothic Europe the

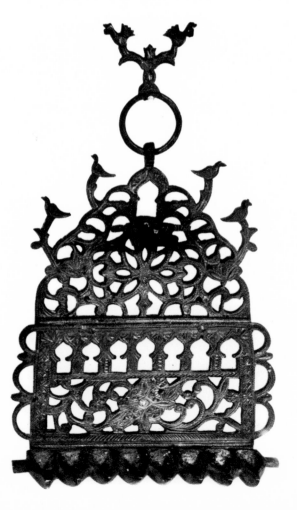

155. Hanukah lamp.
From North Africa, eighteenth century.
Brass, with cut-out, engraved, and embossed decoration; height 11¾", width 9¼".
Backpiece with Moorish arches.
Jewish Museum, New York.
Harry G. Friedman Collection

backpiece is high (figs. 153, 154, 158). Among the Portuguese refugees in Holland and Germany, such Renaissance figures as Justice—blind-folded and holding the scales aloft—became common. Real and imaginary beasts on the backpieces of German hanukiot bespeak the Sicilian influence extending north (figs. 157, 158). Italian and German lamps have backpieces in the Renaissance and Baroque styles (figs. 159, 161, 163). In a strange Renaissance lamp we see centaurs galloping across the backpiece, each with a nude figure clinging to his back (fig. 169).

The backpiece of the bench type of Hanukah lamp lends itself especially well to decoration. The design most frequently seen is the menorah, its spreading branches reminiscent of the tree of life (figs. 157,160,161). Birds, often in association with partial representations of the Temple or the portals of Heaven, remind us of the "souls" sitting in joyous attendance on the Almighty (colorplate 14; figs. 152, 154-56, 166, 167, 173). Flower designs, the Tablets of the Law guarded by lions (fig. 167), and miniatures of Moses and Aaron are common. One of the oldest menorot is a fourteenth-century bronze lamp from Germany, now in Temple Emanu-El in New York; it has a triangular backpiece adorned with two lions and a dragon in relief, and the body of the lamp consists of a series of metal cups joined on a base (fig. 158).

An important group comprises hanukiot created in Frankfurt during the eighteenth century by such masters as Valentin Schueler, Johann Christian Hetzel, Johann Philip Henschel, Carl Sichler, and Johann Adam Boller (colorplate 16). These craftsmen, who were Christian, produced some silver pieces but worked largely in brass, and in the Baroque style. East European, that is, Polish and Russian, lamps are mostly of brass or bronze, as are the Dutch lamps of the

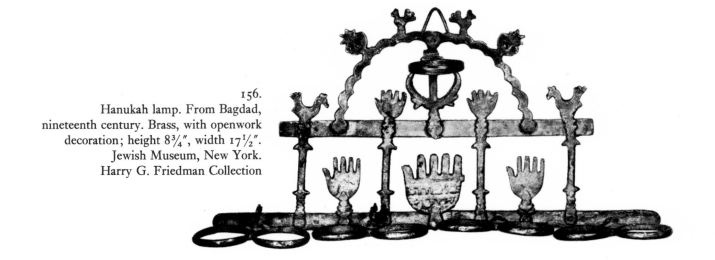

156.
Hanukah lamp. From Bagdad, nineteenth century. Brass, with openwork decoration; height 8¾", width 17½".
Jewish Museum, New York.
Harry G. Friedman Collection

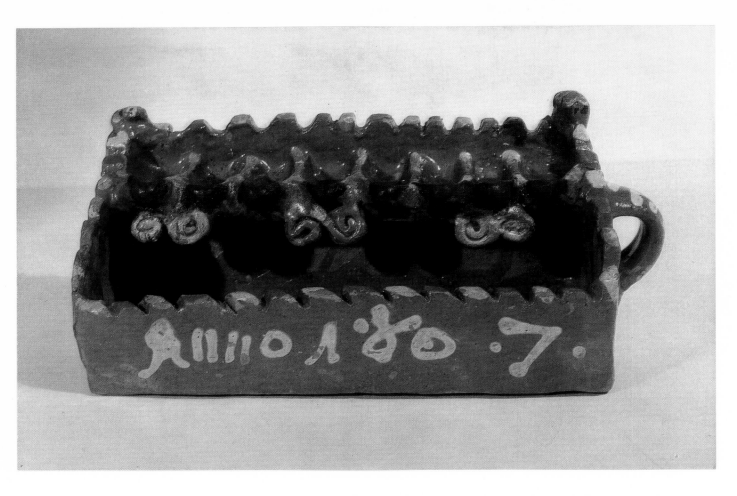

Colorplate 15. Hanukah lamp.
From Germany, 1807. Terra cotta,
glazed and painted. Jewish Museum, New York.
Harry G. Friedman Collection

seventeenth and eighteenth centuries. In Western Europe, especially Germany, pewter and silver (figs. 160, 161) were the metals preferred by most Jews. The pewter lamps—and an occasional brass or bronze one—are of special interest because they are often fine examples of folk art (figs. 164–166). A number of other lamps of the bench type show delicate silver filigree work (colorplate 14; figs. 152, 163, 167), and there is an occasional ceramic piece (colorplate 15).

The standing menorah type of Hanukah lamp is well represented. One of the finest groups, in delicate Rococo style, was produced by Polish coppersmiths; these lamps are refined and slender, with delicate tendrils surging upward to the candle sockets. An example dating from the nineteenth century, now at the Hebrew Union College Museum, in Cincinnati, is the epitome of extravagance in sculpture—and for that matter of disregard of the Second Commandment (fig. 168). Landsberger has described it: "Two bowls joined to one another. . . rest on eight lion bodies . . . there ascends a hill . . . two hares, a mother dog with her pups, a roebuck, a squirrel, a worm, a caterpillar . . . an oak. Up the trunk . . . a bear . . . a honeycomb . . . a bee . . . a hunter.[4]

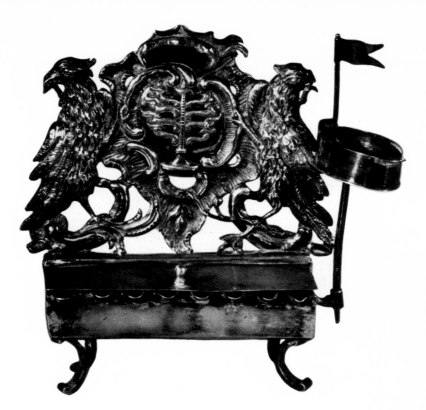

157. Hanukah lamp, by Johannes Reichert. From Germany, 1760. Silver, cast and hammered; height 11½", width 8". Menorah/tree of life and exotic birds. Collection Siegfried and Nanett Bendheim Foundation, New York

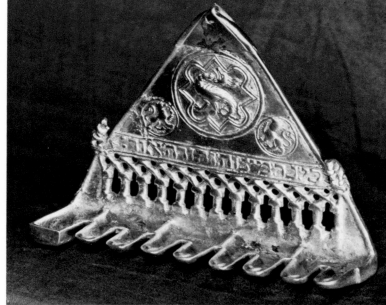

158. Hanukah lamp. From Germany, fourteenth century. Cast bronze; height 5½", width 6¾". Triangular backpiece, with decoration of lions and a dragon, inscribed: "For the commandment is a lamp and the teaching is light" (Proverbs 6:23). Temple Emanu-El, New York. Irving Lehman Collection

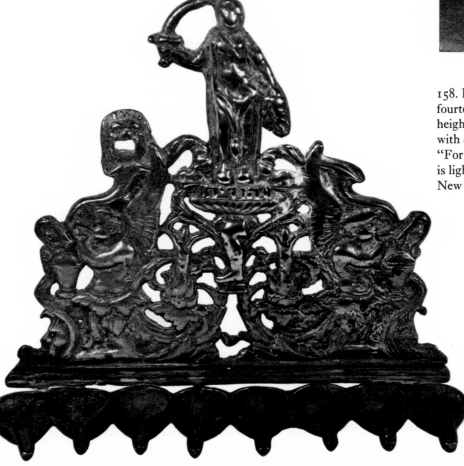

159. Hanukah lamp. From Italy, seventeenth century. Brass, with Baroque carving; height 7½", width 8¾". Judith with head of Holofernes; grotesque beasts. Jewish Museum, New York. Harry G. Friedman Collection

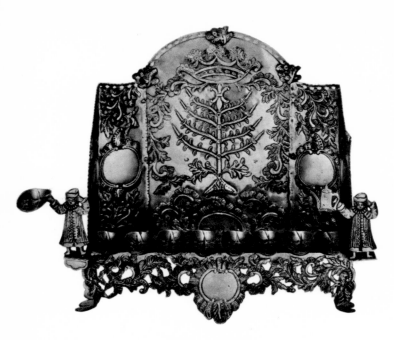

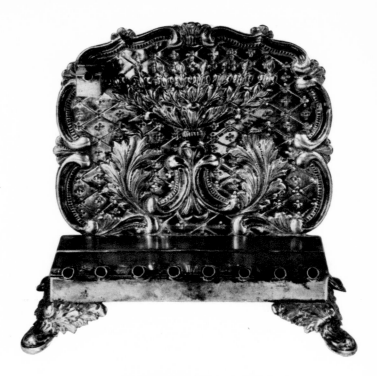

160. Hanukah lamp.
From Germany, eighteenth century.
Silver, repoussé and cast;
height 11″, width 11½″. On backpiece,
menorah/tree of life, floral and
bird motifs, and two figures in the
typical Jewish garb of the period.
Jewish Museum, New York.
Harry G. Friedman Collection

161. Hanukah lamp. From Germany,
eighteenth century. Silver, height 7″.
On backpiece, menorah/tree of life.
Jewish Museum, New York.
Harry G. Friedman Collection

162.
Hanukah lamp. From Galicia, c. 1800.
Silver, with filigree and silver gilt
(parts cast); height c. 20″, width 10″.
Peacocks, ducks, birds, griffins, and
a variety of fruit and plant motifs.
Jewish Museum, New York.
Harry G. Friedman Collection

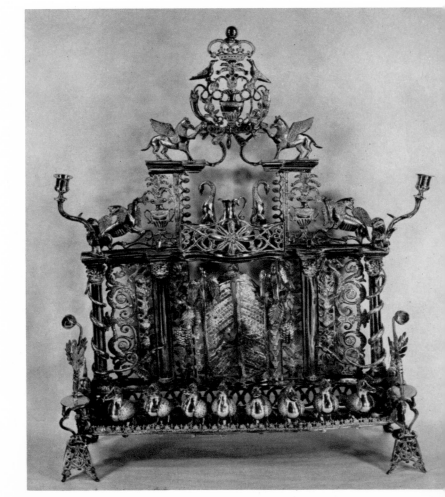

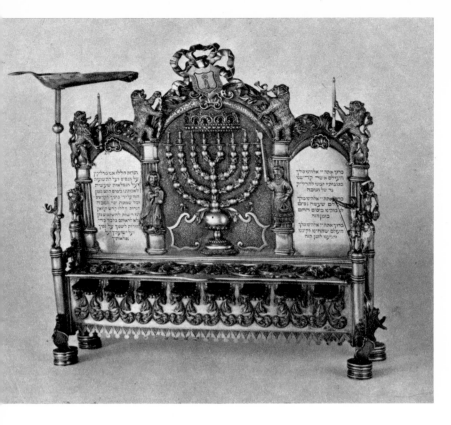

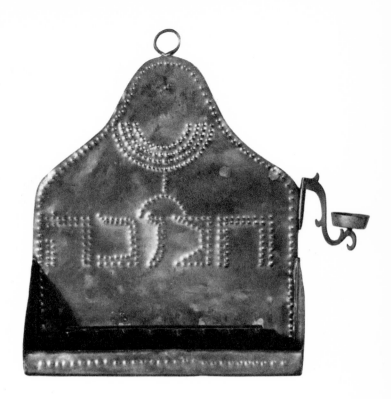

163. Hanukah lamp. From Germany, seventeenth century.
Silver and silver gilt, partly cast, with embossed
and engraved decoration; height 12″, width 12″.
Figures of Moses, Aaron, and Judas Maccabeus;
Judith holding the head of Holofernes, menorah, crown of the Law,
various beasts. Inscribed in Latin *(Providentia tutamur,*
"We are safeguarded by Providence") and in Hebrew.
Jewish Museum, New York. Lemberg Collection

164. Hanukah lamp. From the Netherlands,
eighteenth century. Brass, hammered,
with punched-out decoration; height 13″, width 9½″.
Jewish Museum, New York.
Harry G. Friedman Collection

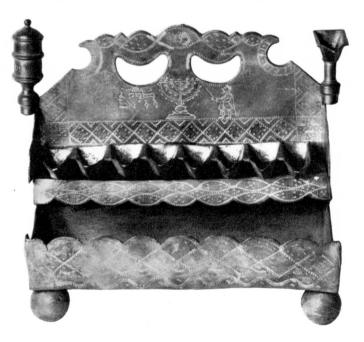

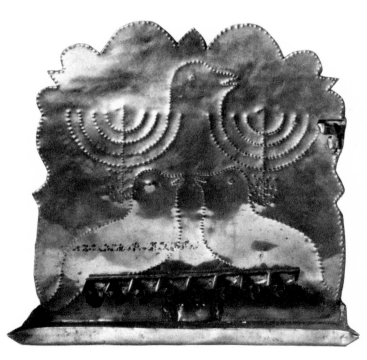

165. Hanukah lamp. From Germany,
late eighteenth century. Pewter, engraved, with cast decoration;
height 8″, width 12″. Jewish Museum, New York.
Harry G. Friedman Collection

166. Hanukah lamp. From the Netherlands,
eighteenth century. Bronze, with punched-out decoration;
height 11″, width 12″. Jewish Museum, New York.
Harry G. Friedman Collection

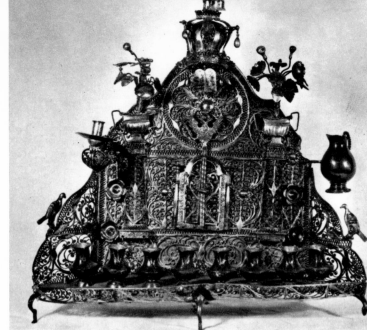

167.
Hanukah lamp. From Poland, early nineteenth century.
Silver filigree with cast decorations;
height 12″, width 11¾″.
Birds, crown of the Law, flowers.
Jewish Museum, New York.
Harry G. Friedman Collection

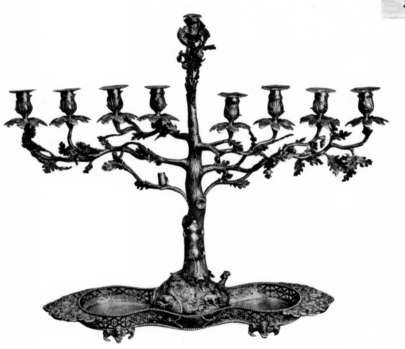

Colorplate 16. (FACING PAGE)
Hanukah menorah, by Johann Adam Boller.
From Frankfurt, early eighteenth century.
Silver, with enamel medallions; height 17″, width 14½″.
On top, figure of Judith with head of Holofernes.
Four medallions on octagonal base:
Rebecca at the well, Jacob's dream,
Jacob rolling the stone from the well,
and Jacob wrestling with the angel.
Jewish Museum, New York. Gift of
Mrs. Felix M. Warburg

168. Hanukah menorah.
From Poland, eighteenth century.
Silver and silver gilt.
Hebrew Union College Museum,
Cincinnati

A prominent motif on many German and Italian standing lamps is the figure of Judith displaying the head of the slain Holofernes. This is the result of storytelling so unrelated to the source that an independent myth finally evolves. In this case, Judith has probably become confused with Judas Maccabeus, and the scene of Judith beheading Holofernes is identified with the story of Judas slaying Nicanor, the Syrian general (colorplate 16; figs. 159, 163). Equally bizarre is the decoration of a group of six bronze candelabra described by Cecil Roth, made between 1561 and 1622, each bearing, as its central design, the heraldic arms of a cardinal; these were probably created for Jews who were proud of the friendship or patronage of a prince of the

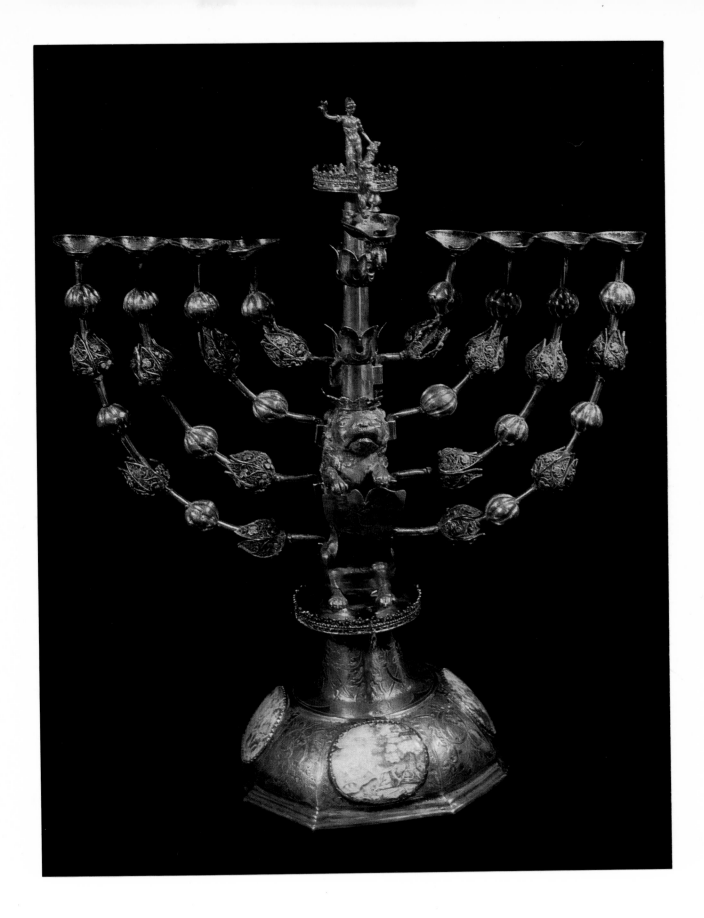

169.
Hanukah lamp. From Italy, sixteenth century.
Bronze, cast; height 6¼″, width 8¼″.
Centaurs with nude riders, Medusa head, phoenix.
Musée de Cluny, Paris

170. Hanukah lamp.
From Frankfurt, c. 1730.
Silver; height 2¼″, width 5½″.
In the form of a chest, with
cast lions for feet;
the shamash can be removed
and the cover closed.
Jewish Museum, New York.
Harry G. Friedman Collection

Church. A unique lamp is made of mirror glass mounted on a wooden frame (fig. 171). A practical traveling Hanukah lamp stands on animal feet and is decorated with a gargoyle (fig. 170).

The inscriptions seen on hanukiot vary with the location and the erudition of the individual craftsman. Most frequently seen is *Hanerot halalu kedeshe haim* ("These lights are holy"; fig. 172). The benediction for kindling the lights also appears often. Occasionally one sees the entire hymn *Rock of Ages,* which is part of the Hanukah service. One of the most interesting inscriptions is taken from Proverbs (6:23): "For the commandment is a lamp and the teaching is light" (fig. 158). The relationship of this quotation to Hanukah is established by Rashi, who used it to uphold his dictum that he who kindles the Hanukah lights regularly will live to see his children grow up to be conscientious students of the Torah.

In the hands of contemporary craftsmen the design of hanukiot has taken a variety of directions. Ilya Schor created an elaborate family of hanukiot that evoke the atmosphere of the Polish-Jewish villages of Chagall and Sholom Aleichem (fig. 173). On the other hand, the search for pure functional designs has led to the rediscovery of primitive forms.

171. Hanukah lamp. From Frankfurt, early eighteenth century. Wooden frame with mirror-glass facing; height 12″, width 12¼″. Joshua's spies, wearing the typical Jewish garb of the eighteenth century. Jewish Museum, New York. Gift of Albert and Vera List

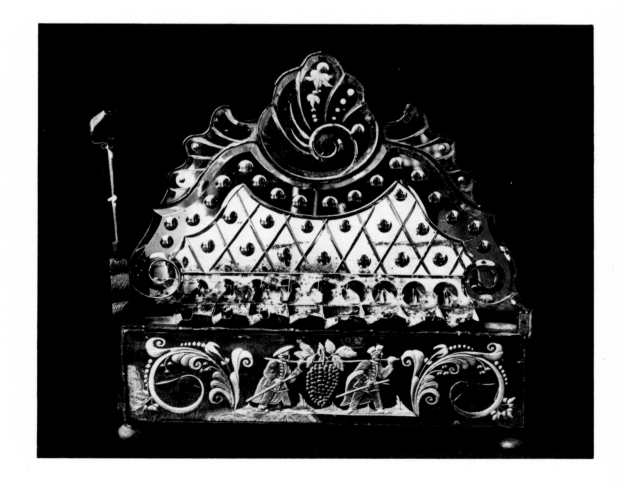

172.
Hanukah lamp, by Herman Roth.
Silver, cast and cut-out, and ebony;
height 3½", width 12". Lettering:
"These lights are holy."
Collection Mr. and Mrs. Max Tendler,
Washington, D.C.

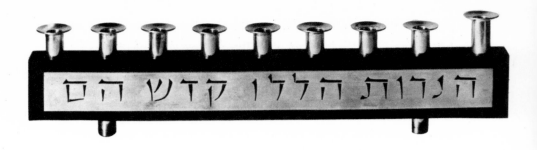

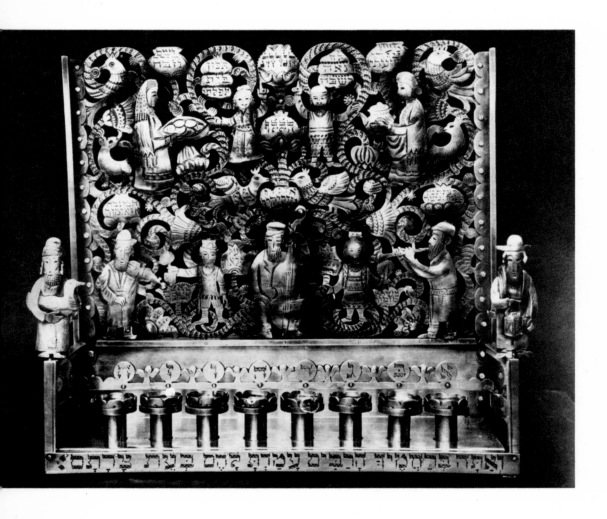

173. Hanukah lamp, by Ilya Schor.
Silver, cast and cut-out.
Collection Siegfried and Nanett
Bendheim Foundation, New York

174.
Hanukah lamp, by Ludwig Wolpert
(Tobe Pascher Workshop). Brass, cut-out;
height 7", width 15".
Jewish Museum, New York

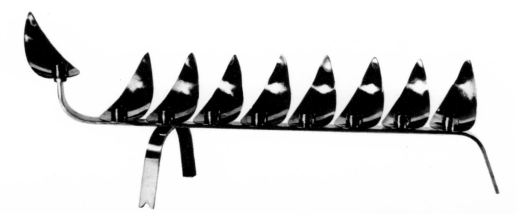

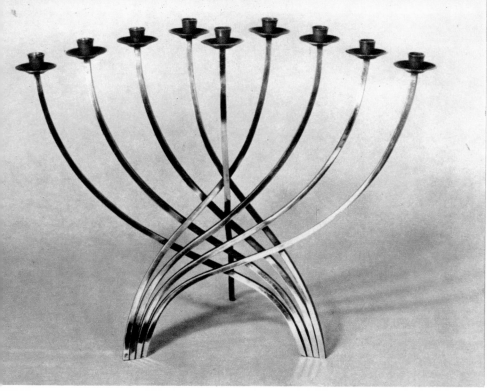

175. Hanukah menorah,
by Ludwig Wolpert. Brass.
Collection Dr. and Mrs. Ronald H. Levine,
Raleigh, North Carolina

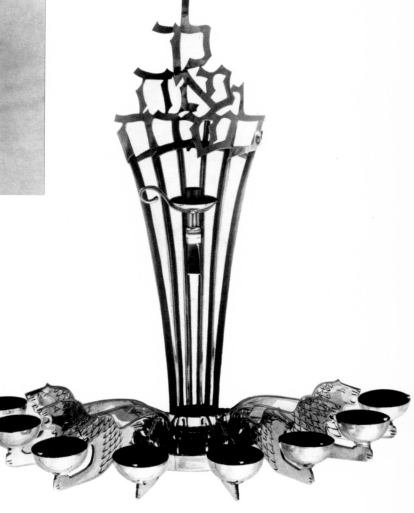

176. Hanukah lamp, by Ludwig Wolpert
(Tobe Pascher Workshop). Brass, cut-out and cast;
height 13″, width 10″.
Jewish Museum, New York

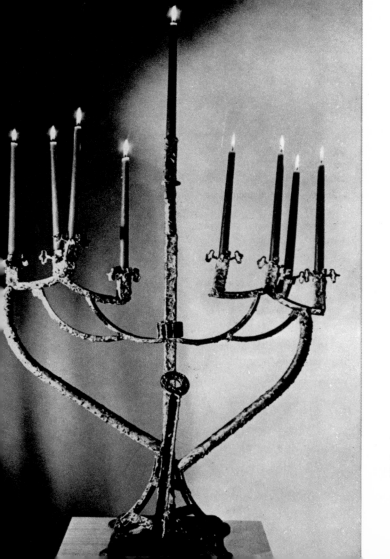

177. Hanukah menorah, by Bernice Kussoy.
Welded steel, hand brazed; height 3′, width 2′.
Collection Mr. and Mrs. Philip Glucker,
Beverly Hills, California

178. Hanukah lamp, by Pfc. Herbert Bilofsky. From the battlefield, inscribed with mark of the "Big Ten" Corps in Korea; 1951. Made of parts of brass shells; height 4″, width 17″. Jewish Museum, New York

Thus Ludwig Wolpert produced in brass a modern version of the Mediterranean lamps, joining them on a base to form a simple hanukiah of the bench type. He has also produced some modern standing lamps (figs. 175, 176), while Herman Roth has set a series of simple cups onto a rectangular block of ebony (fig. 172). Bernice Kussoy has welded a heroic lamp (fig. 177). A battlefield Hanukah lamp speaks for the nostalgia of Jewish ceremonial and also recalls the martial origins of the holiday (fig. 178).

Hanukah is one of the few holidays on which it is permitted to play games, and the Hanukah dreidel is still the favorite toy (fig. 179).

179. Hanukah dreidel. From Poland, eighteenth century. Wood, height 1¾″. Initial letters of "A great miracle occurred there." Jewish Museum, New York. Mintz Collection

PURIM

The story of Purim has the universal ingredients of a good romance: an amorous emperor is in love with a beautiful maiden—a commoner, of course—whom he chooses for a bride, unaware that she is a Jewess, on the basis of a national beauty contest. Esther, the maiden, has a cousin, Mordecai, who discovers a plot against his people: the wicked prime minister, Haman, has drawn lots and picked the fourteenth day of Adar for the extermination of the Jews (the word *purim* means "lots"). Esther, now a queen, uses her high position to save her people and turn the tables on the villain, who is then executed like a common criminal. "The Jews had light and gladness, and joy and honor" (Esther 8:16).

No explicit moral lesson is pointed out in this story, nor does the name of God appear in the entire megillah (scroll). The Book of Esther is one of the five books of the Bible referred to—because they are actually part of the liturgy—as Megillot, the others being the Song of Songs, Ruth, Lamentations, and Ecclesiastes. The reading of the Scroll of Esther in synagogue or at home constitutes the only formal observance of this holiday. It is traditional that before the reading is begun the entire scroll be unrolled, in the manner of an ancient letter, to remind us of the epistles that Mordecai sent to the Jews warning them of their danger. The reading is accompanied by a cacophony of hisses and the grinding sound of whirring gragers that wells up at every mention of Haman's name.

174

The secular character of the narrative and the general absence of sacred references make it possible for Purim to be observed as a hilarious holiday (fig. 180). This is one day on which the Jew may—nay, deems it his duty to—imbibe enough so that in reading the Megillah he confuses the two phrases "Cursed be Haman" and "Blessed be Mordecai." A custom particularly strange for Jews was the making of an effigy of Haman designed, after hanging publicly for some days, to be burned in a public bonfire. More in the holiday spirit were the customs of performing Purim plays, of masquerading, and of feasting. The plays, generally on the folk level, were concerned not only with Purim but with such favorite themes as the stories of Joseph and his brethren and of David and Goliath. Since Mordecai enjoined the Jews to observe this day as one for bringing gifts and distributing alms *(shalach manot)*, the festive Purim charity balls, held annually around the turn of the century, were also particularly appropriate. Isaac Bashevis Singer has recalled the Purim of the Polish Ghetto:

For Krochmalna Street, Purim was a grand carnival. The street was filled with maskers and bearers of gifts. . . . The sweetshops sold cookies in the

180.
Purim players. Illustration from
the 1768 *sefer minhagim* (book of customs)
by Shlomo Maduro, *Ma'aseh Bereshit*

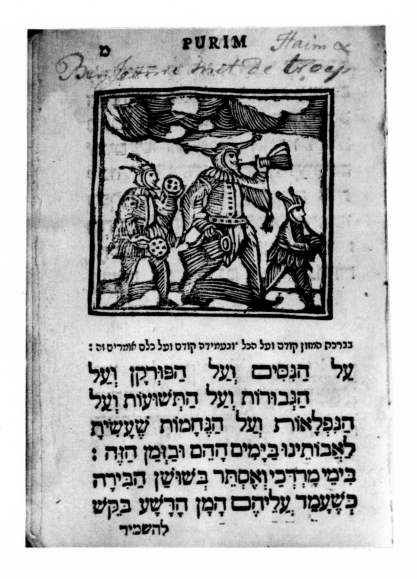

shapes of King Ahasuerus, Haman the Wicked, the chamberlain. . . , Queen Vashti. . . . And the noisemakers kept up a merry clamor, in defiance of all the Hamans. . . . Among betrothed couples, and boys and girls who were "going with each other," the sending of Purim gifts was obligatory.[5]

This holiday, so un-Jewish in its theme, unique in its lack of pious indoctrination and in the boisterousness of its celebration, is thought by some scholars—Graetz, the great Jewish historian, among them—to have no authenticity in history. Theodore Gaster has drawn an ingenious analogy between Purim and pagan celebrations.[6] He finds a close resemblance to ancient New Year celebrations remembered in modern times as Carnival and Twelfth Night. All the features of Purim have counterparts in these non-Jewish observances: the period of fasting (the day before Purim), followed by a release of the carnival spirit, the selection of a new queen, the parade of a commoner dressed as a king (Mordecai), the execution of a felon (Haman), and the distribution of gifts.

In the course of centuries other Jewish communities that have been rescued from calamity have instituted Purims of their own, and individuals who have been rescued from mortal danger or degradation have written their stories and enjoined their descendants to read these in celebration.

The Purim holiday calls for three ceremonial objects: the megillah itself (and its case), the Purim, or *shalach manot,* plate, and the grager, or noisemaker. The Scroll of Esther read in the synagogue is handwritten, usually on parchment, though leather is favored in the Levantine countries. The text is arranged in twelve to twenty columns with a separate sheet for the benedictions preceding and following the

181. Scroll of Esther.
From Italy, late seventeenth century.
Height 8″. Haman and his sons hanged,
as Jews give thanks and rejoice.
Jewish Museum, New York.
Gift of Mr. and Mrs. Ira J. Kaplan

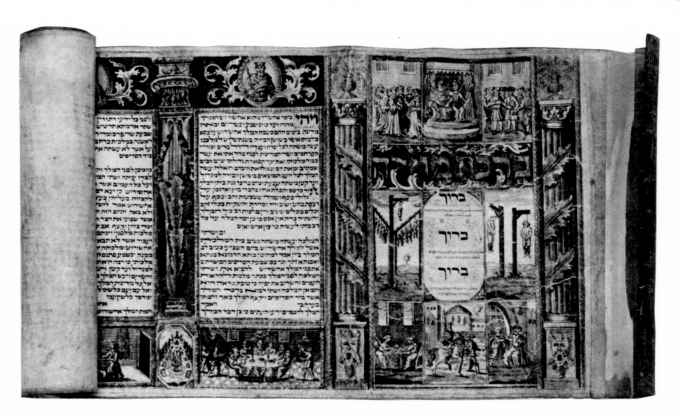

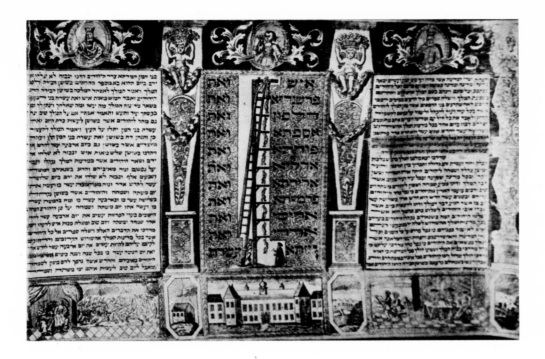

recitation. In a special group of scrolls known as the *ha-melech megillot* the text is so arranged that every column begins with the words *ha-melech* ("the king"). Unlike the Torah scroll, the megillah is mounted on a single roller, often made of ivory; its lower end is prolonged to form a handle for the reader during the reading. The megillah read in the synagogue is, like the Torah scroll, usually unadorned (fig. 183). However, because of the general levity surrounding the holiday and because the Scroll of Esther is a traditional gift of the betrothed to her future husband, megillot intended for use in the home are often extravagantly decorated.

Decoration first appears in fragments from the sixteenth century, but the earliest complete illustrated scrolls date from the seventeenth and eighteenth centuries. The finest of these were produced in Italy and the Netherlands and featured hand-decorated borders on the parchment scrolls, with blank spaces in which the text was later lettered. These borders are distinguished by fanciful colonnades supporting fruit and flower baskets; along the lower and upper edges there are also episodes from the Esther story itself (fig. 182). In a group of Italian megillot the margins are delineated by standing figures of the characters in the story, while the spaces at the foot of the page are filled with romantic court scenes, courtiers, and ladies. In other scrolls not only is the Esther story illustrated but there are also detailed pictures of the customs and ceremonies surrounding the festival. The most frequent illustration is that of Mordecai being led in triumph through the streets of Susa. There are also numerous versions of the hanging of Haman and his sons (fig. 181). Another favorite scene is Haman's daughter

182. Scroll of Esther.
From Eastern Europe, eighteenth century.
Handwritten; copperplate engraving
on parchment. Jewish Museum, New York.
Gift of Albert and Vera List

177

183. Scroll of Esther. From Italy, late seventeenth century. Parchment with cut-out border decoration. Library of the Jewish Theological Seminary of America, New York

mistakenly emptying a slop pail over her father's head, thinking he is Mordecai. A seventeenth-century French scroll (fig. 184) is unusual for the nudity displayed.

Perhaps the most interesting of all megillot is one made in the early nineteenth century for the Chinese-Jewish community of Kai-Feng-Fu; the scroll, which is in the Cecil Roth Collection, is decorated with classic Chinese figures in Chinese dress.[7] Jumping a century, we can see Chinese calligraphy and a Chinese Esther seated in a rickshaw on a Purim greeting card issued by the Jewish Welfare Board for Jewish soldiers stationed in China during World War II. Surprisingly, there are very few megillot being illustrated by contemporary artists. Ilya Schor illuminated, in his characteristic style, a very old scroll; the case, of silver, is decorated with several Purim scenes executed in a hammered technique (fig. 185).

184.
Scroll of Esther.
From France, seventeenth century.
Musée de Cluny, Paris

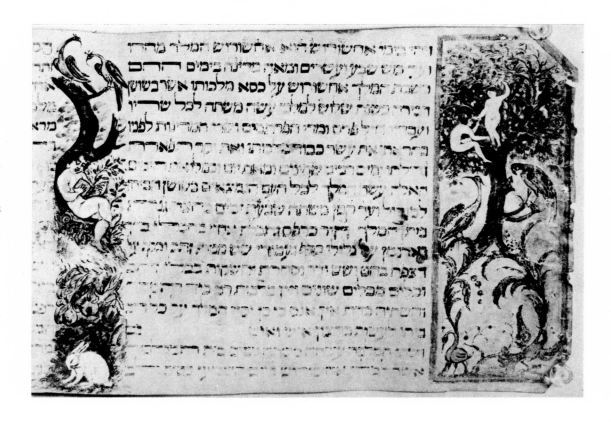

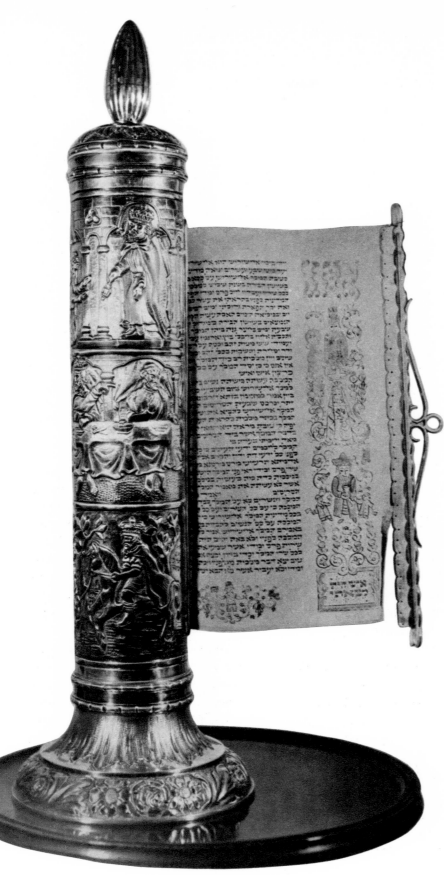

185. Scroll of Esther, with case.
Probably from Germany or Austria, eighteenth century.
Old parchment scroll illuminated by Ilya Schor.
Case, of hammered silver, decorated with scenes from the Purim story.
Collection Dr. and Mrs. Carl Norden,
Rochester, New York

186.
Scroll of Esther, with case.
Eighteenth century. Silver, filigree;
height 11½″, width 21″. Inscribed:
"Gift of Sarah Didel Weissbeg to her
son-in-law, Sholom Eitman, and his wife,
Battia." Jewish Museum,
New York

The megillah case may be a simple cylinder of real or simulated leather, brass, or even cardboard. Most often the older cases are of silver, usually embossed with illustrations of the Esther story. The filigree technique is frequently seen in megillah cases; examples are known from Vienna and Berlin, as well as from Galicia, Russia, Italy, and the Netherlands. A great many were produced in the Middle East (figs. 184, 186). There are occasional larger cases of wood, usually with silver mountings, as well as Italian cases, often adorned with coral, to ward off the evil eye. A modern version, with no decoration, is by Moshe Zabari (fig. 187).

The function of the Purim plate is to hold the gifts that, in accordance with the injunction of Mordecai, are exchanged during the Purim holiday. For alms, there are special silver plates *(kuppot)* passed around in the synagogue. Favorite gifts are Purim delicacies; the most traditional and best-liked of these is the triangular-shaped cake filled with a mixture of poppyseed and honey, called hamantasch ("Haman's pocket"). The conscientious wife is especially anxious, on this holiday, to send a sampling of her kitchen craft to her mother-in-law, and

187. Case for Scroll of Esther, by Moshe Zabari.
Silver rods on ebony base, inner tube of plastic;
height 8½″, diameter 1⅝″. Collection Albert and Vera List, New York

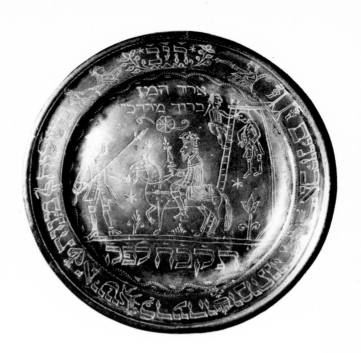

188. Purim plate. From Germany, 1768.
Pewter, with engraved decoration;
diameter 9½". Inscribed: "Cursed Haman,
blessed Mordecai" and (on rim)
"sending portions one to another and
gifts to the poor" (Esther 9:22).
Jewish Museum, New York.
Harry G. Friedman Collection

plates for this purpose became most important and popular. Many of the older *shalach manot* plates are made of pewter (fig. 188); there are some silver ones and a few of porcelain. Scenes from the megillah are favored motifs, along with inscriptions, the most popular of which are the words of Mordecai exhorting the Jews in honor of their deliverance to "make them days of feasting and gladness, and of sending portions one to another, and gifts to the poor" (Esther 9:22). Another stock inscription is "Cursed be Haman, blessed be Mordecai." A contemporary silver plate by Moshe Zabari has no inscription but is identified as a Purim plate by its hamantasch shape; the Oriental setting of Purim is suggested by the skillful use of Persian blue beads (fig. 189).

189. Purim plate, by Moshe Zabari. 1966.
Silver, set with nine green onyx stones;
diameter 8½". In the shape of a hamantasch;
the semiprecious stones lend the
Oriental flavor appropriate to the
Persian setting of the Purim story.
Jewish Museum, New York

190.
Wooden molds for Purim cakes. From Poland, 1870.
Eagle, 5×5¼″; stars, half-moons, and leaves,
3×1⅞″; hamantasch, 2¾×3″.
Jewish Museum, New York

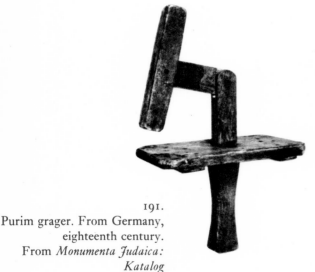

191.
Purim grager. From Germany,
eighteenth century.
From *Monumenta Judaica:
Katalog*

To the realm of folk art belong objects such as the wooden molds, crudely but vividly carved, used for shaping a large variety of Purim cakes (fig. 190), and the embroidered napkins used to wrap the Purim plate and its contents.[8] And no object could be a better example of folkcraft than the grager, the producer of nerve-shattering noise, whose purpose is not to delight the eye but to blot out the name of Haman as it is read aloud from the megillah. Of two striking gragers that come from Germany (figs. 191, 192), one features a hanging Nazi. A more skillfully executed grager, delicately worked in silver, shows Mordecai victoriously waving a pennant decorated with a Shield of David (fig. 193).

Other interesting and charming manifestations of Purim, such as greeting cards, are becoming popular; so also are the posters commissioned in the past few years by the Jewish Museum in New York for its annual Purim ball. These posters, works of art in their own right, have been designed by such artists as Larry Rivers, Jim Dine, and Leonard Baskin.

193. Purim grager.
Nineteenth century.
Silver, with topaz insert;
height 7½″.
Mordecai holding a
triumphant banner.
Jewish Museum, New York

192. Purim grager. From Germany, 1947.
Wood, length 10¼″. Inscribed:
"And they hanged Haman" (Esther 7:10).
Collection Heshil Golnitzki, Haifa

X.

ceremonial markers in the jewish life cycle

Ceremonial life for the Jew begins early—on the eighth day after birth—when he undergoes brit milah (covenant of circumcision) in obedience to the command by God in a covenant with Abraham: "You shall circumcize the flesh of your foreskin, and that shall be the sign of the covenant between Me and you" (Genesis 17:11). The mohel (he who performs the ritual) takes the child from the wife of the *sandek*, or godfather, who has carried him into the room; he places the child on a decorative cushion in the *sandek*'s lap, and after proper benedictions performs the operation, whereupon the congregation recites the traditional threefold blessing, "As he has entered the covenant, so may he succeed to the study of Torah, to the attainment of marital bliss, and to the performance of good deeds."

In those European cities where the ceremony took place in the synagogue there was often a special chair, the so-called chair of Elijah, suitably inscribed, for the ceremony. The child was placed into the chair first and then transferred to the lap of the *sandek*. In some congregations the chair was wide, with two seats; the *sandek* placed the baby for a moment on a cushion beside him, and then took him onto his lap, leaving the empty seat for Elijah. In the Renaissance synagogues of Cavaillon and Carpentras, in France, there is a miniature chair into which the baby was placed and held there by the godfather. Being easily portable, the chair was available for circumcisions performed in the home. When not in use, the chair was mounted on the wall in the sight of the congregation (figs. 194, 223). Elijah's name is associated with the ritual of circumcision because of his renown as "the messenger of the covenant" (Malachi 3:1). In rabbinic literature Elijah is spoken of as the angel of the covenant because God had made him the promise that he would be present at all circumcision ceremonies.

194.
Elijah's chair
in the synagogue in Carpentras,
France; eighteenth century.
(Shown also in Figure 223)

The swaddling cloth used for the occasion was customarily, in Germany and Italy, cut into four strips which were joined end to end. The long ribbon or runner thus formed was then, as already noted, embroidered or stencil-painted with the child's name and vital data, along with the traditional prayer that he succeed to Torah, to the huppah, and good deeds (*ma'assim tovim*) (colorplate 17). In addition, there was a varying assortment of colorful pictures and decorations. When in the course of time the little boy paid his first visit to the synagogue, he brought his wrapper to the Torah; at his bar mitzvah the Torah from which he read would be bound by this wrapper.

The importance of the covenant ceremony is reflected in the care lavished on the design and ornamentation of the set of instruments (fig. 195) used by the mohel. The handle of the scalpel, for instance, was often very elaborate, as was the flacon in which old-time mohalim carried a healing and coagulant powder. A large circumcision platter or plate on which the baby could be passed from hand to hand was usually decorated with either a brit milah scene or a depiction of the offered sacrifice of Isaac (figs. 196, 197). A similarly ancient and curious utensil was a dish, often elaborate, into which the foreskin was dropped[1]—the universal urge toward artistic creativity apparently expressed itself at every opportunity in Jewish life.

If a son is the first-born of his mother, there is a second early ceremonial event, the pidyon haben, or redemption of the first-born, at one month of age. The idea that the first-born son belongs to God is an ancient one. In *The Golden Bough,* Frazer cites examples of the first-born of a primitive family being offered up as a sacrifice. The Bible echoes this ancient concept: " 'Consecrate to Me every firstborn; man and beast, the first issue of every womb among the Israelites is Mine' " (Exodus 13:2).

195. Circumcision set of eight instruments, with box. From the Netherlands, 1865. Silver, filigree. Box, 3¾×8×6″. Jewish Museum, New York

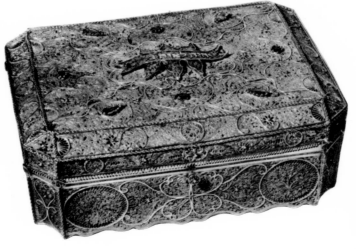

184

In actual practice this principle of consecration was influenced by heavenly reaction to the tenth plague visited upon the Egyptians. Originally it was thought that first-born sons of Israel should do penance for the necessary but dreadful Egyptian calamity by dedicating their lives to the service of God in the Temple. Since that would have been impractical, the Kohanim and Levites were assigned to this duty, and the other first-born redeemed themselves from the obligation by offering tokens. Today's pidyon haben ceremony perpetuates this tradition; among the Orthodox, first-born males still commemorate that ancient night in Egypt by fasting on the eve of Passover.

The first-born baby boy, having reached the age of one month, is presented to the Kohen by the father, who, quoting the appropriate Scripture, fixes five silver shekels as the substitute offering. The Kohen accepts the offering, announces the substitution, and pronounces the threefold priestly blessing. The ceremonial objects used to embellish this ceremony are the large plate on which the child is presented to the descendant of Aaron, and, as a recent innovation, a token used instead of silver coins. The plate is usually a community possession; the token is kept by the family as a remembrance.

The tradition of the pidyon haben plate is an old one, and it is puzzling that this object should not be represented in the two important early works on Jewish ceremonials, Bernard Picart's *Cérémonies et coutumes religieuses* (1723–43) and Paul Christian Kirchner's *Jüdisches Ceremoniel* (1724)—both of which do illustrate circumcision plates. The numerous silver plates in the Jewish Museum of New York decorated with the motif of the Akedah are thought to have been designed for the pidyon haben. An eighteenth-century example from Poland (fig. 197) may have been intended as either a circumcision or a pidyon haben plate. A different theme is seen on an eighteenth-century plate from Germany (fig. 198); it shows a baby in swaddling clothes, with the hands of the Kohen raised above him in the traditional blessing, and

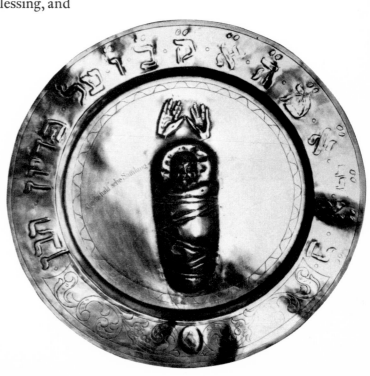

198.
Pidyon haben plate. From Danzig, eighteenth century. Copper, hammered and repoussé; diameter 18″.
Jewish Museum, New York

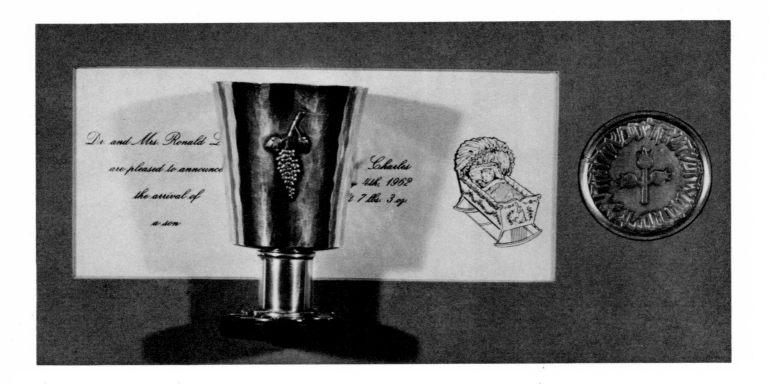

199.
Pidyon haben coin, by Moshe Zabari,
and child's kiddush cup, by Earl Krentzin.
The coin is symbolically given to the Kohen;
the cup belongs to the child.
Cup, height 3½″; coin, diameter 1¾″.
Collection Dr. and Mrs. Ronald H. Levine,
Raleigh, North Carolina

has the benediction recited by the father engraved on the rim. The defects in the face of the baby are not accidental but are there in deference to the prohibition against the re-creation of whole human images.

The Jewish Museum's collection includes a small enamel plate in the modern manner, commissioned to hold the token during a contemporary pidyon haben, and created at the Tobe Pascher Workshop of the Jewish Museum in New York by Chava Wolpert. It shows a growing sapling in the center and is inscribed with the traditional threefold blessing. Moshe Zabari designed a silver token (fig. 199) to replace the traditional shekels; some use a modern Israeli five-pound coin.

At thirteen the boy reaches the status of bar mitzvah, "son of the commandment." The term originally referred to every male in the house of Israel. Its application to the boy who has reached the age of thirteen dates from the fourteenth century. A legend that might explain the emphasis on the age of thirteen has Esau and Jacob attending *cheder* (school) together up to that age. They then parted company, Jacob going on to the *beth ha-midrash* (house of study) for the study of the Law, while Esau went to the house of idols.

The bar mitzvah ceremony usually takes place on the first Sabbath after a boy's thirteenth birthday; from then on, in the Orthodox tradition, he—not his father—is responsible for his ritual conduct. On that Sabbath the boy is "called up" to read the weekly portion from the Prophets; the father offers the benediction "Blessed be He who has

200.
Tefillin case. From Warsaw, 1820.
Silver; 2×3×3″.
Jewish Museum, New York.
Harry G. Friedman Collection

taken the responsibility for this child's conduct from me"; the mother
weeps for joy, and, in some places, her friends throw raisins and can-
dies at the proud young man. The "man" is now recognized as a mem-
ber of the minyan (quorum of ten required for a congregation), and he
acquires two most important possessions, which henceforth symbolize
his commitment to Judaism: his talit (prayer shawl) and his tefillin
(phylacteries).

The talit is a rectangular mantle worn by Jewish men during morn-
ing prayers. It may be woven of white wool or silk, with blue or black
stripes running crosswise at the ends. The Orthodox prefer a coarse
weave of partly bleached lamb's wool. A whiter, finer wool cloth is
also favored, but silk seems to have the ascendancy in many Conserva-
tive synagogues. The talit varies in length, depending on the Ortho-
doxy of the congregant. At each of the four corners hangs a set of four
threads, or fringes, tied and knotted together in a prescribed pattern.
These are the tzitzit, placed there in compliance with the Law (Num-
bers 15:38). A bandlike collar of woven design—often encrusted with

201. Tefillin box, by Moshe Zabari.
Silver and ebony;
height 2½″, length 5½″.
The letter *aleph* for the armpiece
and the letter *tet* for the headpiece
stand for the words "sign" *(ot)*
and "frontlet" *(totafot)* in the command
"Bind them as a sign on your hand
and let them serve as a frontlet on
your forehead" (Deuteronomy 6:8).
Collection Philip Kanof, Brooklyn,
New York

silver thread—marks one edge of the shawl as the top. The workshop Bet Arigah in Philadelphia produced a modern talit of finely woven white, blue, and silver thread, with a collar marked by a ribbonlike weave rather than a metallic rectangle (fig. 203).

Preparing for prayer, the pious Jew, having recited the proper benediction, drapes the talit over his head and forehead. He then, with his right hand, brings the right half over his chest, and with his left he gathers up all four corners, with their tzitzit. After a minute of meditation, he allows the collar to fall back from his head to the nape of his neck; he is then ready for prayer. The less orthodox simply prefold the shawl into a convenient shape and drape it over the shoulders.

Tefillin are small leather cases containing the basic Jewish declaration of faith, written on parchment. Their use is prescribed in Deuteronomy 6:8 ("Bind them as a sign on your hand, and let them serve as a symbol on your forehead"). Tefillin are strapped by leather thongs to the left arm and the forehead during weekday morning services. Their position on the left arm, close to the heart, and on the forehead may be interpreted as placing head, heart, and hands at the service of God. Tefillin are also called phylacteries, from the Greek word meaning to guard or protect, in the sense of an amulet. Their Jewish purpose is much better expressed by the Hebrew *tefillin,* which is related to *tefillah* ("prayer").

The parchment inside the cube is often rather beautiful in terms of regularity of script. The leather cases are usually enclosed in protective boxes, which are frequently embellished with ornamentation (fig. 200). These may be made of leather or silver. Moshe Zabari has designed a silver box with two compartments, one for each of the tefillin, each decorated with the initial letters of the key words of the biblical injunction (fig. 201). More often the cubes, in their leather or individual silver boxes, are kept in a special pouch, which offers an opportunity for fine needlework (fig. 202).

202. Case for talit and tefillin.
From the Mediterranean area, early eighteenth century. Red velvet with silver cut-outs; height 7½″, width 10½″.
Jewish Museum, New York.
Harry G. Friedman Collection

190

203. Talit,
woven at Bet Arigah, Philadelphia.
White, blue, and silver thread.
Collection Dr. and Mrs. Abram Kanof,
New York

The *arba kanfot* (lit. "four corners"), or *talit katon* (small prayer shawl), is worn by the children of the very orthodox before they attain the dignity of a full talit. It is a short rectangular cloth of wool, with fringes at the four corners and an opening in the center for the head.

The new bar mitzvah boy may also want a yarmulke, or skull cap. Plaut[2] suggests that the word was derived from a common mispronunciation of the diminutive form, *almucella* (or *armucella*), of the Latin word *almucia,* designating the almuce, a hooded cape once worn by the clergy. It seems plausible that the Slavic *yermolka,* applied to this vestment, was borrowed by the Jews from neighbors in Eastern Europe, where for centuries there was the greatest concentration of Jewish communities. While highly decorative skull caps are available commercially, they also offer opportunity for intricate embroidery, lovingly applied (fig. 14).

Having attained to Torah at his bar mitzvah, the young Jew looks forward to the huppah. Marriage has first priority in the calendar of Jewish life. A story told about Rabbi Judah ben Ilai, one of the great rabbis of the second century, illustrates this dramatically. He was at his studies when he noticed a small wedding party pass by. "Let us leave off our studies," he said to his colleagues, "and join the procession, for it is too small at present to honor a bride." Rabbi Jacob said,

191

204. Wedding procession.
From Paul Christian Kirchner,
Jüdisches Ceremoniel

"He who has no wife is without good, without blessing." To which his colleagues added "and without peace." These and many other quotations indicate how important marriage is in the Jewish tradition; it is not surprising that the wedding is surrounded by beautiful ceremonial objects (fig. 204).

The most important of these ceremonial objects is the marriage contract, the ketubah, a legal document by which the bridegroom contracts to protect his wife economically in the case of death or divorce. Though other peoples use similar contracts, it was the Jews who made it a practice to adorn them, thereby creating an art form that is uniquely Jewish. The earliest known decorated ketubah, dating from the tenth century, was found near Fostat, a suburb of Cairo, and is preserved in the Bodleian Library at Oxford. An early Karaite example, originating in Palestine about the year 1000, is in the Lemberg Collection of the Jewish Museum in New York. Another ketubah of great interest is that marking the wedding of the Revolutionary patriot Haym Salomon; it is in the collection of the American Jewish Historical Society at Waltham, Massachusetts (fig. 205).

Illuminated and decorated ketubot were produced by Jews throughout the world, the style varying according to the country of origin. The art of the ketubah reached the acme of color and beauty in Italy,

בסימן טוב

205. Ketubah recording the marriage
of Haim Salomon and Rachel Franks. 1777.
Collection American Jewish Historical Society,
Waltham, Massachusetts

especially in the seventeenth and eighteenth centuries. A characteristic
technique was to cut out part of the ornamental design and insert a
colored sheet underneath to highlight the intricate spacing. Many of
the most appealing ketubot are the work of folk artists and have a sim-
ple beauty of their own. The handsomest, however, are the work of
professional scribes and artists. In many instances the most decorative
element is the ornamental lettering. The text is usually framed in an
architectural portal. Frequently there are spiral columns reminiscent
of the traditional columns before the Temple of Solomon, or the

193

קול
ששון
וקול
שמחה
קול וקול
חתן וכל

בששי

בשבת תשעה ימים לחדש מרחשון שנת חמשת אלפים וחמש מאות ושלשים
וחמשה לבריאת עולם למנין שאנו מנין פה טריאיסטי מתא דיתבא על כיף
ימא הבחור היקר והנבון כמר שמשון בן הנביר והמרומם כמר קולונימוס הלוי אמ
להדא בתולתא הכבודה והצנועה מרת גראציה בת הנביר והנשא כמר אשר נאנו
הוי לי לאנתו כדת משה וישראל ואנא אפלח אוקיר אזון ואפרנס יתיכי כהלכת גוברין
יהודאין דפלחין מוקרין זנין ומפרנסין ית נשיהון בקושטא ויהיבנא ליכי מהר בתוליכי
כסף זוזי מאתן דחזו ליכי מדאוריתא ומזוניכי וכסותיכי וסיפוקיכי ומיעל לותיכי כארח
כל ארעא וצביאת הכבודה מרת גראציה בתולתא דא והות ליה לאנתו ודא נדוניא
דהנעלת ליה מבי אבוה סך שני אלפים וחמש מאות זילואטי וצבי הבחור הנעם
כמר שמשון הלוי הנל חתן דנן והוסיף לה מדיליה מאתים וחמשים זילואטי
סך הכל כתובתא נדוניא ותוספתא שני אלפים ושבע מאות וחמשים זילואטי
וכך אמר לנו מן חתן הנל אחריות הנל אחריות שטר כתובתא נדוניא ותוספתא דא
קבלית עלי ועל ירתאי בתראי להתפרעא מכל שפר ארג נכסין וקנינין דאית לי תחות
כל שמיא דקנאי ודעתיד אנא למקני נכסין דאית להון אחריות ודלית להון אחריות
כלהון יהון אחראין וערבאין להתפרעא מנהון שטר כתובתא נדוניא ותוספתא
דא ואפילו מן גלימא דעל כתפאי בחיי ובמותא מן יומא דנן ולעלם ואחריות וחומר
כל שטרי כתובות דנהיגי בישראל העשוין כתקון חזל דלא כאסמכתא ודלא
כטופסי דשטרי וקנינא אנן חתן סהדי דחתומי לתתא מכבר שמשון החתן לזכות הכבודה
הכלה מרת גראציה הנל על כל מאי דכתיב ומפרש לעיל במנא דכשר למקניא ביה והכל שריר וקיים

Temple itself may be represented. Ornamental motifs include flowers, butterflies, and other insects, and birds such as woodpeckers, robins, and swallows. The plant life may be intended to illustrate the symbolism in Psalm 128: "Thy wife shall be as a fruitful vine, in the innermost parts of thy house; thy children like olive plants, round about thy table."[3] The frequent appearance of the pomegranate, with its plethora of seeds, bespeaks the hope for a plenitude of offspring. The restriction against portraying human figures was entirely disregarded, and loving couples are frequently pictured. A fine eighteenth-century example in the Jewish Museum (colorplate 18) shows a well-delineated Adam and Eve regarding each other ardently, perhaps accentuating the benediction in the marriage ceremony: "Blessed art Thou who makes these loved companions greatly to rejoice, even as of old Thou didst gladden thy creatures in the Garden of Eden." Illustrations were often inspired by the Torah reading and the *haftorah* of a Sabbath close to the day of the wedding. Various other themes recur: the four seasons, Temple scenes, the family "coat of arms" of bride or bridegroom, and the blessing hands of the Kohanim. Illustrations sometimes refer to biblical namesakes of the bridegroom or bride. A unique Italian ketubah (colorplate 19) contracts the symbolic wedding of God and Israel, the two witnesses being Heaven and Earth. Inscribed are extracts from the Torah reading on Shavuot, which refer to the giving of the Law on Mount Sinai and its acceptance by Israel (Exodus 19: 16–25).

Representations of God are not found on ketubot. The sun and the moon are rarely seen because of talmudic prohibition, but the term *mazel tov,* meaning "favorable star," often illustrates the wish that a favorable constellation shine upon the marriage. The zodiac signs that appear on ketubot are from antique and Christian art, but they differ from the sources in that they run counterclockwise.

As in other manifestations of Jewish art, the decoration of the ketubah strongly reflects the period in which it was executed. During the Baroque, the marriage contract assumed an exuberant appearance, and it became even more elaborate in the Rococo period. Then the Neoclassic took the stage, and we find one ketubah that shows the bride and groom being joined in matrimony by the pagan deities Venus and Cupid. A contemporary version by Ben Shahn returns to the original concept and depends entirely on calligraphy for decorative effect (fig. 206).

One of the most interesting and distinctively Jewish additions to the wedding ceremony is the community marriage ring. While the

Colorplate 18. Ketubah. From Italy, 1775. Parchment,
with painted and cut-out decoration and gold-painted inner frame;
$27\frac{3}{4} \times 22\frac{1}{4}$". Adam and Eve, the sacrifice of Isaac, and the drunkenness of Noah.
In the four corners of the border framing the text,
symbols of the four seasons. Jewish Museum, New York.
Harry G. Friedman Collection

Colorplate 19. Ketubah. From Italy, eighteenth century.
Parchment, folio size. The marriage recorded is the symbolic union
of God and His people, the dowry being the Law: "And the nation
consented to become his beloved wife, and said,
'We will obey and listen.' " The signatories are "the heavens
and the earth as witnesses." Jewish Museum, New York.
Harry G. Friedman Collection

206. (FACING PAGE)
Ketubah, by Ben Shahn.
India ink and gouache, written
and painted on paper; 26 × 20″.
Jewish Museum, New York.
Gift of Albert and Vera List

207. Wedding rings.
From Italy, seventeenth century.
Musée de Cluny, Paris

208. Wedding ring,
by Ilya Schor. Gold.
Collection Resia Schor,
New York

209.
Wall plaque, by Ilya Schor.
1956. Silver; height 6″, width 4″.
Celebrating twenty-fifth wedding
anniversary; inscribed with part of
the wedding benedictions. Patterned
after the paper cut-outs of Eastern
Europe. Collection
Dr. and Mrs. Abram Kanof, New York

plain circlet is a universal token, the rings that appeared around the sixteenth century are uniquely Jewish ceremonial objects; the most unusual examples are Venetian in origin. These rings often bear a representation of a home or of the Temple with the inscription *mazel tov* (fig. 207). Occasionally marriage rings were a family possession, handed down to successive generations of brides; more often they were owned by the community and lent to the new bride for the week following her marriage. A ring by Ilya Schor shows a bride and groom under the huppah (fig. 208).

Among objects of interest created for the wedding ceremony is a barrel-shaped double cup, from which the two ceremonial sips of wine are drunk. Traditional gifts for the bride included a sash, often of woven silver, a veil, a wreath, and, most typically Jewish, a *siflonot tefillah,* a Hebrew prayer book, inscribed with sentiments of love and peace. The bridegroom often received a talit and a Scroll of Esther. Sentimental German Jews commissioned other objects to commemorate a marriage. A medal struck for the wedding of Helen Emanuel of Cologne and Siegfried Haventhal of Frankfurt shows the date, two hands clasped in a reproduction of a huppah, the insignia of the two cities thus happily related, and the Hebrew inscription "Who finds a wife, finds good."[4] A similar commemorative piece by Ilya Schor, made in 1956, marks the twenty-fifth anniversary of a happy marriage (fig. 209).

XI.

hallmarks of
a jewish home

In addition to the objects used in specific rituals and ceremonials, there are others that, by their presence, distinguish the Jewish home. The mezuzah, the east-wall marker, and—throughout the home—various indications of religious and historical heritage serve as hallmarks of the Jewish home.

The mezuzah (lit. "doorpost") is, technically speaking, a rectangle of parchment on which is inscribed in twenty-two lines the first two of the three passages of the Bible (collectively called the Shema) that express the central idea of the Jewish faith (Deuteronomy 6:4–9; 11:13–21; Numbers 15:37–41). This custom of displaying on the doorposts passages declaring the unity of God—followed in obedience to the injunction "inscribe them on the doorposts of your house and on your gates" (Deuteronomy 6:9; 11:20)—is of great antiquity. Ancient Egyptians customarily placed a sacred document at the entrance to their houses, and Muslims today place a profession of faith over their doors or windows.[1]

At first only a summary of the twenty-two lines was inscribed on the doorpost. When it became customary to exhibit the verses in full they were inscribed on a parchment which was fastened to the doorpost. Later the parchment was placed into a scooped-out hollow in the doorpost. On a trip to Israel the author saw a mezuzah, visible behind a rectangle of glass, in a space created by omitting a brick in the wall near the entrance.

It was but a short step to the use of a container; the first were hollow reeds, and eventually a great variety of ornamental cases evolved. The case is affixed at eye level on the right doorpost, with its upper end turned obliquely inward. On the reverse of the parchment the scribe usually writes the word *Shaddai* ("Almighty") so that it can be read through a small window in the container. The pious touch this special

210.
Mezuzah. From Galicia, 1850.
Wood; height 10½″, width 2¼″.
Jewish Museum, New York

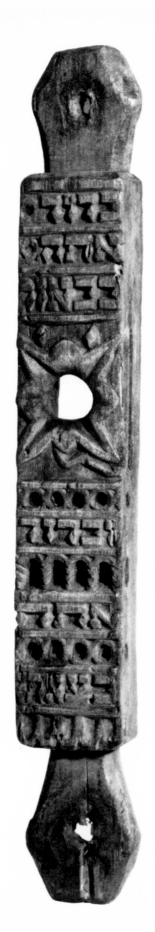

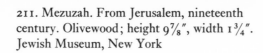

211. Mezuzah. From Jerusalem, nineteenth
century. Olivewood; height 9⅞", width 1¾".
Jewish Museum, New York

212.
Mezuzah, by Resia Schor. Silver; height 7",
width 4". The offering of Isaac, surmounted by the *shin*.
Collection Mr. and Mrs. William Bell, Hartford, Connecticut

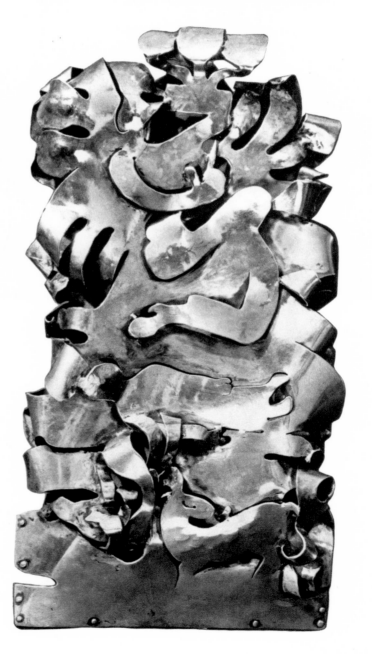

Bodleian Library in Oxford, the library of the Jewish Theological Seminary of America, and other libraries have many Bible manuscripts and commentaries. The first important collector of such objects in the United States was Judge Mayer Sulzberger, whose collection of rare Hebraica forms the core of the great library of the Jewish Theological Seminary. Jacob Schiff helped establish an important Judaica collection in the Library of Congress, Washington, D.C., around the Deinard Collection. Ephraim Deinard was a remarkable man who spent his life searching for books, and the results were not only the founding of the Sulzberger and Library of Congress collections of Judaica but also those at the Hebrew Union College in Cincinnati and at Harvard University (Littauer Collection), Cambridge, Massachusetts.

During the Middle Ages, manuscript illumination was a widely practiced art form among the Jews. Just as the artists of the Christian world expressed their love of form and color in religious painting, so the medieval Jews found creative expression in the calligraphy and illumination of their sacred books. In the large collections of Judaica mentioned above, about seven per cent of manuscripts are thus embellished. We know that this art form was practiced mainly by Jewish artists not only from signed colophons but also from intrinsic evidence

214. Mizrach.
Nineteenth century.
Paper, with painted and drawn decoration; height 12¼″, width 15″. Moses, Aaron, angels, and cherubim. Jewish Museum, New York. Harry G. Friedman Collection

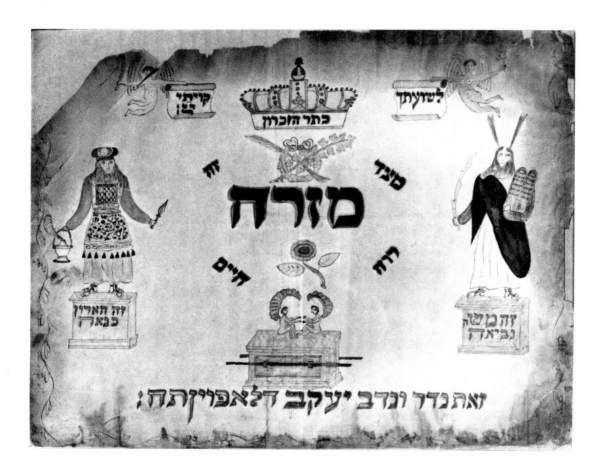

in the illustrations. The most popular of such decorated manuscripts were the Passover Haggadah, the Purim megillah for home use, and the ketubah.

It is not surprising that for the "People of the Book" those artists who have a part in the mechanics of bookmaking—the scribe *(sofer)*, the illuminator, the printer, and the binder, not to mention the author— should all enjoy quasi-official status. The tradition of the Jewish scribe is an ancient one, and his craft was revered. A Talmudic sage, for example, exhorted a scribe as follows: "My son, take care how thou dost thy work, for thy work is a divine one." Aaron Freiman[2] added a list of 491 medieval Italian scribes to his previous enumeration of German, Spanish, and Portuguese experts. There is even, as noted earlier, a book on the art of manuscript illumination written in Portuguese and Hebrew by Abraham ibn Hayyim and published in Portugal in 1262.[3] When the invention of printing rendered superfluous the non-Jewish scribe, the *sofer* continued in active service. Today he is still needed, to produce Torah scrolls and Megillot Esther and to inscribe tefillin, mezuzot, and occasionally a ketubah—all of which, to be ritually acceptable, must be written by hand.

Soon after the advent of printing we find Jews well represented in the new craft. The first dated Hebrew book produced on a printing press was a Rashi commentary on the Pentateuch published in Reggio in 1475. In Portugal, the first book printed in any language was a Hebrew Bible of 1487. The most famous of all Jewish printers were the

215. Mizrach, by Ludwig Wolpert (Tobe Pascher Workshop). Bronze letters against enamel ground; diameter 6″. Jewish Museum, New York

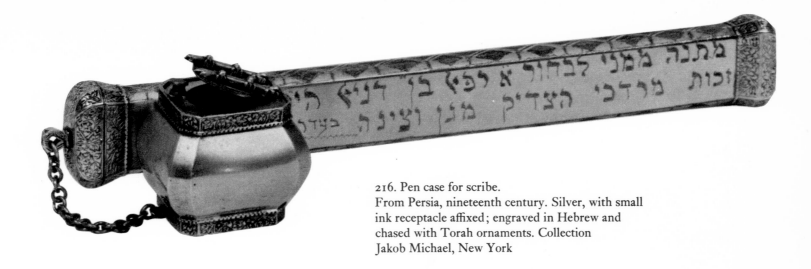

216. Pen case for scribe.
From Persia, nineteenth century. Silver, with small ink receptacle affixed; engraved in Hebrew and chased with Torah ornaments. Collection Jakob Michael, New York

Soncino family, whose press was founded in the Italian town of Soncino in 1483; their colophon was a tower, probably representing the town's Castel Maggiore. The first printed siddur, or prayer book, was produced by them in 1486. They printed not only Hebrew books but many secular works and books of Christian religious interest. The press moved around considerably during its existence, and the last of the original Soncinos died in Constantinople in 1547. Daniel Bomberg was a Christian who issued one of the first printed Bibles with rabbinical commentaries; he is often referred to as the father of Jewish typography. Bomberg was born in Antwerp but worked in Venice, where he died in 1549. Menasseh ben Israel, famous in history for his successful efforts to restore Jewish rights under Cromwell, completed the printing of the first Hebrew book in Amsterdam in 1627, establishing a tradition in Hebrew typography and publishing in which that city remained pre-eminent until the beginning of the eighteenth century.

Along with the Jewish scribes, illuminators, and printers serving the beauty of holiness was the Jewish bookbinder. There was at least one in every ghetto; especially famous were those in Prague and in Italy. Jewish bookbinders were held in such high esteem that in 1459 a Jew bound several books for the city council of Nuremberg—the same Jew who wrote and illustrated the Nuremberg Haggadah now in the Hebrew Union College collection. The earliest bindings for Jewish books that we know are those in the Cairo Genizah. They are parchment envelopes in which the pages are secured with ribbons or straps, a form of binding still seen among the Jews of Yemen. After the invention of printing, wealthy book owners frequently ornamented Bibles and prayer books with brass, gold, and silver covers. Some of these covers are distinguished only by their massiveness, the metal forming a complete case for the book. In others, the case is formed by delicate filigree or the binding is of leather, with the edges, or corners, and part of the spine reinforced and beautified by metal ornamentation.

217. Decorative tablecloth for
Rosh Hashanah. From Italy, eighteenth century.
Jewish Museum, New York

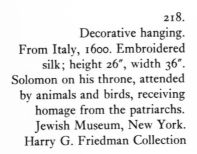

218.
Decorative hanging.
From Italy, 1600. Embroidered
silk; height 26″, width 36″.
Solomon on his throne, attended
by animals and birds, receiving
homage from the patriarchs.
Jewish Museum, New York.
Harry G. Friedman Collection

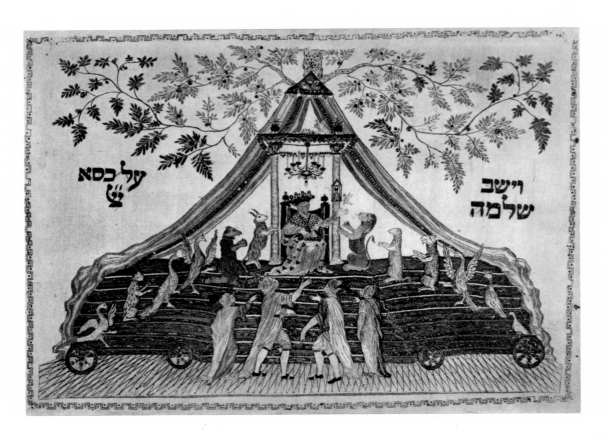

Today it is not feasible to commission an illuminated Bible or mahzor; however, it is not impossible to secure a stock book personalized by a craftsman's binding. Such a mahzor could well be used as a modern *siflonot tefillah,* a prayer book for presentation to the bride (colorplate 21). Such gifts have recognized status in Jewish law and are the subject of much talmudic discussion. An even more popular gift, in the eighteenth and nineteenth centuries, was the *tehinah* or *tsena ure'ena.* This was a compendium of Bible, Talmud commentary, romance, martyrology, marriage guidance, prayers for every day and for special situations (pregnancy, for example)—a general prop for womankind for use throughout the trials and joys of married life.[4]

Jewish book collectors have given much thought to the design of bookplates, and there has developed a small but appealing genre which has been fully annotated by Philip Goodman in a monograph listing about seven hundred examples.[5] Goodman refers to two sixteenth-century bookplates with Hebrew inscriptions by Albrecht Dürer, but there was no widespread use of bookplates by Jews until two centuries later. In this age of commercial printing, an expressive bookplate and a specially commissioned binding are important ways to express one's own personality and love of books.

Colorplate 21. Mahsor binding, with plaques by Ludwig and Chava Wolpert. Silver on enamel; heights, 7¾", 1¾", 7¾". Inscribed: "Who maketh the barren woman to dwell in her house as a joyful mother of children" (Psalms 113:9); "God is King, was King and will be King for ever and ever" (from the Rosh Hashanah liturgy). Collection Dr. and Mrs. Abram Kanof, New York

XII.

the synagogue: evolution, architecture, and contents

The origins of the synagogue have been the subject of much scholarly investigation. There is evidence that the synagogue is an even older institution than the Temple, and that community prayer services date back to early biblical times. The term *mikra kodesh* (sacred reading), which appears so often in the Bible, seems to refer to that kind of religious convocation. Moreover, Solomon's prayer at the dedication of the Temple does not mention animal sacrifice but seems on the contrary to indicate the existence of ancient houses of prayer (I Kings 8:28). Thus even at the beginnings of Judaism there probably was an institution which, forgoing animal sacrifices, gradually developed into a synagogue for prayer, supplication, and study.[1]

In conformity with the program of religious reform carried out by Josiah (621 B.C.E.), the local sanctuaries, or *bamot* ("high places"), far from Jerusalem, were forbidden to engage in sacrificial worship, which again was centered exclusively in the Temple. However, there was no prohibition against other types of worship, and the people of distant towns continued to gather at their local sanctuaries for study and prayer. In the earliest times worship must have been conducted in the open air. Later, dwellings may have been used. Still later, perhaps, the *beth am*, or town hall, was used for religious services. In time, buildings were erected exclusively for religious purposes. There is general agreement that the synagogue was an important institution by 600 B.C.E.

When, in 586 B.C.E., the Temple was destroyed, the synagogue became the only place for Jewish worship. After the restoration of the Temple (516 B.C.E.), the synagogue persisted as an indispensable institution, not only for the Jews in Babylonia but for the returned exiles. Synagogues began to spring up in Jerusalem itself; residents

219.
Ark from the Genizah in Cairo.
Thirteenth century. Wood, 119×76½×20½". Inscriptions quote Psalms and Deuteronomy and name and praise the donors.
Jewish Museum, New York

and those who had come for the pilgrimage festivals might, in addition to offering sacrifices in the Temple, worship through prayer and study. Five centuries later, when the Temple of Herod was destroyed, the synagogues of Jerusalem also suffered, but by then there were hundreds of others, not only in Palestine but in many cities of Asia, Africa, and Europe. The earliest as yet discovered by archaeological exploration is that in Masada: a Jerusalem-oriented, rectangular structure originally built by Herod (30 B.C.E.) and remodeled by the Zealots, who occupied the fortress-palace for three years after the fall of Jerusalem.[2] Thereafter, wherever the Jews wandered they built their synagogues; the development of the synagogue may have meant the difference between extinction and survival, since it made possible the conduct of religious services in any place where there were Jews.

Although the synagogue and the Temple have played a central role in Jewish religious observance, there are major differences between them. The Temple was unique, and its location was fixed; there are no numerical or geographical limitations for synagogues. The Temple was an imposing national house of worship; the synagogue has no political tradition, and its appearance as a building is secondary to its function. The Temple was a governmental institution ruled by a hereditary caste; the synagogue service can be conducted by any pious Jew. In the Temple, participation of the congregation was generally subordinate to the role of the priest, as in the pagan shrines; in the synagogue the congregation joins actively in prayer and study. In the Temple service the people sought the presence of God; in the synagogue Jews communicate with God, study His wishes, and learn His law. The Temple entrance faced east so that the first rays of the rising sun would enter through it and shine along the axis of the building to the Holy of Holies on the western wall (Ezekiel 43:1–4). The Prophets were suspicious of solar-directed idolatry, however, and actually bricked up the eastern portal. When synagogues were built, they were entered from the west, while the Holy Ark was placed to the east. The tradition of east orientation was further strengthened by the injunction of the rabbis that worshipers face in the direction of the Temple. Such is the mystique of the east that even Jews for whom Jerusalem is to the west face eastward during prayer.

Despite these important differences, memories of the Temple linger on in the order of synagogue services. The morning service *(Shaharit)* is modeled after the regular morning sacrifice in Jerusalem; the afternoon service *(Minha)* harks back to the afternoon sacrifice. Following the afternoon sacrifice, the priests would wait in the courtyard until the fat of the sacrificed animals had burnt itself out. Because of this waiting there arose the habit of prayer at night, and it is from this custom that the evening, or *Ma'ariv,* service derives. There are also reminders of the Temple in the synagogue appurtenances: the lion decorations, reminiscent of the cherubim; the seven-branched

220. (FACING PAGE) Ark, by Ludwig Wolpert, in Temple Emanuel, Great Neck, New York. Wood, with oxidized brass Hebrew lettering mounted on aluminum spiral; height 27′

candelabrum, symbolized or in actual use; and, of course, the turning toward the east as the congregation stands for important prayers.

Although the synagogue idea of congregational worship and study is a unique contribution to religious thought and organization, and although the rabbis elaborated a detailed order *(seder, siddur)* of prayer, the architecture of the synagogue building has no intrinsic Judaic tradition. The synagogues of the early centuries resemble the secular buildings of the Greeks and Romans, modified consistently by orientation toward the east and the presence of the Ark and the central bimah, or platform. As Christianity gained ascendancy, the synagogue often took its architectural style from the churches. However, there is an important difference. The exterior of the church became more and more complex and decorative with time, as transepts, chapels, and a steeple were added. The Jewish service required none of these, so that as the church became more elaborate externally, the synagogue remained simple in its exterior. During the Middle Ages the tendency was for even greater restraint owing to restrictive papal regulations. However, no matter how stringently law or custom might restrict the outer appearance of the synagogue, the interior usually enjoyed at least a modicum of decoration, and an impressive beauty was apparent in its ceremonial objects.

The most distinctive features of the synagogue interior are the Ark which houses the Torah scrolls, the central bimah, and the

221.
East wall of the
synagogue of Suchowola, Poland. From
M. and K. Piechotka, *Wooden Synagogues*

212

women's section. Reading from the Torah became an important part of the synagogue ritual in the time of Ezra (fifth century B.C.E.). The scrolls originally were kept in a room outside the prayer hall and were brought in for reading at the appropriate time. Later they were kept in a cabinet or in a niche in the prayer hall throughout the service (they could be removed when the area was used for civic events). The permanent Ark probably first appeared in the homes of Jews who could afford to set aside a room exclusively for services.

From these modest beginnings the Holy Ark *(aron hakodesh)* became the outstanding feature of the synagogue. It always stands against or is built into the east wall, generally elevated so that it is preceded by several steps; congregants, looking upward, can truly say, "Out of the depths have I called Thee, O Lord" (Psalms 130:1). The platform in front of the Ark is usually large enough to accommodate several persons, and in modern structures it may also accommodate the pulpit for rabbi and cantor and the table from which the Torah scroll is read. The platform is usually surrounded by a balustrade. Frequently the structural style and decorative motif of the Ark are continued onto the wall on both sides, so that the whole of the east wall, or at least the greater part of it, is richly ornamented. All degrees of elaborateness are to be found in the design of the Ark. In some synagogues the Ark is thoroughly integrated into the architectural scheme of the building; in others, for example the Sephardic synagogue in Amsterdam, it is a handsome piece of cabinetwork independent of the structure. In some cases the Ark, following the ancient custom, is made entirely of wood; in others, it is made of the same material as the walls.

Despite the growing elaborateness of the Ark the idea of a freestanding cabinet was never forgotten. An ancient and beautiful example from thirteenth-century Cairo is in the Jewish Museum of New York (fig. 219). All the parts but the top were found by Solomon Schechter in the Cairo Genizah. Reconstructed in 1902, this Ark was used in the Jewish Theological Seminary of America from that year until 1932. About three centuries later in date is a painted and gilded wooden Ark from Germany (colorplate 25), with carvings of the Tablets of the Law and of a pair of lions, rampant, supporting the characteristic Crown of the Torah. In a twentieth-century freestanding Ark by Ludwig Wolpert (fig. 220) the antiquity of the artist's concept is apparent, yet the finished work has the contemporaneity of modern materials fabricated into a modern design. The ten words mounted in the spiral express the divine attributes: the will to create, wisdom, understanding, love, justice, beauty, everlastingness, majesty, stability, and kingship.

During the eighteenth century it became customary to surmount the Ark with the Tablets of the Law, usually supported by two lions, rampant (fig. 221). According to scriptural tradition (I Kings 8:9) such tables of stone were placed by Moses in the Ark at ancient Horeb,

Colorplate 22. (FACING PAGE)
Ark of the Jewish Chapel, Brandeis University,
Waltham, Massachusetts. Wood. Curtains
(parochot) designed and woven by
Helen Kramer

and they were still there when the Temple of Solomon was dedicated. Generally these Tablets of the Law are the focus of the architectural design of the synagogue (fig. 222).

The closed doors of the Ark are usually covered by a curtain, the parochet. In the Tabernacle and the Temple of Solomon a curtain shielded the Holy of Holies. In the earliest synagogues there was a curtain setting off the area containing the niche in which the scrolls remained during the services. When the Ark became a permanent fixture, the curtain was hung within its doors to protect the individual scrolls. When the five books came to be incorporated into a single scroll, this scroll was covered, or "dressed," with a mantle. With the introduction of the Torah mantle the curtain became purely decorative and was moved outside the Ark doors, except in Sephardic synagogues, where it remains within the doors. The Sephardic custom afforded Ilya Schor the opportunity to create one of the finest Ark doors of modern times (fig. 224). An old tradition, and one now enjoying a renaissance, is for the women of a congregation to design the Ark curtain and assemble it from pieces of fabric having special personal associations, such as a portion of a wedding dress. The art of the parochet flourished in the seventeenth and eighteenth centuries under the sway of the Baroque (colorplate 3). Not only were curtains made of the richest material, but, since the number of donors who could afford to have their names perpetuated was considerable, there were different sets for weekdays, for the Sabbath, for the festivals, and for the High Holy Days. In addition to personal inscriptions, the designers favored floral arrangements, fruits, grapevines, doves, eagles, lions, and all the appurtenances of the ancient Temple, especially the spiral fluted columns supposedly reminiscent of those before the entrance to Solomon's Temple.[3] Commonly a horizontal top piece—the kapparet—matches the parochet. Another companion piece is the richly embroidered cloth covering the reading table. In a small Ark designed for the home (fig. 225) Helen Kramer combined door and curtain by covering the wooden door with an intricately symbolic woven fabric. Mrs. Kramer also designed the Ark curtains in the Jewish chapel at Brandeis University; these are always visible through the open doors, and give the Ark the feeling of a desert tabernacle (colorplate 22). A design by Helen Frankenthaler was executed on a red background for the usual service, on a white background for the High Holy Days (fig. 226).

The central bimah, a prominent feature of Orthodox synagogue architecture, has no counterpart in the Christian church. The tradition that the bimah be placed in the middle of the synagogue is based on the precept "You shall read this teaching aloud in the midst of all Israel" (Deuteronomy 31:11). In the days of Ezra, when exposition of the Bible was an important feature of Jewish worship, people gathered about the reading platform in order to hear. In the synagogue,

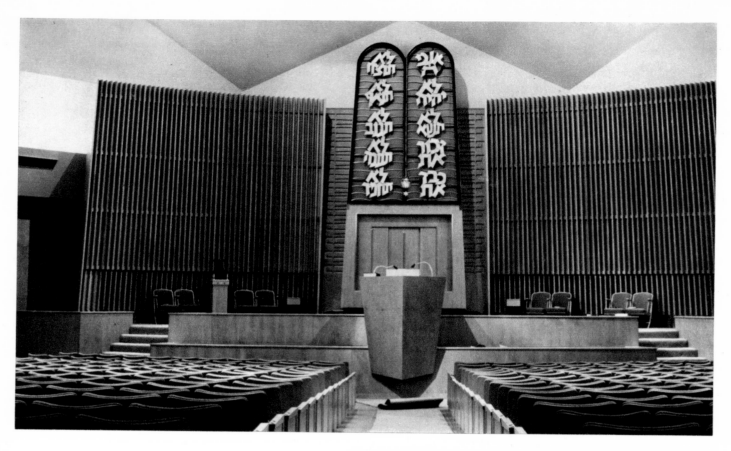

222. Ark, with Tablets
of the Law, by Ludwig Wolpert, in Temple
Har Zion, Baltimore. Bronze;
height 14', width 8'

223.
East wall of the synagogue
in Carpentras, France (reconstructed 1741).
On a carved corner bracket to the right
of the Ark, a miniature Elijah's chair
(shown also in Figure 194)

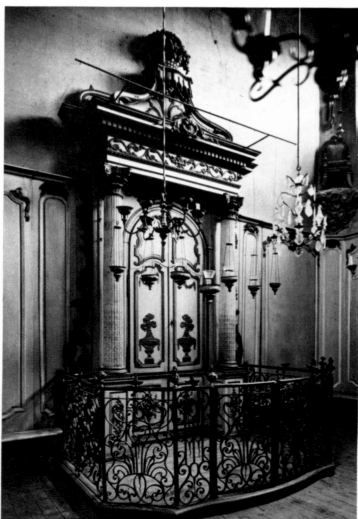

224. Ark doors *(The Doors of the Thirty-Six)*, by Ilya Schor, in Temple Beth El, Great Neck, New York. Silver repoussé panels on wood; height 6', width 4'. Each panel represents one of the thirty-six righteous men *(tzaddikim)* whose existence in each generation, according to Hasidic legend, makes possible the continuance of the world

when the Ark and the reading table are separated by a space, there is a splendid interval in the service during which the Torah scrolls are carried ceremoniously from the Ark to the table. To the bimah come ten or more members of the congregation, called upon to service the reading of the scrolls; from here the hazzan (cantor) sings some of his most stirring prayers, often surrounded by an imposing choir; from here too the scrolls are dramatically lifted and exhibited to the congregation.

225. Ark for the home, by Helen Kramer. 1961. Hand-woven fabric on wood; height 36", width 18½". *Echod* ("One") dominating three areas, representing sky, water, and land—all made by one God. Collection Dr. and Mrs. Abram Kanof, New York

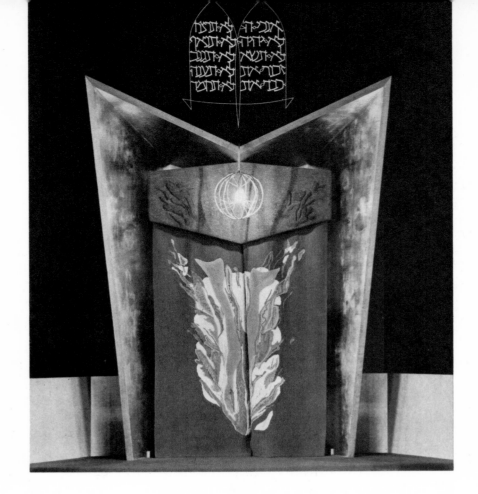

226.
Ark in the Temple of Aaron,
St. Paul, Minnesota. Curtain by Helen
Frankenthaler (executed by Fields); eternal
light by Ibram Lassaw. Courtesy
Percival Goodman

As time went on, there was increasingly lavish development of the bimah: steps, banisters, and canopy-like roofs of timber, iron, or stone were added (fig. 227). In some synagogues of Europe the bimah was surrounded by pillars or columns on all four sides; these often supported a stone baldachin. Thus the bimah assumed an even greater architectural importance, making the center of the synagogue not only the place for Torah reading but the architectural focus as well. Throughout the centuries there has been a struggle between the bimah and the Ark for architectural supremacy. The recent tendency is to move the bimah toward the east wall, and in most Conservative and Reform synagogues the platform in front of the Ark serves as the bimah. This creates one large, impressive focal point for the congregation, but it tends to diminish the individuality of the synagogue, and to bring it closer to the arrangement in a Protestant church.

Colorplate 23. (FACING PAGE)
Miniature rimonim. Gold, height c. 4".
Colonettes enclose, in upper tier,
ewer and basin, and, in lower tier, menorah
and Tablets of the Law; filigree rings
applied on dome; eight bells suspended on chains.
Collection Jakob Michael, New York

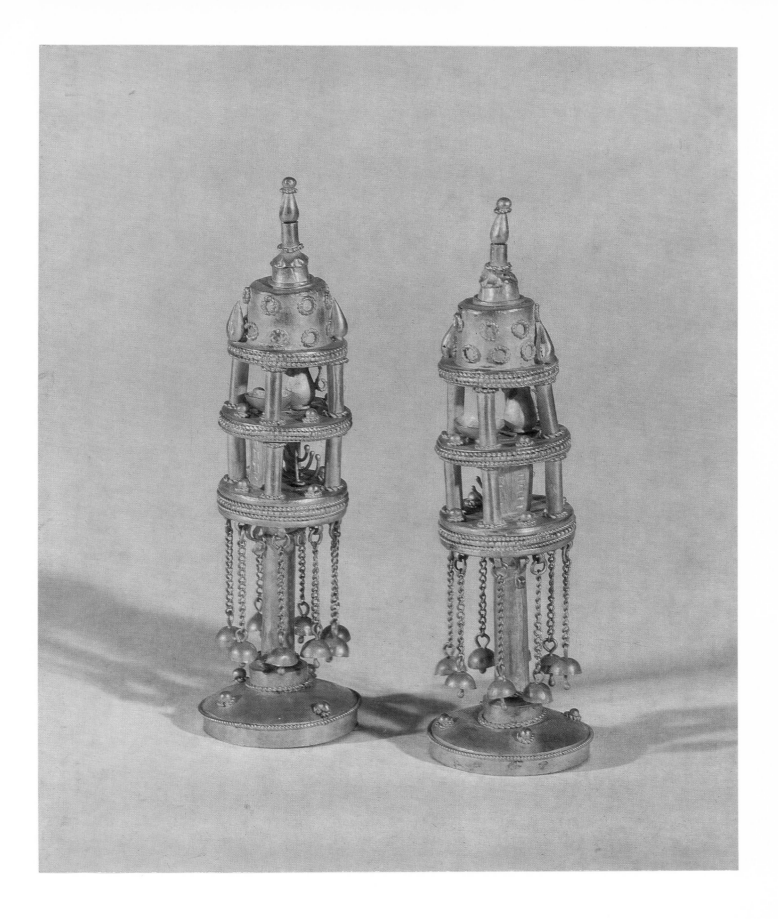

The traditional separation of the sexes created its own architectural problems. In the ancient classical synagogues of Palestine there was a gallery for women, supported by stone columns, running around three walls of the structure. Later, as in the Dura Europos synagogue, the women worshiped, or watched and heard the men worship, from a separate room connected by a narrow door or archway to the main hall. The same plan of a connected but separate room for the women was followed in medieval times in such synagogues as those in Worms and Prague; in others, as in El Transito in Toledo, the women's gallery persisted. In the synagogue at Carpentras, the problem of separation was solved in an original manner: the women worshiped in the basement and they heard the cantor's voice through an opening measuring about one by two feet and covered with an iron grille. Later this arrangement was changed; the women's section is now an aisle running along one side of the main hall and separated from it by wooden latticework.

In the Sephardic synagogue of Amsterdam there was a space between the Ark in the eastern wall and the central bimah, and the benches faced each other within this space. While this arrangement—still adhered to by the Sephardim—made for an intimate service, it reduced the number of seats. In compensation, galleries were built for women

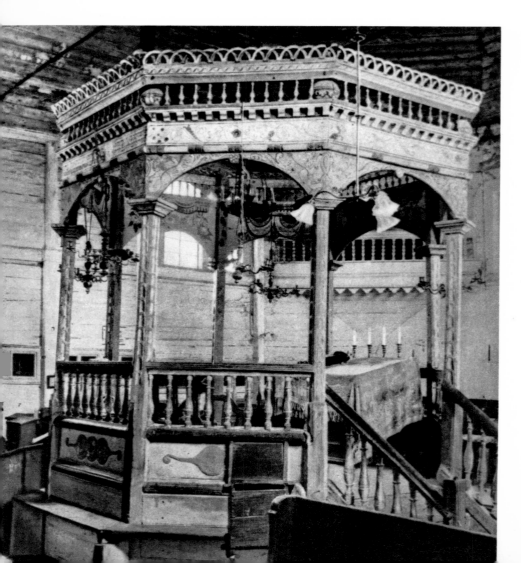

227. Bimah of the synagogue in Gabin, Poland. From M. and K. Piechotka, *Wooden Synagogues*

worshipers. The gallery arrangement was adopted by most Ashkenazic synagogues and became the usual arrangement in America, with or without the addition of curtains or screens. Since World War II, there has been a tendency in Orthodox synagogues to bring the women again down to the main floor and to separate them by a curtain or screen. Reform Judaism entirely eliminated this symbolic separation, an innovation also adopted for the most part in the Conservative movement. It is of interest that the separation of the sexes during worship was customary in some of the early American churches. In Williamsburg and in New Haven men and women were separated—albeit on the same floor—while in the Old Dutch Church of lower Manhattan in New York men sat "for the most part" in the gallery while the women were allowed on the main floor.[4] The Quakers separated men and women as late as 1830. Today in the Amana Colony in Iowa the women not only worship separately but enter the church by a separate door.

Equally as prominent as the Tablets of the Law, and focusing attention on the contents of the Ark, is the eternal light (ner tamid). In medieval engravings of synagogue interiors, especially those of Sephardic Italy and southern France (fig. 223), we see many lamps but never an eternal light. Nor does the literature of the period refer to such a fixture. Perpetual lamps were used in the Polish synagogues of the sixteenth century, but they were placed in a niche in the wall near the entrance to avoid imitating the Temple custom, which placed the eternal light near the Ark of the Covenant.

On the platform before the Ark there are also usually one or two seven-branched menorot and occasionally a hanukiah. Keeping one bulb unscrewed was the old-fashioned way of distinguishing the contemporary candelabra from the originals. The modern menorot are so removed in design from the classical Temple originals that no subterfuge is necessary. The hanukiah in America is generally seen only during Hanukah, in contrast to the European tradition, which keeps it at all times to the right of the Ark, as a constant reminder of the purification and rededication of the ancient sanctuary.

In the older synagogues there was usually an inscribed plaque (figs. 228, 229) near the cantor's table, with the word *shiviti,* which is the opening word of the personal prayer of humility uttered by the cantor before engaging in public prayers. This decoration has survived in some modern synagogues as a large ornamental inscription arching over the Ark.

The least conspicuous synagogue object and yet the one that when in use indisputably surpasses all other appurtenances in evocative power is the shofar. This ancient reminder of Abraham's implicit obedience to God shares with the menorah the distinction of being one of the most Jewish of Jewish symbols. Unlike the menorah, however, it has had an uninterrupted use in Jewish history. Its most ancient purpose was to frighten demons, or enemies, as the case might

228. Shiviti of the synagogue in Olkienniki, Poland. Hand lettering and wood carving. From M. and K. Piechotka, *Wooden Synagogues*

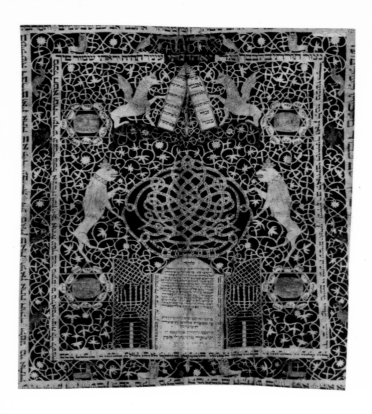

229. Shiviti. From Galicia, 1846.
Cut-out parchment, 14×12½″. Open Ark,
menorot, cherubim supporting the Tablets of
the Law, lions, flowers, griffins, birds, and
appropriate inscriptions. Jewish Museum,
New York. Gift of Mr. and Mrs. George Sagan

be. It was the sound of the shofar "exceeding loud" that, coming from the thick clouds on Sinai, heralded a new ethical religion. On Sinai two psychological effects were combined: the sound was the herald of a new order, but it also may have served to frighten the Israelites away from the confines of the holy mountain.

In ancient days the sound of the shofar accompanied the procession that carried the Ark back to Jerusalem after it was recaptured from the Canaanites. Thereafter it ushered in the Sabbath, announced the new moon and the festivals, and celebrated the accession of a king. In battle it initiated the fighting, rallied a dispirited army, and signaled the end of a conflict, announcing either victory or defeat. In times of stress it was blown even on the Sabbath: to bring rain, to warn of floods, to ward off locusts, and to warn of wild beasts or enemy armies. In past ages it was used to call the congregation to a day of penance, to announce an excommunication, to publicize a rabbinic decision, or to signal a funeral. On these occasions practical, superstitious, and pious motivations merged, for the sound not only warned and awed the populace but also reminded the Almighty of the plight of His people.[5]

At present the most solemn occasion of the shofar's use is in the synagogue on Rosh Hashanah and Yom Kippur. The rabbis explain that the sound of the shofar reminds God to move from the throne

230. Omer calendar. From the Netherlands,
eighteenth century. Wood with parchment manuscript;
height 16″, width 10½″. Jewish Museum, New York.
Harry G. Friedman Collection

of judgment to the throne of mercy. It also reminds Him of the willingness on the part of Abraham to serve Him with the sacrifice of Isaac. While the shofar may be made of the horn of any clean animal (except the cow or calf, which would remind us of the graven image worshiped in the desert), it is usually made of a ram's horn. The decorative aspect of the shofar derives both from its shape, which varies considerably with the animal whose horn is used, and from the designs carved on it, which are sometimes quite intricate.

A conspicuous furnishing of the older synagogues, infrequently seen today, is the Omer calendar (fig. 230). It is used to record and announce each of the forty-nine days between the second day of Passover and the last day of Shavuot (Leviticus 23:15–16). During this period the cantor refers to the calendar as he begins the benediction that states the number of days that have elapsed since Passover.

The full splendor of synagogue ceremonial art is revealed when the Ark is opened. Toward the end of the Sabbath *Shaharit* service the congregation rises as the parochet is drawn aside, the doors of the Ark are opened, and the Torah scrolls are revealed (figs. 231–234). The sacred scrolls are removed by the cantor and the rabbi and are held up to the view of the congregation. Cantor and congregation then recite the declaration of Jewish faith: an affirmation of the unity of God and the centrality of His law. The "dressed" Torah is a resplendent sight. Protecting and exalting the scroll is the mantle, through the top of which protrude the two wooden staves on which the scroll is rolled—called, like the Torah itself, *etz hayyim* ("tree of life").

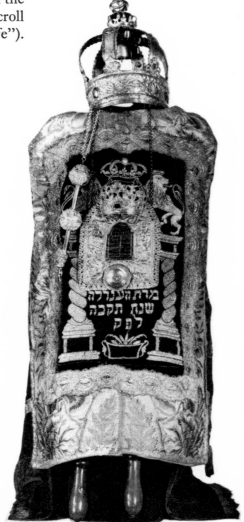

231.
Torah scroll, dressed: Torah crown, from Poland, silver and silver gilt. Tas, from Galicia, 1818; silver and silver gilt, repoussé. Pointer, from Galicia; silver filigree. Mantle, from Germany, 1765; blue brocade with floral patterns and green velvet center panel. Jewish Museum, New York. Harry G. Friedman Collection

223

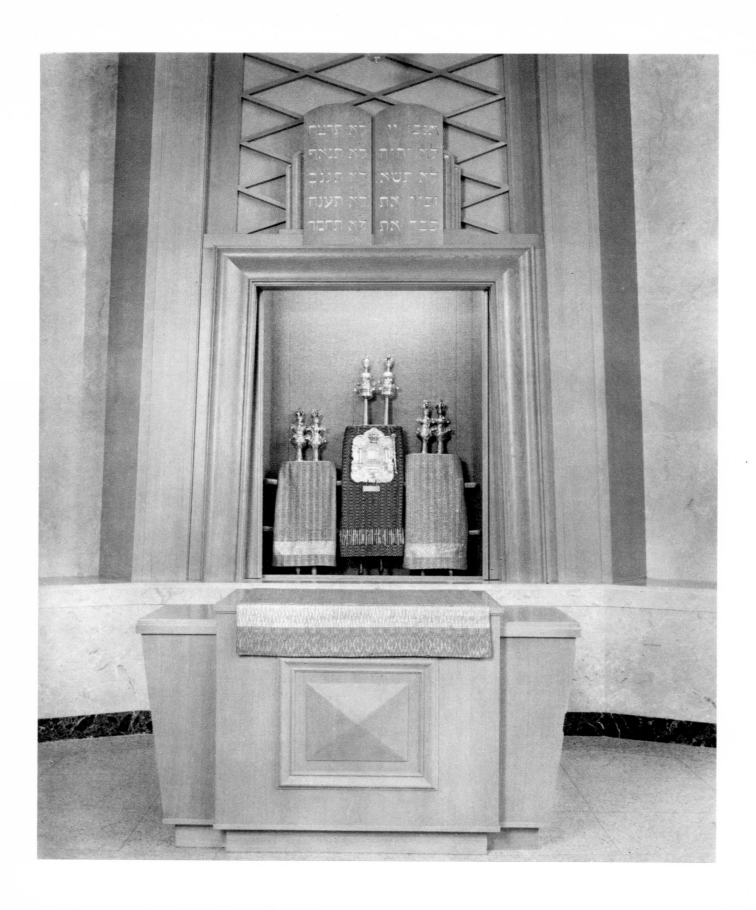

232. (FACING PAGE) Ark in the synagogue
of Congregation Kenneseth Israel, Philadelphia.
Textile lining the Ark, mantles, and table cover by
Bet Arigah, Philadelphia

233. Torah scrolls, dressed, with
accessories by Ludwig Wolpert. Motifs on
rimonim: "the pillar of cloud by day. . .
and the pillar of fire by night"
(Exodus 13:22). Jewish Chapel, United States
Air Force Academy, Colorado Springs

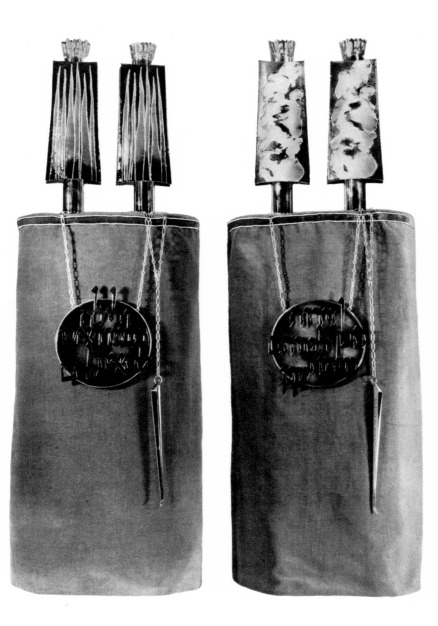

234. Torah scroll, dressed,
with accessories by Moshe Zabari (Tobe Pascher
Workshop). Temple Sinai, Summit,
New Jersey

Resting on each of these staves is a silver finial or small crown (rimon); or there may be a large crown *(keter Torah)* dominating both staves. Over the front of the mantle, suspended from the *etz hayyim,* is a metal breastplate, or shield (tas), while from one stave there hangs a Torah pointer, or scepter (yad).

After the Torah reading, the scroll is rolled up and tied with a long wrapper. As has been noted, in some European communities the wrapper is made of a baby boy's swaddling cloth (colorplate 17). The scroll having been rolled up, and its two halves bound together, the mantle is lowered over the staves and arranged to clothe the sacred word. The Torah mantle, protective and also beautiful, is one of the accessories that serve to focus attention on the holiest object in the synagogue. It developed in literal obedience to the talmudic admonition to have a beautiful scroll of the law prepared, copied by an able scribe with fine ink and fine calamus, and wrapped in beautiful silks. In the Ashkenazic synagogue the mantle is a sheath, open at the bottom and closed at the top except for two circular apertures for the *etz hayyim*. In the Sephardic ritual the front of the mantle opens and the edges overlap.

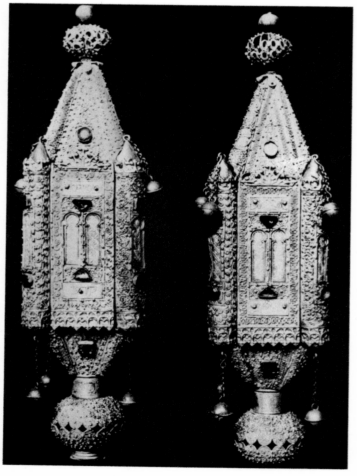

235. Rimonim. From Sicily,
fifteenth century. Silver, with bells. Now in
the treasury of the cathedral of
Palma, Mallorca

These mantles, of silk or velvet, are richly decorated: motifs frequently used are the columns of Jachin and Boaz, lions rampant, crowns, and pomegranates. In some older examples bells like those sewed into the clothes of the high priest ("so that the sound of it is heard when he comes into the sanctuary"; Exodus 28:35) were stitched to the wrapper. In time these gave way to pictured replicas, while actual little silver bells became part of both the Torah crown, the rimonim, and the breastplate. Most often the family names and dates are worked into the designs. The Jewish Museum of New York has a fine collection of mantles and curtains, while the Jewish Museum of Prague has an incredibly beautiful collection of velvets, brocades, silks, and other textiles from Bohemia, Moravia, and southern France.[6] These are important not only because of their intrinsic beauty but also because, like the Haggadot, the Megillot Esther, and the ketubot, they were made by Jews for Jewish use.

The *etz hayyim*, by which the scroll is rolled, and by which it is lifted up to be viewed by the congregation, invited ornamentation from the earliest period. The Romans and Greeks sometimes used golden rods with a knob on the upper end on which to roll their finest manuscripts; this may have inspired the Jews to decorate the *etz hayyim* likewise with precious metals. In any case, by the Middle Ages the Torah staves came to be ornamented with hollow golden headpieces that were fitted over the ends. The globular shape of these finials was reminiscent of the pomegranate designs on the Temple

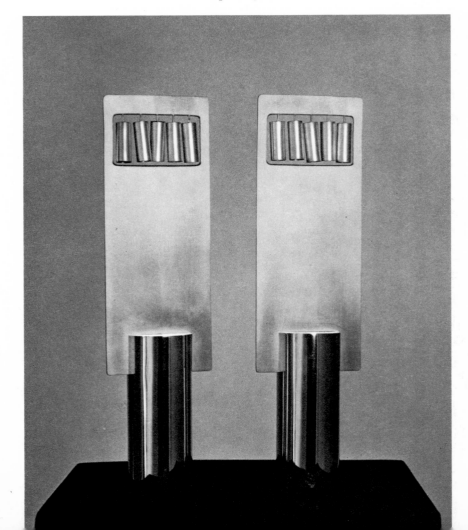

236. Rimonim, by Moshe Zabari. Silver, height 10″. The bells, ten in all, symbolize the Commandments. Collection Ernst Freudenheim, Buffalo

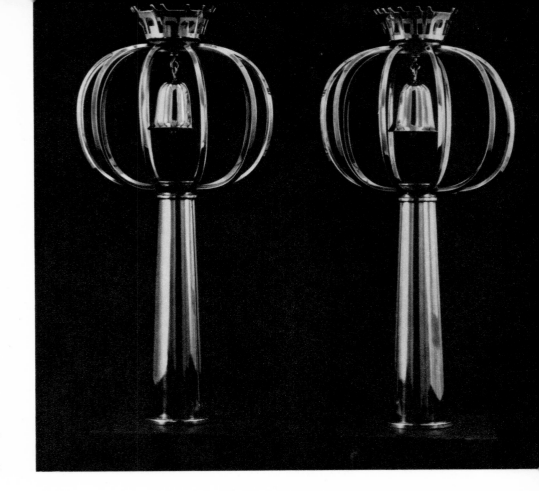

237.
Rimonim, by Ludwig Wolpert (Tobe Pascher Workshop). Silver, height 10¼″. Jewish Museum, New York

238.
Rimonim, by Bernard Bernstein. Silver, height 10″. Designed and executed in fulfillment of the requirements for a Master of Arts degree in fine arts at the University of Rochester. Courtesy the artist

228

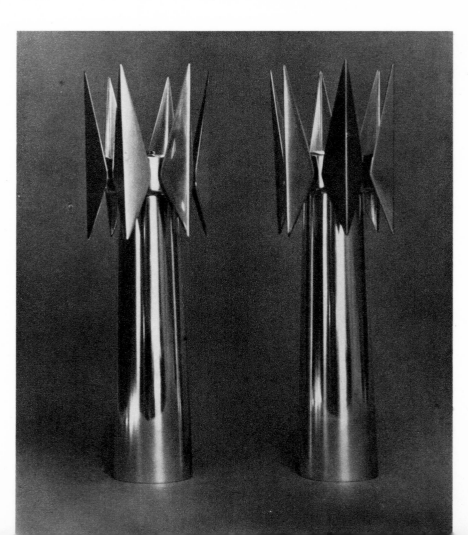

pillars, hence the term *rimonim,* which means "pomegranates." In his Mishne Torah, Maimonides states, "The silver and gold rimonim made to beautify a scroll of the Torah are sacred objects."

The bells, decorative and tinkling, that were originally used on mantles, were, as noted, later added to rimonim (colorplate 23; figs. 10, 232, 235). Pairs of rimonim by Moshe Zabari (fig. 236) and Ludwig Wolpert (fig. 237) are severely modern, designed as simple cylinders, but recall the past by their sets of tiny bells. Another modern set of rimonim (fig. 238) abandons the bell motif in favor of crowns.

While the rimonim developed in antiquity, it was not until the Middle Ages that the Torah crown was developed (figs. 231, 239, 243). It is thought that placing a crown on the Torah perhaps follows the custom of placing a wreath, or crown, on the head of the *chatan Torah* ("groom of the Torah"), the man who had the honor of being the first "called up" on Simhat Torah, when the new cycle of reading began. This may account for the old custom of using the Torah crown only on Simhat Torah and the rimonim the rest of the year.

239. Torah crowns and tas,
by Ludwig Wolpert (Tobe Pascher Workshop).
Silver: (left) height 19″; (right) height
of crown c. 12″, height of tas c. 9″.
Jewish Museum, New York

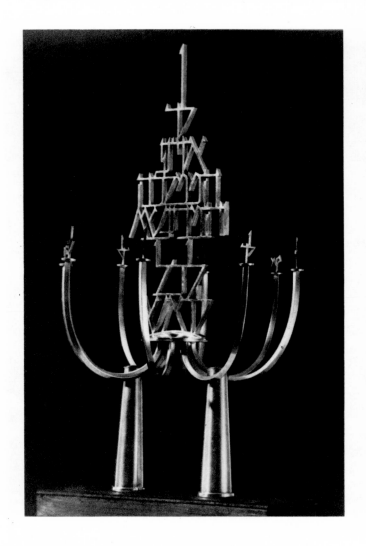

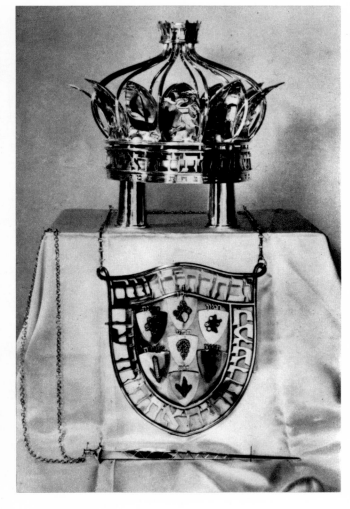

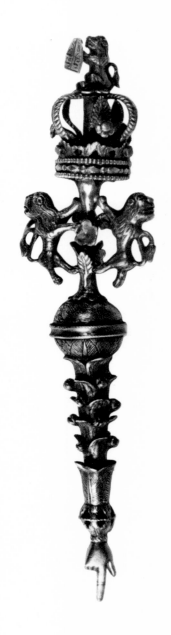

The crown is a familiar metaphor. As noted, in Pirke Avot the crown of Torah is enumerated along with the crown of royalty, the crown of priesthood, and the crown of a good name. The earliest mention of a literal crown appears in the year 1000, in the *responsum* of a Spanish rabbi concerning the question of using women's jewelry in making a Torah crown. A second reference occurs in the records of the city of Arles, in France: a contract dated 1439 indicates that the Jewish community ordered a crown from a Christian goldsmith; the contract also provided for further embellishment for a crown they already owned.[7]

The breastplate and the pointer are ornaments of more recent origin. The breastplate (figs. 231–234) originated as a tab hung around the Torah to distinguish the various scrolls on particular occasions. It is called breastplate to commemorate the breastplate worn by the high priest.[8] The priestly breastplate was made of gold and of blue, purple, and scarlet linen (Exodus 28: 13–30; 39:8–21). On the front face there were twelve precious stones in four rows; on each stone was engraved the names of one of the twelve tribes of Israel. Ludwig and Chava Wolpert have designed a modern breastplate based on the biblical description (colorplate 24). The earliest known Torah breastplate is dated 1612, but there are written accounts of earlier ones. The borders of breastplates often represent Moses and Aaron or the two pillars, Boaz and Jachin, that stood before the entrance to Solomon's Temple. In the center of the breastplate there is frequently a miniature Ark with doors in the form of Tablets of the Law. The lower part of the breastplate may have an aperture for the insertion of a small tag specifying the Sabbath or holiday on which the scroll is being read.

Suspended by a chain from one stave is the yad, or pointer (figs. 240, 241). The pointer meets the caution of the Talmud, "Whoso touches a naked Torah will lie naked when buried." Nevertheless, the pointer is not mentioned in ancient or medieval manuscripts, and we have no description earlier than 1570.

In many Sephardic congregations, especially those in Arabia and North Africa, the Torah scroll is contained in a contoured box of wood, leather, or metal. The two halves are hinged and open like a book to reveal the Torah, which is read without being removed (fig. 242). The scroll is rolled to the proper place by manipulation of the staves, which protrude from the top of the box, and which are sur-

Colorplate 24. (FACING PAGE)
Tas, by Chava and Ludwig Wolpert (Tobe Pascher Workshop). Silver, with enamel insets representing the twelve stones (symbols of the twelve tribes of Israel) set in the breastplate worn by the high priest (Exodus 28:13–21). Jewish Museum, New York

231

241.
Torah pointer, by Menachem Berman.
Silver and gold, length 9″. Courtesy Tas
Decorative Arts, Jerusalem

mounted by rimonim. Ludwig Wolpert has created a modern version (fig. 243).

The Torah scroll itself is a handwritten work of simple beauty. Written on parchment from a ritually clean animal, the Torah scroll consists of a standard number of lines. The length, height, and number of columns, the letters in each line, the width of the various spaces, and the margin size are all marked with a stylus in accordance with strict prescription. The writing is done with a quill, and the square Hebrew letters are carefully formed and spaced, using the best black ink. The vowel marks are omitted. When the writing is done, the sheets are sewed together with threads made by drying tendons of a clean beast. The continuous roll thus formed is attached at each end to the *etz hayyim;* then about half the scroll is wound on each stave. Until the beginning of the Common Era, each book of the Torah was inscribed separately on small scrolls. It was customary to equip each scroll with a single rod, which prevented it from being crushed when other scrolls were piled on top of it. When the five books came to be written on one large scroll, it became advisable to fasten each end of the parchment to a rod or stave. The heavy scroll could then be lifted from the Ark by the rods, and it could be unrolled without the parchment being touched.

The architecture of the synagogue has been extensively reviewed in three recent publications.[9] When conditions permitted, the Jews were not slow to construct synagogues of impressive architecture. Generally they modeled their houses of worship after the local mode, as we have seen. The synagogues of medieval Spain were Moorish; the synagogue in Worms was Romanesque; in Prague the Altneuschul was Gothic. Berlin and Düsseldorf built Renaissance synagogues; later there were Baroque structures. The Classical revival is reflected in the classical synagogue in the German city of Cleve, the Neoclassical synagogues in Carpentras and Avignon and the Georgian synagogue in Newport, Rhode Island (figs. 244, 245), the Neo-Greek synagogue in Charleston, and, somewhat later, the French classic Shearith Israel in New York.

It is hard enough for a people to suit its art to the changing moods and needs of the times. Added to this are the problems of changing environment, disparate backgrounds stemming from all corners of the earth, and the insecurities of minority existence. These difficulties became evident when, in the middle of the nineteenth century, architects began to seek an authentic Jewish style of synagogue building. In the Europe of that time, Oriental-style art was the vogue. This, combined with a sentimental idea that Judaism's roots were somehow Oriental (in the sense of Byzantine), gave rise to an Orientalistic style in synagogue art. Such structures arose all over Europe, and they came to be recognized as typical Jewish houses of worship. The same misconception extended into America, and the past century saw many syn-

agogues reaching back to a Moorish style: the old Temple Emanu-El (Fifth Avenue at Forty-third Street), the Central Synagogue, and the Chapel of Yeshiva University, all in New York City, are examples of this trend. Besides the imitation "Turkish" there arose an occasional Romanesque or Gothic synagogue and a large number of nondescript, purely utilitarian buildings.

The modern style in architecture—which first was applied to banks, office buildings, and factories—was soon applied to the building of synagogues. In the early 1930s, Felix Ascher and Robert Friedman built a modern synagogue in Hamburg, while Fritz Nathan built a similar chapel in the cemetery in Frankfurt. The advent of Nazism stifled this movement. It was revived in America during the boom in synagogue building after World War II. This style thrived so vigorously here that it has been appropriately called the "American" style.

Some of the most eminent architects, art historians, and rabbis have debated the problems of synagogue architecture. On the one hand are the traditionalists, who say that the synagogue is built around worship, and neither the grandeur of the structure nor the splendor of its furnishings should obscure this function. The synagogue should promote *yirat shamaim* ("fear of heaven"), a sense of holiness. ("Know before Whom you stand" and "I set God before me always" are two popular inscriptions in the synagogue.) It should also foster a sense of serenity, communal unity, and involvement. Above all, the building itself should not be the total goal. When Moses had completed the desert Tabernacle, the Israelites rejoiced; this the rabbis later apologetically explained: "Something more significant than the finishing of the tent was celebrated, for on that day Moses brought down the *shechinah*, 'the spirit of holiness,' to his people, and on that day Israel established its belief in one God."

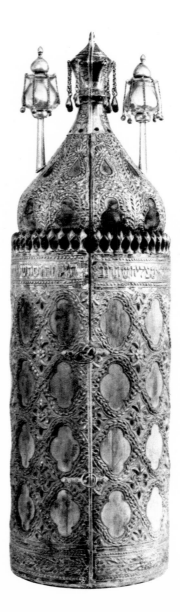

242.
Torah case. Wood with cut-out and embossed silver. Inscription names Joseph ben Aaron and his wife as donors. Collection Jakob Michael, New York

233

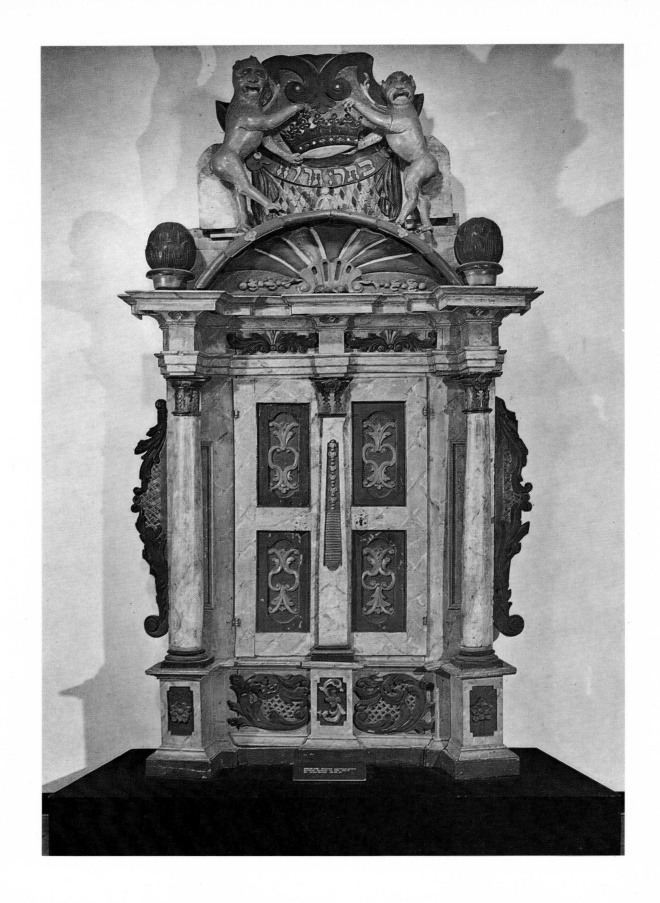

234

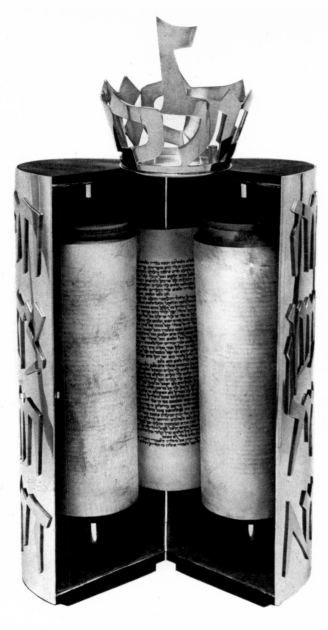

243. Torah case, by Ludwig Wolpert.
Birchwood with silver cut-out lettering;
height 31″, width 12″. Inscriptions:
"Thy word is a lamp unto my feet, and a light
unto my path" (Psalms 119:105); "For the
commandment is a lamp and the teaching is
light" (Proverbs 6:23). Temple Beth El,
Richmond, Virginia

On the other hand, those who approach the problem with a "new"
outlook stress that the synagogue is a place of prayer *and* study,
tefillah and Torah: "He who turneth his ear from Torah, his prayer
is an abomination." They argue, further, that the synagogue structure
should not only house prayer and study but should also be a house of
assembly. As in the olden days, when the house of prayer contained a
matzoh factory, a ritual bath, and even, on occasion, a place for ritual
slaughter, so the modern synagogue should meet all the needs of its
community. The modern architect interprets this as a mandate for a
building with a form free to adapt to function: low, clinging to earth,
rather than of an imposing height, crowned with spire and dome,

Colorplate 25. (FACING PAGE)
Ark. From Weilheim, Germany;
c. 1720. Freestanding; pinewood, carved and
painted; height 9′ 5″, width 5′ 3″. Tablets
of the Law; lions, rampant, supporting the
crown of the Law. Jewish Museum, New York

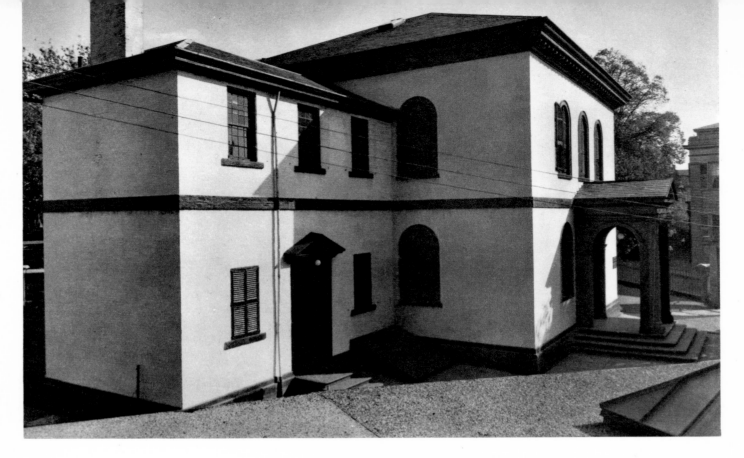

reaching to heaven. He includes in his plan a parking lot, a school meeting all modern standards, and even a gymnasium. For these purposes, the building is open, well-lighted, and airy, and the partitions are adjustable to the varying needs—there is a sense of mobility, rather than a sense of dominant holiness; there is almost no *yirat shamaim*.

Lewis Mumford has emphasized the importance of both function and form, the organic as opposed to the arranged. He sets these criteria for the architecture of the American synagogue: "It must express the Jewish concept of the cosmos, it must proclaim the unity of the Jewish community; it must provide for the broader conception of religion as identified in practical life with social service."[10]

The broad auditorium of the modern synagogue, uninterrupted by a bimah and split into three sections by two aisles (this was forbidden by the older rabbis as reminiscent of the Trinity), encourages a passive, listening role for the congregation in contrast to the intimacy of the benches clustered around the bimah. On the positive side, the contemporary trend resumes and amplifies the Dura Europos tradition: an unrestricted employment of the artist for the beautification of the sacred edifice.[11]

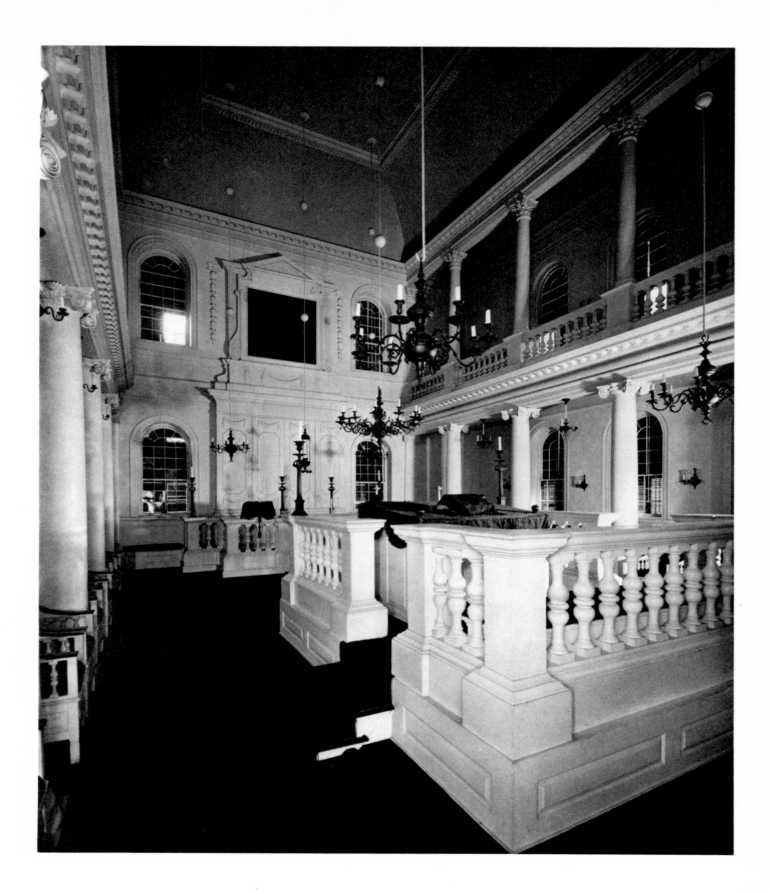

notes

Introduction

1 A. J. Heschel, *Man's Quest for God*, New York, 1954, p. 5.

2 *Jerusalem Post* (Weekly Overseas Edition), December 10, 1966.

3 L. Finkelstein, "Judaism as a System of Symbols," in *Mordecai M. Kaplan: Jubilee Volume*, New York, 1953, English section, p. 231.

I

1 M. Haram, "The Ark and the Cherubim," in *Israel Exploration Journal*, vol. IX (1959), pp. 30–38, 89–94; R. D. Barnett, *Illustrations of Old Testament History*, London, 1966.

2 W. F. Albright, *Archeology of Palestine and the Bible*, New York, 1932; J. Finegan, *Light from the Ancient Past*, Princeton, 1949.

3 F. Landsberger, "The Jewish Artist before the Time of Emancipation," *Hebrew Union College Annual [HUCA]*, vol. XVI (1941), p. 327.

4 L. Blau, "Early Christian Archeology from the Jewish Point of View," *HUCA*, vol. III (1900), pp. 157–214.

5 See, e.g., the following: F.W. Madden, *History of Jewish Coinage*, London, 1864; G.C. Williamson, *The Money of the Bible*, London, 1894; A. Reifenberg, *Ancient Jewish Coins*, London, 1903; T. Reinach, *Jewish Coins*, London, 1903; A. Reifenberg, *Ancient Hebrew Arts*, New York, 1950; A. Kindler, "The Coinage of the Hasmonean Dynasty," in *The Dating and Meaning of Ancient Jewish Coins* (Numismatic Studies and Researches, vol. II), Jerusalem, 1958; L. Kadman, *The Coins of the Jewish War of 66–73 C.E.*, Tel Aviv and Jerusalem, 1960; A. Kindler, *The Coins of Tiberias*, Tiberias, 1961; P. Romanoff, "Jewish Symbols on Ancient Coins," *The Jewish Quarterly Review* (N.S.), vol. XXXIII (1942–43), no. 1, pp. 1–15, no. 4, pp. 435–44; vol. XXXIV (1943–44), no. 2, pp. 161–77, no. 3, pp. 299–312,

no. 4, pp. 425–46. On Jewish portrait coins, see A. Reifenberg, "Portrait Coins of the Herodian Period," *Numismatic Circular*, London, 1935.

6 E. Bickerman, *The Maccabees: An Account of Their History from the Beginnings to the Fall of the House of the Hasmoneans*, New York, 1962, p. 15.

7 E. R. Goodenough, *Jewish Symbols in the Greco-Roman Period*, Bollingen Series XXXVII, 13 vols., New York, 1953 ff.

8 E.N. Adler, "Jewish Art," in *Occident and Orient...* (Gaster Anniversary Volume), London, 1936, p. 37.

9 E.E. Urbach, "The Rabbinical Laws of Idolatry in the Second and Third Centuries in the Light of Historical and Archaeological Facts," *Israel Exploration Journal*, vol. IX (1959), no. 3, pp. 149–65, no. 4, pp. 229–45.

10 R. Wischnitzer, *The Messianic Theme in the Paintings of the Dura Synagogue*, Chicago, 1948, p. 11. Other valuable sources on the Dura paintings are: I. Sonne, "The Paintings of the Dura Synagogue," *HUCA*, vol. XX (1947), pp. 255–362, and C.H. Kraeling, *The Synagogue*, New Haven, 1956.

11 B. Cohen, "Art in Jewish Law," *Judaism*, vol. III, no. 2 (Spring 1954), pp. 165–76.

12 Y. Yadin, *Masada*, New York, 1966, p. 63.

13 On Jewish mosaic art see, e.g., E.L. Sukenik, *The Ancient Synagogue of Bet Alpha*, London, 1932; *Israel Ancient Mosaics*, with preface by M. Schapiro and introduction by M. Avi-Yonah, Greenwich, Connecticut, 1960.

14 H. Howarth, "Jewish Art and the Fear of the Image: The Escape from an Age-old Inhibition," *Commentary*, vol. IX, no. 2 (Feb. 1950), p. 142.

15 *Israel Ancient Mosaics.*

16 H. Howarth, *op. cit.*, p. 142.

17 B. Cohen, *op. cit.*

18 C. Roth, Historical Introduction, G. Loukomski, *Jewish Art in European Synagogues: From the Middle Ages to the 18th Century*, London, 1947.

19 A. Yaari, *Hebrew Printers' Marks*, Jerusalem, 1943 (in Hebrew, with English introduction).

20 Moshe Davidowitz, "The Human Figure in Jewish Ceremonial Art," *Fourth World Congress of Jewish Studies: Papers,* Jerusalem, 1968.

21 C. Roth, *Jewish Art,* New York, 1961, col. 26.

22 C. Roth, *The Jews in the Renaissance,* Philadelphia, 1959, p. 204. For illustrations of the exuberant decoration of Italian synagogues see J. Finkerfeld, *Italian Synagogues,* Jerusalem, 1954 (in Hebrew).

23 For pictures and descriptions of old European synagogues see G. Loukomski, *op. cit.;* M. and K. Piechotka, *Wooden Synagogues* (English ed.), Warsaw, 1959; R. Wischnitzer, *The Architecture of the European Synagogue,* Philadelphia, 1964. For a discussion of the Jupiter figures see Guido Schoenberger, "A Late Survival of Jupiter Fulgur," in *Essays in Memory of Karl Lehmann* (*Marsyas* Supplement I), Locust Valley, New York, 1964.

24 E. Rivkin, "A Decisive Pattern in American Jewish History," *Essays in American Jewish History* (American Jewish Archives Tenth Anniversary Volume), Cincinnati, 1958, pp. 23–61.

25 For a fairly complete bibliography of books on Jewish art see L.A. Mayer, *Bibliography of Jewish Art,* Jerusalem, 1967.

26 "Prophet of Bezalel," *Jerusalem Post,* March 23, 1962.

2

1 I. Benzinger, "Art among the Ancient Hebrews," *The Jewish Encyclopedia,* vol. II, p. 141.

2 M. Buber, *Jüdische Künstler,* Berlin, 1903. Quoted in H. Howarth, "Jewish Art and the Fear of the Image," *Commentary,* vol. IX, no. 2 (Feb. 1950), p. 143.

3 F. Landsberger, "The Jewish Artist before the Time of Emancipation," *HUCA,* vol. XVI (1941), p. 321–414. See also Landsberger, "New Studies in Early Jewish Artists," *HUCA,* vol. XVIII, 1944, pp. 279–320; C. Roth, "New Notes on Pre-Emancipation Artists," *HUCA,* vol. XVII (1943), pp. 499–510; M. Wischnitzer, "Notes to a History of the Jewish Guilds," *HUCA,* vol. XXIII, part 2 (1950–51), pp. 245–63; M. Wischnitzer, "Origins of the Jewish Artisan Class in Bohemia and Moravia, 1500–1648," *Jewish Social Studies,* vol. XVI (1954), pp. 335–50; M. Wischnitzer, *A History of Jewish Crafts and Guilds,* New York, 1965

4 Landsberger, "The Jewish Artist before the Time of Emancipation," *HUCA,* vol. XVI (1941).

5 Among the remains in Israel that give an idea of the architecture of the classical period are those at Sifsofa (Upper Galilee), 3rd century (artifacts in Archaeological Museum, Jerusalem); Chorazim, Lower Galilee, 2nd–3rd century (artifacts in Archaeological Museum, Jerusalem); Capernaum, 3rd century; Beth Alpha, 6th century; Isfiya, Haifa area, 5th–6th century (all artifacts in the Archaeological Museum, Jerusalem); Beth Shearim, Haifa, Nazareth area, 2nd century; Yafi'a, Nazareth, 3rd century; Meron, Sefad area; Gush-Halav Sefad area, 3rd–4th century; Peki'in, 2nd–3rd century; Kfar Biram, Upper Galilee, 3rd century (artifacts in Archaeological Museum, Jerusalem).

6 R. Wischnitzer, *The Architecture of the European Synagogue,* Philadelphia, 1964.

7 F. L. May, *Hispanic Lace and Lace Making,* New York, 1939, pp. 292–94.

8 A. A. Neuman, *The Jews in Spain,* Philadelphia, 1942, vol. II, p. 149.

9 J. W. Thompson, *Economic and Social History of Europe in the Later Middle Ages,* New York and London, 1931.

10 F. Baer, *A History of the Jews in Christian Spain,* Philadelphia, 1961.

11 C. Roth, *The Jews in the Renaissance,* Philadelphia, 1959.

12 M. Wischnitzer, *A History of Jewish Crafts and Guilds,* New York, 1965.

13 H. Volavkova, *The Synagogue Treasures of Bohemia and Moravia,* Prague, 1949, and *Schicksal des Jüdischen Museums in Prag,* 1965.

14 C. Roth, *The Kennicott Bible,* Bodleian Picture Books No. 11, Oxford, 1900; "A Masterpiece of Medieval Spanish-Jewish Art: The Kennicott Bible," *Sefarad,* vol. XII (1952), pp. 351–58.

15 E. N. Adler, "Jewish Art," in *Occident and Orient...* (Gaster Anniversary Volume), London, 1936.

16 C. Roth, *Jewish Art,* New York, 1961.

17 S. Kirschstein, *Jüdische Graphiker aus der Zeit von 1625–1825,* Berlin, 1918.

18 *Miniaturemaleren Liepmann Fraenckel,* Copenhagen, 1951.

19 J. W. Rosenbaum, *Myer Myers, Goldsmith, 1723–1795,* Philadelphia, 1954.

20 J. Gutmann, "Jewish Participation in the Visual Arts of Eighteenth- and Nineteenth-Century America," *American Jewish Archives,* vol. XV (1963), no. 1; S. M. Collman, *Jews in Art,* Cincinnati, 1909; M. Birnbaum, *Introductions: Painters, Sculptors and Graphic Artists,* New York, 1919.

21 K. Schwarz, *Jewish Ceremonial Objects,* catalogue of an exhibition held at the Jewish Museum, Berlin, 1933.

22 Percival and Paul Goodman, "The Modern Artist as Synagogue Builder: Satisfying the Needs of Today's Congregations," *Commentary,* vol. VII, no. 1 (Jan. 1949), p. 524.

23 *The Patron Church,* catalogue of an exhibition held at the Museum of Contemporary Crafts, New York, 1957–58; Percival Goodman, "Vigorous Art in the Temple," *Architectural Forum,* May 1959, p. 140; "Today's Religious Art," Munson-Williams-Proctor Institute, Utica, New York, *Art Museum Bulletin,* March, 1959.

3

1 A. Kindler, "The Coinage of the Hasmonean Dynasty," (cited in note 5, Chap. 1).

2 E. Namenyi, *The Essence of Jewish Art,* London and New York, 1960.

3 M. I. Rostovtzeff, *Dura-Europos and Its Art,* Oxford, 1938.

4 J. Neusner, "Judaism at Dura Europos," *Journal of Religion,* vol. IV, no. 1 (1964), p. 81.

5 A. A. Cohen, Introduction, *The Hebrew Bible in Christian, Jewish and Muslim Art,* catalogue of an exhibition held at the Jewish Museum, New York, 1963.

6 M. Diamant, *Jüdische Volkskunst,* Vienna and Jerusalem, 1937; A. Levy, *Jüdische Grabmalkunst in Osteuropa,* Berlin, 1923; B. Wachstein, *Die Grabschriften des alten Judenfriedhofes in Eisenstadt,* Vienna, 1922; D. H. De Castro, *Keur Van Grafsteenen op de Nederl.-Portug.-Israël. Begraafplaats te Ouderkerk aan den Amstel,* Leiden, 1883.

7 "Jewish Art," *Encyclopedia of World Art,* vol. V, col. 495.

8 L. S. Freehof and B. King, *Embroideries and Fabrics for Synagogue and Home: 5000 Years of Ornamental Needlework,* New York, 1966.

9 M. and K. Piechotka, *Wooden Synagogues,* Warsaw, 1959.

10 M. Narkiss, *Bezalel Study* No. 2, National Museum, Jerusalem.

4

1 *Illuminated Hebrew Manuscripts . . . ,* catalogue of an exhibition held at the Jewish Museum, New York, 1965.

2 I. Sonne, "The Zodiac Theme in Ancient Synagogues and in Hebrew Printed Books," *Studies in Bibliography and Booklore,* vol. I (1953), p. 14.

3 D. H. De Castro, *op. cit.* (in note 6, Chap. 3).

4 M. Schapiro, "The Angel with the Ram in Abraham's Sacrifice: A Parallel in Western and Islamic Art," *Ars Islamica,* vol. X (1943), pp. 134–47; *The Hebrew Bible in Christian, Jewish and Muslim Art,* catalogue of an exhibition held at the Jewish Museum, New York, 1963 (illustrations of the Akedah on a 12th-century enamel, a Roman ceramic bowl of the 4th century, a Coptic relief, as the theme of an etching by Rembrandt, etc.); B. Goldberg, *The Sacred Portal,* Detroit, 1966.

5 E. R. Goodenough, *Jewish Symbols in the Greco-Roman Period,* New York, vol. IV, p. 73.

6 A. Kindler, "The Coinage of the Hasmonean Dynasty," (cited in note 5, Chap. 1); L. Kadman, *The Coins of the Jewish War of 66–73 C.E.,* Tel Aviv and Jerusalem, 1960.

7 M. Seligsohn, "Star-Worship," *The Jewish Encyclopedia,* vol. XI, p. 527.

8 F. W. Madden, *History of Jewish Coins,* London, 1864.

9 G. Scholem, "The Curious History of the Six-pointed Star: How the 'Magen David' Became the Jewish Symbol," *Commentary,* vol. VIII, no. 3 (Sept. 1949), pp. 243–51.

10 K. Kohler, "Leviathan and Behemoth," *The Jewish Encyclopedia,* vol. VII, p. 39.

11 I. Sonne, *op. cit.*

12 C. Roth, "Messianic Symbols in Palestinian Archeology," *Palestine Archeological Quarterly,* October, 1955.

13 E. R. Goodenough, "Pagan Symbols in Jewish Antiquity," *Commentary,* vol. XXIII, no. 1 (Jan. 1957), pp. 74–80.

14 E. E. Urbach, "The Rabbinical Laws of Idolatry. . . ," *Israel Exploration Journal,* vol. IX (1959), no. 3, pp. 149–65, no. 4, pp. 229–45.

15 J. Neusner, "Jewish Use of Pagan Symbols after 70 C.E.," *Journal of Religion,* vol. XLIII (1963), no. 4, p. 285.

16 F. Landsberger, "The Origin of the Winged Angel in Jewish Art," *Hebrew Union College Annual,* vol. XX (1947), pp. 227–54.

17 F. Landsberger, *A History of Jewish Art,* Cincinnati, 1946, p. 17.

18 H. Friedlander, "Modern Hebrew Lettering," *Ariel* (Winter 1963), p. 6.

19 B. Shahn, *The Alphabet of Creation,* New York, 1954.

5

1 E. R. Goodenough, *Jewish Symbols in the Greco-Roman Period,* vol. IV, p. 96.

2 *Monumenta Judaica,* catalogue of the exhibition "2000 Jahre Geschichte und Kultur der Juden am Rhein," held in Cologne, 1963.

3 A. J. Heschel, *The Sabbath: Its Meaning for Modern Man,* New York, 1951 (wood engravings by Ilya Schor), plate opposite p. 62.

6

1 E. R. Goodenough, *Jewish Symbols in the Greco-Roman Period,* vol. VI, p. 146.

2 *Monumenta Judaica: Kataloga,* Item E 154. See also J. C. G. Bodenschatzen, *Kirchliche Verfassung der heutigen Juden,* Leipzig, 1784, part 2, p. 35.

3 J. B. Frey, *Corpus Inscriptiorum Judaicarum,* Vatican City, 1936.

4 F. Cantera Burgos and J. M. Milas y Vallicrosa, *Las Inscripciones Hebraicas de España,* Madrid, 1956.

7

1 L. Finkelstein, *The Pharisees,* 3rd ed., Philadelphia, 1962.

2 B. Chagall, *Burning Lights*, New York, 1946, pp. 48–49.

3 A. J. Heschel, *The Sabbath: Its Meaning for Modern Man*, New York, 1951, p. 29.

4 Candles were used in the earliest times; see Harrison, "Fire Making, Fuel and Lighting," in *A History of Technology*, London, 1954, p. 216.

5 M. Oppenheim, *Bilder aus dem altjüdischen Familienleben*, Frankfurt, 1882.

6 I. B. Singer, *In My Father's Court*, Philadelphia, 1966.

8

1 See T. H. Gaster, *Passover: Its History and Tradition*, New York, 1949.

2 See R. Wischnitzer, "Passover in Art," in Philip Goodman, ed., *The Passover Anthology*, Philadelphia, 1961; J. Gutmann, "The Illuminated Medieval Passover Haggadah: Investigations and Research," *Studies in Bibliography and Booklore*, vol. VII (1965), pp. 3–25.

3 B. Kisch, "The Neuendorf Haggadah: A Unique Document of the Time of Nazi Terror in Germany," *The Leo Jung Jubilee Volume*, New York, 1962, pp. 133–37.

4 F. Landsberger, *Einführung in die jüdische Kunst*, Berlin, 1935, p. 54.

9

1 Josephus, *Antiquities* XIII, p. 13.

2 F. W. Madden, *op. cit.*

3 S. Zeitlin, *The History of the Second Jewish Commonwealth*, Philadelphia, 1933.

4 F. Landsberger, "Old Hanukkah Lamps," *Hebrew Union College Annual*, vol. XXV (1954), p. 347–67.

5 I. B. Singer, *In My Father's Court*, Philadelphia, 1966.

6 T. H. Gaster, *Purim and Hanukah in Custom and Tradition*, New York, 1950.

7 C. Roth, "The Art and Craft of Jewish Collecting: Dealings in the Higher 'Junk,'" *Commentary*, vol. XXIII, no. 6 (June 1957), pp. 541–47.

8 *Monumenta Judaica: Kataloga*, Item E 701.

10

1 *Monumenta Judaica: Kataloga*, Item E 130.

2 W. G. Plaut, "The Origin of the Word 'Yarmulke,'" *HUCA*, vol. XXVI (1955), pp. 567–70.

3 F. Landsberger, "Illuminated Marriage Contracts, *HUCA*, vol. XXVI (1955), pp. 503–42.

4 *Monumenta Judaica: Kataloga*, Item E 185.

11

1 *The Jewish Encyclopedia*, vol. VIII, p. 532.

2 A. Freiman, *Union Catalogue of Hebrew Manuscripts and Their Location*, vol. II, New York, 1964.

3 D. S. Blondheim, "An Old Portuguese Work on Manuscript Illumination," *Jewish Quarterly Review* (N. S.), vol. XIX, no. 2 (1928).

4 T. Dub, "My Booba's Tehinnah," *Jewish Chronicle*, March 11, 1966.

5 Philip Goodman, "American Jewish Bookplates," *Publications of the American Jewish Historical Society*, vol. XLV, no. 3 (March 1956), pp. 129–216.

12

1 L. Finkelstein, "The Origin of the Synagogue," *Proceedings of the American Academy for Jewish Research, 1928–1930*, pp. 49–59.

2 Y. Yadin, *Masada*, New York, 1966.

3 F. Landsberger, "Old-Time Torah-Curtains," *HUCA*, vol. XIX (1946), pp. 353–87.

4 *The America of 1750: Peter Kalm's Travels in North America* (the English version of 1770 revised from the original Swedish and edited by Adolph B. Benson. . . with a translation of new material from Kalm's diary notes), New York, 1937, vol. I, pp. 132–33.

5 S. B. Finesinger, "The Shofar," *HUCA*, vols. 8–9 (1931–32), p. 193.

6 H. Volavkova, *The Synagogue Treasures of Bohemia and Moravia*, Prague, 1949.

7 See F. Landsberger, "The Origin of European Torah Decorations," *HUCA*, vol. 24 (1952–53), pp. 133–50. On a group of Colonial Torah ornaments see G. Schoenberger, "The Ritual Silver Made by Myer Myers," *Publications of the American Jewish Historical Society*, vol. 43, no. 1 (Sept. 1953), pp. 1–10.

8 This derivation has been questioned by Dr. Joseph Gutmann (see his article "Torah Ornaments, Priestly Vestments, and the King James Bible," *Central Conference of American Rabbis Journal*, Jan. 1969, pp. 78–80).

9 R. Wischnitzer, *The Architecture of the European Synagogue*, Philadelphia, 1964; R. Wischnitzer, *Synagogue Architecture in the United States*, Philadelphia, 1955; A. Kampf, *Contemporary Synagogue Art*, New York, 1966.

10 L. Mumford, "Towards a Modern Synagog Architecture," *Menorah Journal*, vol. XI (June 1925), p. 225.

11 See W. Schack, "Synagogue Art Today, I: Something of a Renaissance," *Commentary*, vol. XX, no. 6 (Dec. 1955), pp. 548–59, and "Modern Art in the Synagogue, II: Artist, Architect, and Building Committee Collaborate," *Commentary*, vol. XXI, no. 2 (Feb. 1956), pp. 152–61.

Glossary-Index

PHOTOCREDITS Oliver Baker: 58, 85; Rudolph Burckhardt: 54; Frank J. Darmstaedter: 6, 7, 16, 18, 21, 23, 37, 45, 46, 48, 56, 61, 62, 63, 64, 67, 68, 69, 75, 76, 78, 80, 81, 82, 90, 91a, 91b, 93, 99, 103, 105, 110, 112, 113, 122, 125, 134, 146, 147, 148, 149, 150, 151, 152, 153, 154, 155, 156, 157, 158, 159, 160, 161, 162, 163, 164, 165, 166, 167, 169, 170, 171, 173, 174, 178, 184, 188, 196,197, 198, 200, 202, 203, 207, 215, 217, 218, 219, 231, 232, 233, 235, 237, 240; Gough Photo Services: 49; Emerich C. Gross: 52; Ambur Hiken: 181, 189, 208, 236; John Hopf: 8, 10; Ryszard Horowitz: 212; Gretchen Lambert: 175, 243;Victor Laredo: 38; Erich Locker: 220; O.E. Nelson: 145; Eric Pollitzer: 4, 5, 17, 19, 20, 24, 25, 27, 28, 29, 30, 33, 39, 60, 66, 70, 77, 79, 86, 88, 89, 91, 92, 95, 96, 97, 101, 104, 107, 111, 114, 114a, 116, 117, 118, 119, 126, 127, 128, 135, 135a, 137, 139, 140, 143, 177, 180, 183, 187, 190, 191, 193, 195, 199, 204, 206, 209, 210, 211, 214, 221, 225, 227, 228, 229, 230; John D. Schiff: 94; Taylor and Dull, Inc.: 102, 109, 124, 213, 216, 242.